THE
BIBLE
IN ART

Susan Wright

TODTRI

This book was designed and produced by

Todtri Productions Limited

P.O. Box 572, New York, NY 10116-0572

FAX: (212) 279-1241

Printed and bound in Singapore

ISBN 1-880908-68-9

Author: Susan Wright

Publisher: Robert M. Tod

Book Designer: Mark Weinberg

Production Coordinator: Heather Weigel

Senior Editor: Edward Douglas

Project Editor: Cynthia Sternau

Assistant Editor: Don Kennison

Desktop Associate: Michael Walther

Typesetting: Command-O, NYC

Picture Credits

Antwerp Cathedral, Antwerp 106
The Art Institute of Chicago, 43
Art Resource, New York, NY pp. 16, 20-21, 36, 37, 38, 48, 53, 54, 58, 62 (top), 74, 89, 97, 106
Art Resource/Bridgman, New York, NY pp. 29, 62 (bottom), 115
Art Resource/Erich Lessing, New York, NY pp. 17, 30 (top), 31, 40-41, 45, 46, 61, 67, 75, 86, 94-95, 98, 111, 127
Art Resource/Giraudon, New York, NY pp. 30 (bottom), 32, 35, 44, 51, 59, 60, 64-65, 76, 83, 90, 96, 107, 108, 110, 112-113, 124, 126
Art Resource/The Pierpont Morgan Library, New York, NY pp. 52, 87
Art Resource/Scala, New York, NY pp. 14-15, 24-25, 26, 34, 56-57, 63, 68-69, 70, 71, 72-73, 78, 80, 81, 82, 84, 85, 91, 99, 100, 102, 116, 117, 118-119, 120-121, 122, 123, 125
Art Resource, New York, NY/Tate Gallery, London. pp. 114
Bargello, Florence 26, 34
Bibliotheque Municipale, Epernay 76
Bibliotheque Nationale, Paris 48, 108, 110
The British Library, London 22
The British Museum 28, 97
Cappella Scrovegni, Padua 117, 123
Cathedral at Speyer, Germany 45
Cathedral Museum 100
Cathedral Treasury, Aachen 74
Chartres Cathedral, Chartres 60
Chiostro dello Scalzo, Florence 72-73
City Galleries, Augsburg 62 (top)
The Collection of Pallavincini, Rome 54
Contarelli Chapel, S. Luigi dei Francesi, Rome 77
Dijon Museum, Dijon 84
Doria Gallery, Rome 85
Galleria dell'Accademia, Florence 46
Galleria dell'Accademia, Venice 16,
Galleria Palatina, Florence 63
Gemaldegalerie, Kunsthistorisches Museum, Vienna 17, 40-41, 61, 75
Georges de la Tour 66
Hadassah Medical Center Synagogue, Jerusalem 38
The Institute of Fine Arts, Minneapolis 55
Lateran Museum, Rome 56-57
Logge, Vatican, Rome 24-25, 37
Louvre, Paris 44, 67, 82, 83, 86, 92, 94-95, 104-105, 111, 112-113, 118-119
Metropolitan Museum of Art, New York 5, 6, 7, 8-9, 10, 11, 12, 13
Musée Bonnat, Bayonne 51
Musée Conde, Chantilly 30 (bottom), 42, 49, 59, 64-65, 79, 90, 126
Musée de Beaux-Arts, Rouen 96
Musée de la Chartreuse, Donai 32
Musée Unterlinden, Colmar 107
Museo dell'Opera del Duomo, Florence 98
Museum of Fine Arts, Boston 18, 33, 103
National Collection of Fine Arts, Washington, D.C. 50
National Gallery, London 62 (bottom)
National Gallery of Scotland, Edinburgh 115
The Nelson-Atkins Museum of Art, Kansas City, Missouri 77
Philadelphia Museum of Art, Philadelphia 93
Pierpont Morgan Library, New York 87
Pinacoteca Comunale, Volterra 102
Pinocoteca di Brera, Milan 80
Prado, Madrid 29, 109, 127
S. Apollinare in Classe, Ravenna 120-121
S. Michele, Carmignano 81
Sacristy, Santa Maria della Salute, Venice 19
Sammlungen des Stiftes Klosteeneuburg, Austria 30 (top)
Santa Maria delle Grazie, Milan 99
Santa Maria del Populo, Rome 53
Santa Maria del Popolo, Cerasi Chapel, Rome 91
Santa Maria Maggiore, Rome 36
Santa Maria Novella, Florence 20-21
Santa Trinita, Florence 70
Scuola di San Rocco, Venice 116
Sistine Chapel, Vatican, Rome 14-15
The Smithsonian Institution, National Collection of Fine Arts, Washington, D.C. 58
St. Madeleine, from the tympanum of the narthex, Vezlay 124
St. Peter's Vatican, Rome 122
St. Pietro in Vincoli, Rome 31
St. Sulpice, Paris 27, 35
Staatliche kuntsammlungen, Gemaldegalerie, Kassel 39
Tate Gallery, London 52, 114
Toledo Museum of Art, Ohio 101
Uffizi, Florence 68-69, 71, 125
Vatican, Rome 88-89

CONTENTS

INTRODUCTION

Truly Christian art did not begin to appear in Europe until the late second century A.D., but thereafter it quickly spread to all the provinces of the Roman Empire. From approximately the second century to the fifth century, this art is known collectively as Early Christian. The style was based on Greco-Roman traditions, and the earliest biblical narrative scenes are sometimes indistinguishable from the mythic renderings of Greek gods. As the influence of Christianity spread, its art was adapted to the existing cultural and pagan forms, leading to stylistic evolutions in different areas of Europe.

Most often, Early Christian art is found in the form of funerary decorations, in catacomb frescoes or in carved reliefs on sarcophagi. It was not until the early fourth century that new mosaic murals began to appear as decoration on church walls.

Early Christian manuscripts consisted of scrolls of joined sheets of parchment. A great number of ancient Greek papyri have been found preserved in Egypt, containing the exact working for most of the texts for the Books of the New Testament, which document the life of Christ and his Apostles. Matthew and John were said to have written their Gospels, in addition to the Letters and the Acts of the Apostles, early in the first century A.D. Mark and Luke, the two Evangelists who did not know

Jesus, are said to have composed their Gospels during the second half of the first century.

In the fourth century, St. Jerome consulted translations of the Hebrew Bible that had been created by the legendary "seventy Jewish scholars" at least a hundred years prior to his time and gave us the first translation of the whole Bible, known as the Latin Vulgate. This was composed of the New Testament as well as the Hebrew Bible—what the Christians called the Old Testament, which told of Jewish traditions with God.

Eastern Christianity

Constantine the Great (306–337) founded the capital of his empire in Constantinople, formally known as Byzantium, and fostered the Christian Orthodox church. The cultural style that sprang from his patronage was known as Byzantine art, and it spread far beyond the Eastern Christian regions, affecting even the art of western Europe well into the middle ages.

Byzantine art was dedicated to the service of the Christian faith, and by the end of the eighth century elaborate representational decorations were created in mosaics, frescoes, and icons. The Byzantine monks perfected the bound book form—called a codex—and these texts were

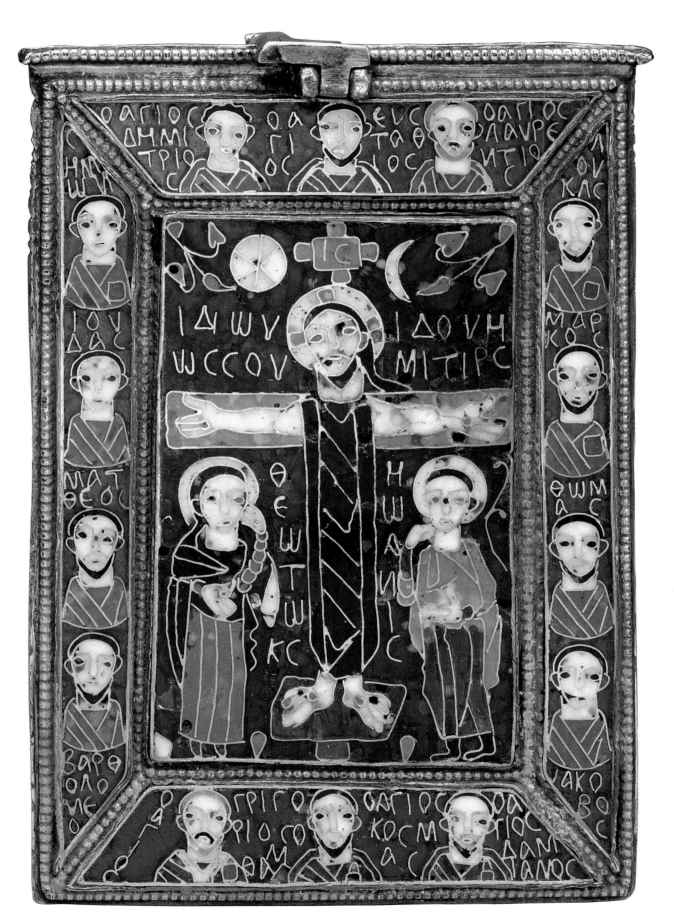

Reliquary of the True Cross

Byzantine, late eighth century; silver gilt, cloisonne enamel, and niello; 4 x 2 7/8 in. (10 x 7 cm). Gift of J. Pierpont Morgan, 1917, The Metropolitan Museum of Art, New York.

The top and sides of this small reliquary are decorated with enamels portraying the Crucifixion and busts of twenty-seven saints, including the twelve Apostles. On the lid, Christ is shown alive on the cross, wearing a long Eastern-style tunic, mourned by the Virgin Mary and St. John the Evangelist.

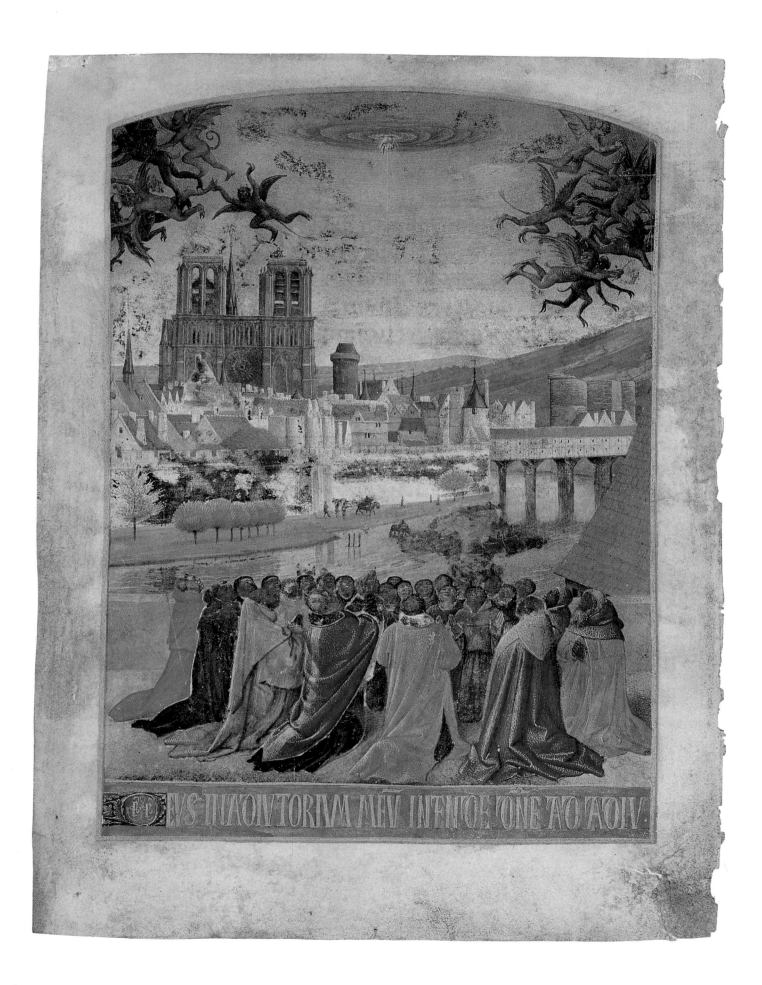

lavishly illustrated with biblical scenes done in gold and colored pigment.

Byzantine art consisted basically of a symbolic system that arranged the figures according to their religious importance, and relied on detailed iconography for the depiction of each subject. The drapery and poses were highly stylized, and delineated with bold lines.

The Middle Ages

Romanesque art had its beginnings during the Carolingian period of the eighth century, under the patronage of Charlemagne, then continued during the Ottonian Empire until 1050. The influence of Byzantine art can be seen in the strong lines of the Romanesque style, and the positioning of relief-like figures against a flat background.

The unifying theme of Romanesque art had its basis in monasticism, re-flected in the founding of hundreds of Christian monasteries from 650–1200. These monasteries served as focal points of Christianity throughout Europe, and were the vanguard in intellectual and artistic development. This religious fervor can be felt in the vigor of the Romanesque style, although its rich expressiveness has at times been interpreted as somewhat crude.

Monks labored away in their scriptoria, producing multiple copies of manuscripts, from works of ancient classical authors to scriptural and liturgical texts,—including the Gospels, works on eccle-

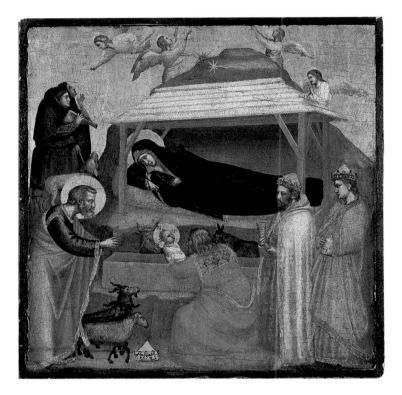

The Epiphany

Giotto, c. 1320; tempera on wood, gold ground; 17 3/4 x 17 1/4 in. (45 x 44 cm). John Stewart Kennedy Fund, 1911, The Metropolitan Museum of Art, New York. Giotto (Italian, c. 1266–1337) completed this panel as one of a series of seven, representing scenes from the life of Jesus Christ. The artist created this scene at the height of his artistic powers, evidenced by the clear organization of space and simplified shapes, which indicated the growing concern for verisimilitude during the middle ages.

**Descent of the Holy
Ghost upon the Faithful**

Jean Fouquet, c. 1452; illumination; 7 3/4 x 5 3/4 in. (20 x 15 cm). Robert Lehman Collection, 1975, The Metropolitan Museum of Art, New York. Jean Fouquet (French, c. 1420–1481) illustrated this Book of Hours (a book with prayers for the canonical hours of the day) for Etienne Chevalier, treasurer of France. This page of luminous colors and gold is the earliest known topographical view of medieval Paris—which includes the facade of Notre-Dame, the Pont Saint-Michel, and the Petit Chatelet.

siastical law, the Psalters, and books of hours. During the middle ages the Bible was commonly known as the *Bibliotheca* or *Scriptura*, though the first use of the word "Biblia" did in fact occur in the twelfth century. The text of the manuscript was invariably accompanied by biblical scenes, with the figures conceived in linear terms; spatial representations were either ignored or treated as a decorative design.

Gothic art thrived from 1200–1350. It was typically dynamic in design, in an attempt to break free of the stylistic constraints of Romanesque and Byzantine art. The turmoil of the middle ages was accompanied by agricultural and technical advances, as well as by the rise of new social frameworks. Monarchies were stabilizing throughout the countries of Europe; in Italy cities were free, tradesmen were protected by guilds, and the new middle class—the bourgeoisie—finally obtained a share of power in the government.

The International Gothic period—beginning in the late fourteenth century and lasting to the mid-fifteenth century—marked a unity in the style of painting and sculpture throughout the whole of Europe. An abundance of private religious sculpture and manuscripts were commissioned by courts, churches, and wealthy individ-

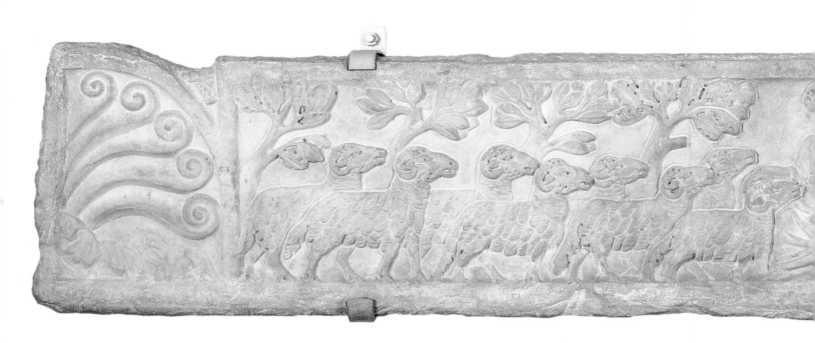

Sarcophagus Lid with the Last Judgment
Roman, late third century; marble; 16 x 93 1/2 x 2 3/4 in. (41 x 238 x 7 cm).
Rogers Fund, 1924, The Metropolitan Museum of Art, New York.
This relief is the earliest surviving example depicting the theme of the Last
Judgment, symbolized by the parable of the separation of the sheep from the
goats. (Matt. 25:31–46) The pastoral setting of paradise was common in
Early Christian art; Christ is dressed in the robes of a teacher-philosopher.

uals. Artists, too, were becoming well known in
their own right. Elegance in figure portrayal
became fashionable, yet there remained a marked
concern with realism in the details of setting and
composition.

The Renaissance

The Renaissance in the arts could be said to have
begun in 1435 with Italian painter and theorist
Leone Battista Alberti's *Della pittura*, the foundation
that served as the classical basis of art and art theo-
ry for the next five centuries. Alberti determined
that the artist was a creator rather than mere tech-
nician or scribe, and it was up to the individual to
arrange and harmonize all the elements of his work.

The guiding principle of the Renaissance was
the rebirth of classical culture, including a revival
of naturalism in art. Italy was the birthplace of
the Renaissance (naturally, since it was filled
with ruins and sculpture from the classical era)
yet one of its greatest masters, Michelangelo,

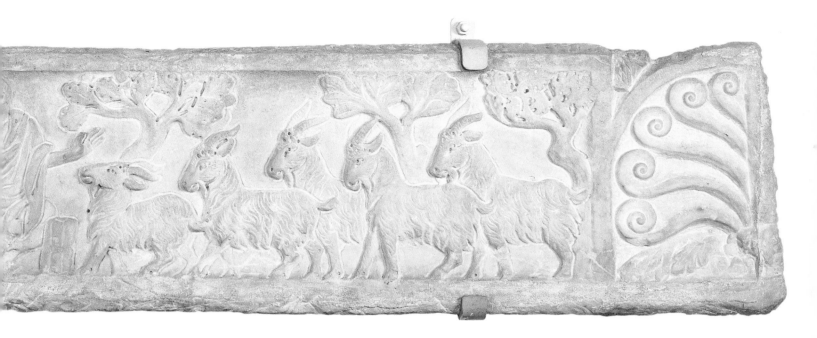

would help usher in the close of the Renaissance period by introducing a more abstract, less proportionate style.

Renaissance artists in the northern countries of Europe placed their emphasis on verisimilitude, looking to the environment and social settings to reveal humanity. A vast quantity of religious altarpieces, images of saints, and prayer books reveal the lingering spirit of the middle ages, while new spatial techniques and other artistic methods were employed in the service of the Church.

Renaissance style flourished for only about a hundred years but it had a profound impact on the thinking of man and in the development of the sciences. The Mannerist style which followed it in the early 1500s appeared in Italy, France, Flanders, and Spain, as the absolute values of the Renaissance were wearing thin. An obsession with compositional style outweighed the importance of the subject matter, and the standard became one of formal complexity and idealized beauty.

The Protestant Reformation

The artistic shift from the concerns of naturalism coincided with a religious reformation in the sixteenth century, led by Martin Luther and John Calvin. The Protestant Reformation was an attempt to recover from the Catholic Church the primitive purity of the Bible that had been perceived as lost in the rites of the Papacy. This became the basis for the founding of Protestant Christianity in the northern countries.

Germany was reborn as an empire during this time. There was an artistic revival of the popular tradition, leaning toward the demands of expressionism rather than more formal concerns. Albrecht Dürer was the greatest, most influential German artist of this period. He successfully expressed the questioning, devout spirit of contemporary Germany in his engravings, paintings, and essays.

As far as the production of Bibles was concerned, Protestants followed Jewish tradition and included

only the Books of the Old Testament that were written in Hebrew, while Roman Catholics included eight additional Books written in Greek, known as the Deuterocanonical Books. In about 1525, William Tyndale developed the first English translation of the Bible. He was, however, soon after burned at the stake by the Church for his "willful perversions" of the meaning of the Scripture.

The King James Version of the Bible (1611) was based on English translations made during the sixteenth century, as well as on a Greek text that contained the accumulated errors of fourteen centuries of monastic copying. For the following 250 years, no other translation into English of the Bible was authorized.

After the Reformation, cultural unity in Europe was all but destroyed. The baroque period—a term of chronology rather than of style—ran its course from the end of the sixteenth century to the late eighteenth century. One classical association remained—the word baroque derived from the Italian "barocco," meaning contortion in logical thought. Basically, the baroque style was a variation on classical composition and themes, ignoring the rules of symmetry and proportion while making use of new knowledge to create dramatic compositions. France was the most powerful nation during this period, and under Louis XIV the official court style was considered "Classical Baroque." The Rococo style was associated with the Baroque, with an emphasis on fanciful, decorative curves, and counter-curves.

In Italy during the baroque period, Catholicism retained a powerful grip on the people, and southern artists struggled with questions of faith and reality. For instance, Caravaggio, one of the most colorful figures who created biblical art, worked and lived at this time. He was aggressive, reckless, and indepen-

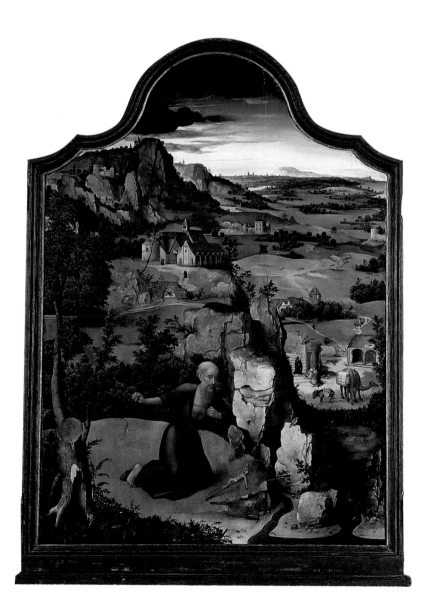

The Penitence of Saint Jerome

Joachim de Patinir, c. 1515; tempera and oil on wood; central panel 46 1/4 x 32 in. (118 x 81 cm). Fletcher Fund, 1936, The Metropolitan Museum of Art, New York.
Joachim Patinir (Flemish, d. 1524) emphasized the natural setting of his paintings over religious narrative. He is often regarded as the first landscape painter, and was known to provide landscapes for other artists. This painting shows a panorama so vast that it includes harbors, towns, a monastery, as well as uncultivated land.

The Holy Family with the Infant Saint John

Andrea del Sarto, c. 1530; oil on wood; 53 1/2 x 38 1/2 in. (117 x 98 cm). Maria DeWitt Jesup Fund, 1922, The Metropolitan Museum of Art, New York.
Andrea del Sarto (Italian, 1486–1531) was a master of the High Renaissance era, seen in this example by his exceptional draftsmanship and complex grouping of figures, with a young St. John (the patron saint of Florence) given prominent position. The artist's rich palette heralds the Mannerist tendency to adopt color as a form of expression.

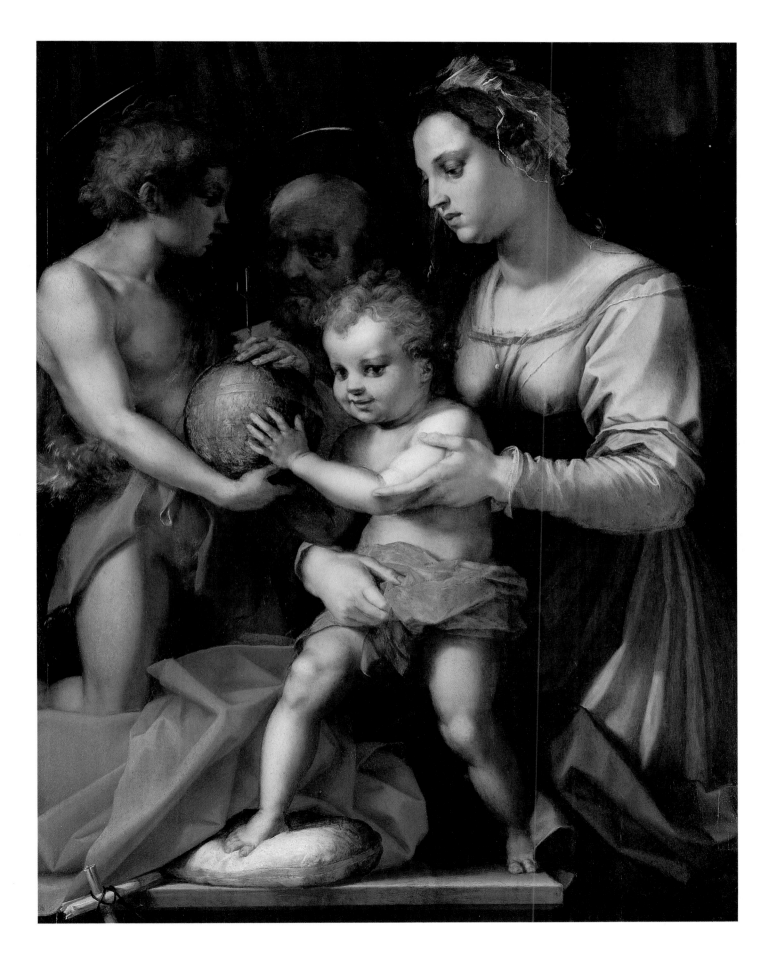

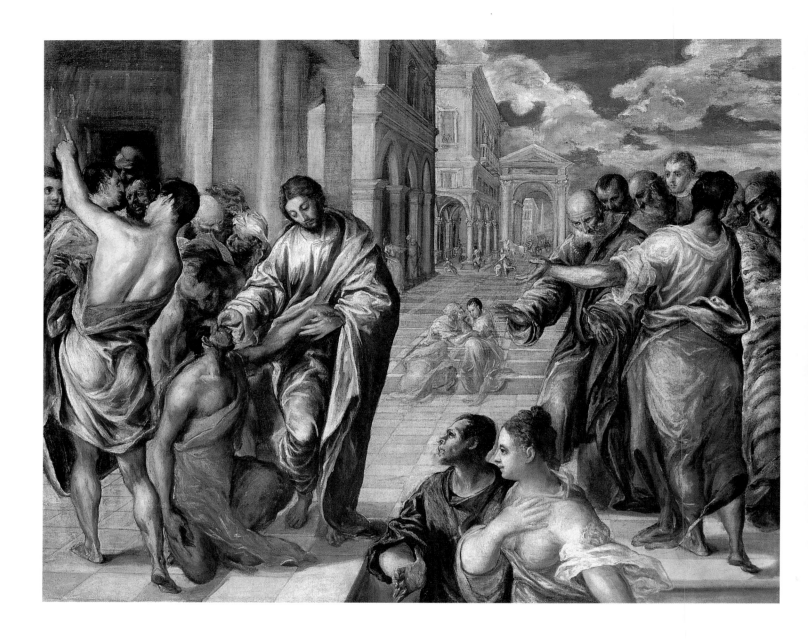

The Miracle of Christ Healing the Blind

El Greco, c. 1575; oil on canvas; 47 x 57 1/2 in.
(119 x 146 cm). Gift of Mr. And Mrs. Charles Wrightsman,
1978, The Metropolitan Museum of Art, New York.
El Greco (Spanish [Greek-born], 1541–1614) studied art
in the workshop of master painter Titian, and created this
individual work shortly before going to Spain in 1577.
In the Gospels, there are three different accounts of Christ
healing the Blind; El Greco's painting seems to follow
Mark's telling (10:46–52), which relates how the blind
Bartimaeus cried out for Christ's mercy and was healed.

dent, and his career was a series of confrontations with the
Church, the State, and his neighbors. He preferred to paint low
peasant types in rough, tattered clothing, an approach to reli-
gious subjects that was at the time seen as sacrilegious. To
Caravaggio, however, the vivid realism, dramatic lighting, and
expressiveness of his subjects were designed to involve the view-
er more intimately.

In the northern countries during the seventeenth century,
Flemish art (in the Netherlands) and Dutch art (in Holland)
rapidly developed a character distinct from that of the rest of
Europe. The populace was almost entirely Protestant, inde-
pendent, and rich, and they supported artists such as
Rembrandt, Sir Anthony Van Dyck, and Jan Vermeer, who
produced more modest and sophisticated paintings of still
lifes, genre scenes, and landscapes.

The Age of Reason

After the Baroque came the Enlightenment and the Age of Reason, lasting from the late eighteenth century until the middle of the nineteenth century. Neoclassical art flourished, emphasizing classical serenity and stringently correct proportions in both settings and human form. A rising concern for "history painting" furthered the production of biblical subjects.

In the Age of Reason, biblical scholars were encouraged to retranslate ancient texts, and by the middle of the nineteenth century the King James Version of the Bible was judged to be seriously flawed. By the authority of the Church of England, in 1881 the English Revised Version of the Bible was published.

Around the same period, there was a general reaction against the restraints of Neoclassicism. A new style in literature and the arts was born and became known as Romanticism. Its primary creative inspiration was based upon the artist's emotional response to a subject; thus artists reserved the right to define beauty by their own criteria. The Romantic sensibility was based in a profound sensory appreciation of the natural world, and as a result was an important component in the development of the art of early America—a country at the time of abundant unexplored wilderness. Often during this period, biblical subjects were introduced into landscapes to add the weight of "history painting" to their Romantic renderings.

By the late nineteenth century an absorption with modernism marked the end of formal, classical concerns, and was the jump start for a series of innovative artistic movements. Beginning with Impressionism in France in the 1860s, it was the artist's view of reality that was paramount—whether via Cezanne's theory of the edifying underlying structure of nature or Van Gogh's intense expressionism, which used color to depict emotional response to nature. Through Cubism, Surrealism, Abstract Expressionism, and Minimalism, most artists stressed form and function rather than representation or narrative, limiting as a result the use of modern movements in the rendering of biblical art.

The Bible itself was also going through a series of changes and innovations. The American Standard Version of the Bible was copyrighted in 1928 by the International Council of Religious Education to prevent unauthorized publications. The Council worked for two years on their revisions, which would "embody the best results of modern scholarship as to the meaning of the Scriptures."

The biblical narratives that follow are accompanied by iconographic notes on their artistic style as well as on the artists who rendered the scenes. The quotes from the Bible are taken from the Revised Standard Version, a translation authorized by a vote of the National Council of the Churches of Christ in the United States and first published in 1952.

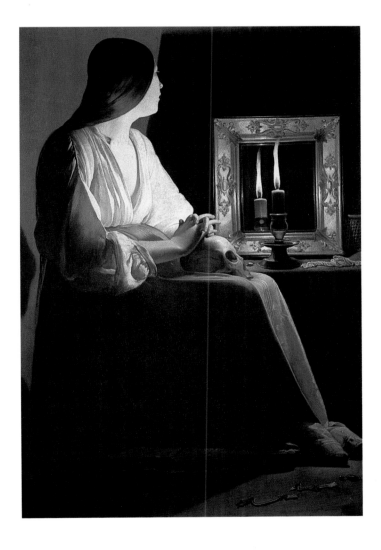

The Penitent Magdalen

Georges de la Tour, c. 1640; oil on canvas; 52 1/2 x 40 1/4 in.
(133 x 102 cm). Gift of Mr. and Mrs. Charles Wrightsman, 1978,
The Metropolitan Museum of Art, New York.

Georges de la Tour (French, 1593–1652) created at least four scenes of the penitent Magdalen; in this dramatic candlelit scene the artist depicts her at the moment of her conversion. The shadowly intensity of feeling is similar to other northern followers of the Italian master Caravaggio, as are the symbols of death—such as the skull—and luxury, illustrated by the mirror.

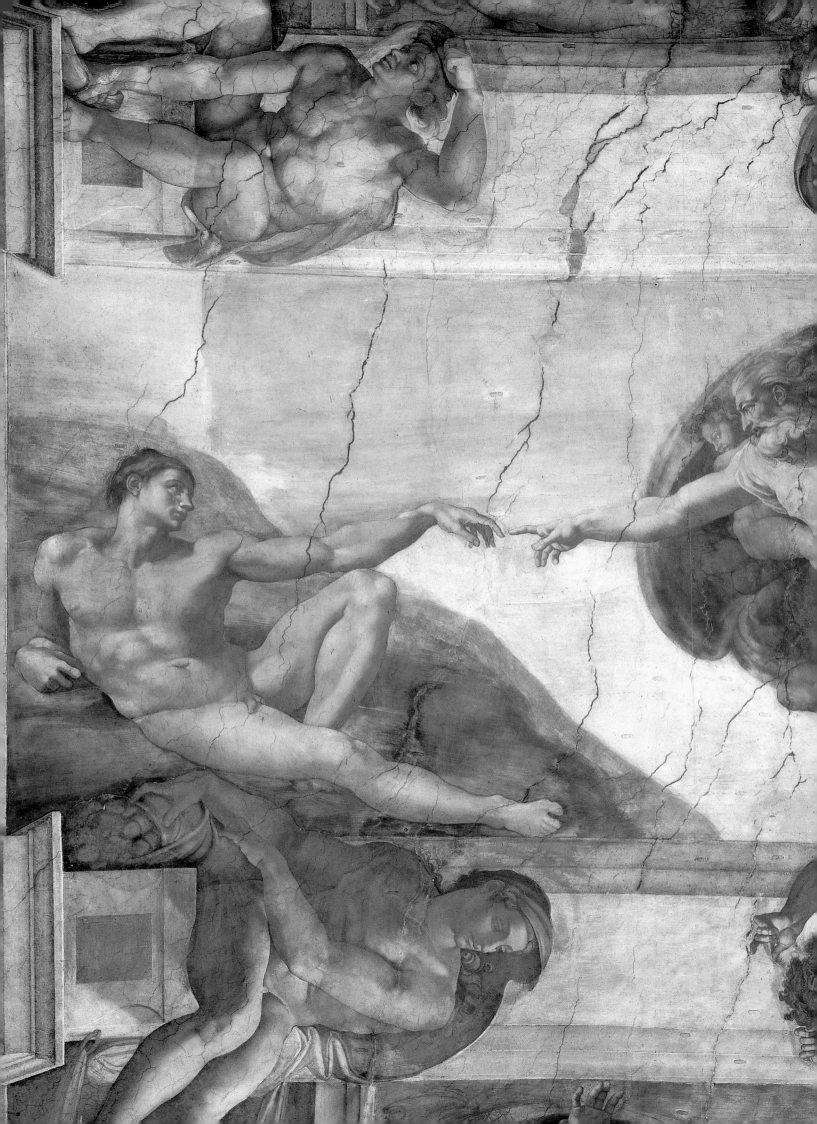

FROM THE CREATION TO THE PROMISED LAND

The Creation

On the first day, God said, "'Let there be light'; and there was light."(Gen. 1:3) The light was called day, and the dark was named night. On days two and three, God separated the waters from the heavens and the earth. On day four, he placed the sun and the moon in the sky to light the earth. On the fifth day, God created the animals: "And God blessed them, saying, 'Be fruitful and multiply and fill the waters in the seas, and let birds multiply on the earth.'" (Gen. 1:22)

On the sixth day, God created man in his own image. When God decided that he wanted someone to till the barren fields, he gathered the dust from the ground and breathed life into Adam. Eve was then created from one of Adam's ribs while he was sleeping. Then, on the seventh day, when the heavens and earth were finished, God rested and blessed that day. This is the origin of both the Jewish Sabbath and the Christian Sunday observance.

Iconography

The earliest artists represented God as Christ, usually with a crossed nimbus over his head. From about the fourteenth century onward, God took the familiar form of an old man with a long white beard.

The Creation of Adam

Michelangelo, 1508–1512; fresco. Sistine Chapel, Vatican, Rome.
Michelangelo (Italian, 1475–1564) created his most famous Renaissance paintings on the ceiling of the Sistine Chapel. The nine large panels down its center are scenes from the Book of Genesis. Michelangelo took into account the perspective of the viewer on the floor of the chapel when he designed his magnificent compositions.

To represent the creation of light, God is sometimes shown hanging two disks symbolizing the sun and the moon, as in the quatrefoil medallion at the base of the portal walls in Cathedral of Auxerre (fourteenth century). Raphael's interpretation (1518–1519) shows the image of God hovering in the sky, parting the clouds to let through light.

To represent the creation of the animals, low reliefs at the Orvieto Cathedral (fourteenth century) show the creatures arranged according to size. Tintoretto's version incorporates the hovering God sending forth birds, fish, and animals.

In early Christian renderings, Adam was depicted as touched by God or as lit by a ray of light coming forth from God. Michelangelo portrays, on the ceiling of the Sistine Chapel, God straining to touch the recumbent Adam, as Adam lifts his hand listlessly, perfectly created though not yet fully alive.

The creation of Eve of course lends itself to the potent symbolism of man and woman in marriage, and as a result their union has been rendered many times by many artists throughout the ages. Frequently, Adam and Eve are portrayed lying side by side, or God is shown helping Eve, fully formed, step from Adam's side.

Adam and Eve

God placed man and woman in the Garden of Eden; they were naked "and were not ashamed."

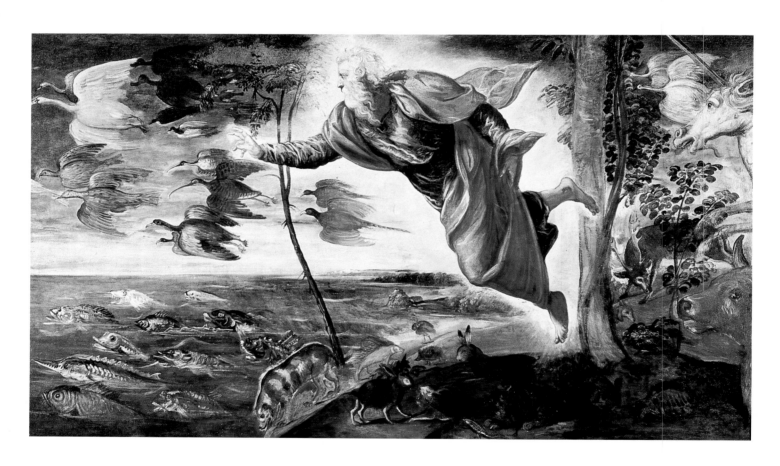

The Creation of the Animals

Tintoretto, 1550–1553; oil on canvas; 13 ft 8 in. x 11 ft. 7 in. (4.2 x 3.5 m). Galleria dell'Accademia, Venice.
Tintoretto (Italian, c. 1518–1594) took from Titian the legacy of sixteenth-century Italian Classicism and transformed the sensual naturalism of color and light into a style which distorted space and figures in order to achieve a dynamic composition—thereafter known as Mannerism.

The Fall, Adam and Eve Tempted by the Snake

Hugo van der Goes, c. 1470; oil on oakwood; 9 x 13 in. (23 x 33.5 cm). Gemaeldegalerie, Kunsthistorisches Museum, Vienna.
Hugo van der Goes (Dutch, c. 1440–1482) displays the early precision of the northern European countries for detail and realism, incorporating a sophisticated sense of spatial composition. Van der Goes' Portinari altarpiece had a great influence on painters of the High Renaissance such as Leonardo da Vinci.

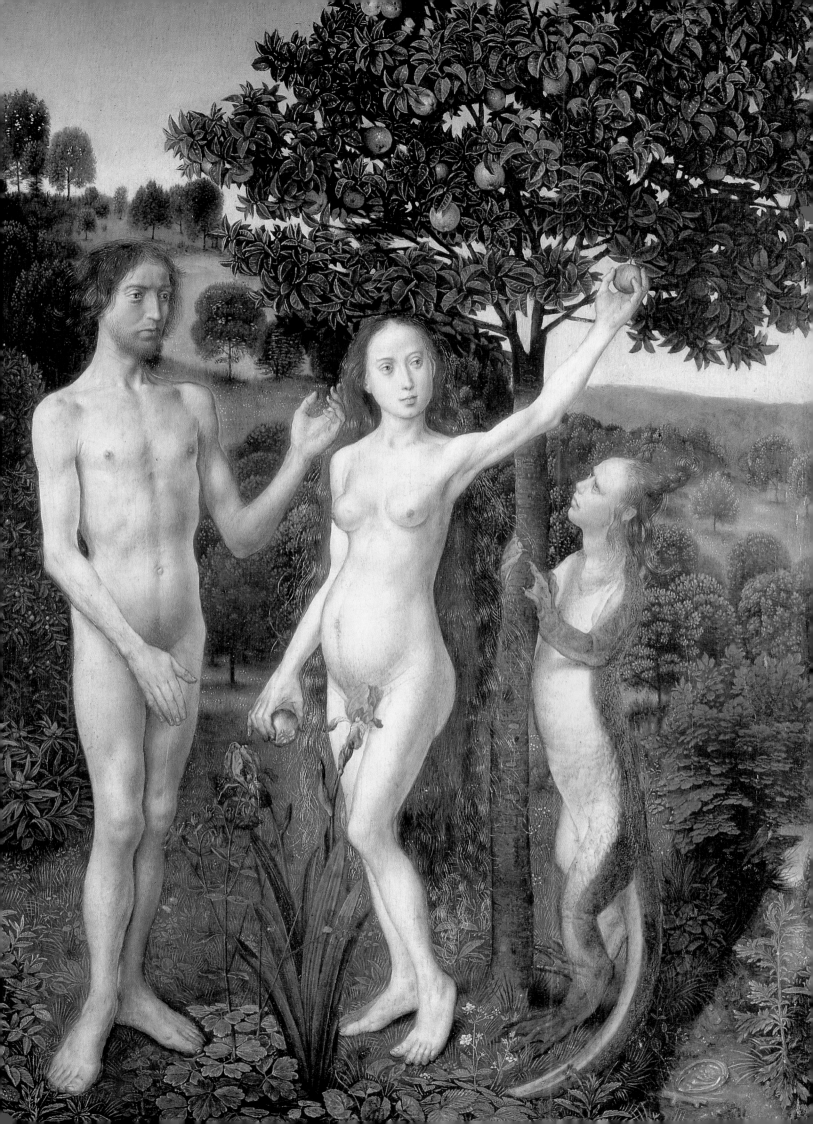

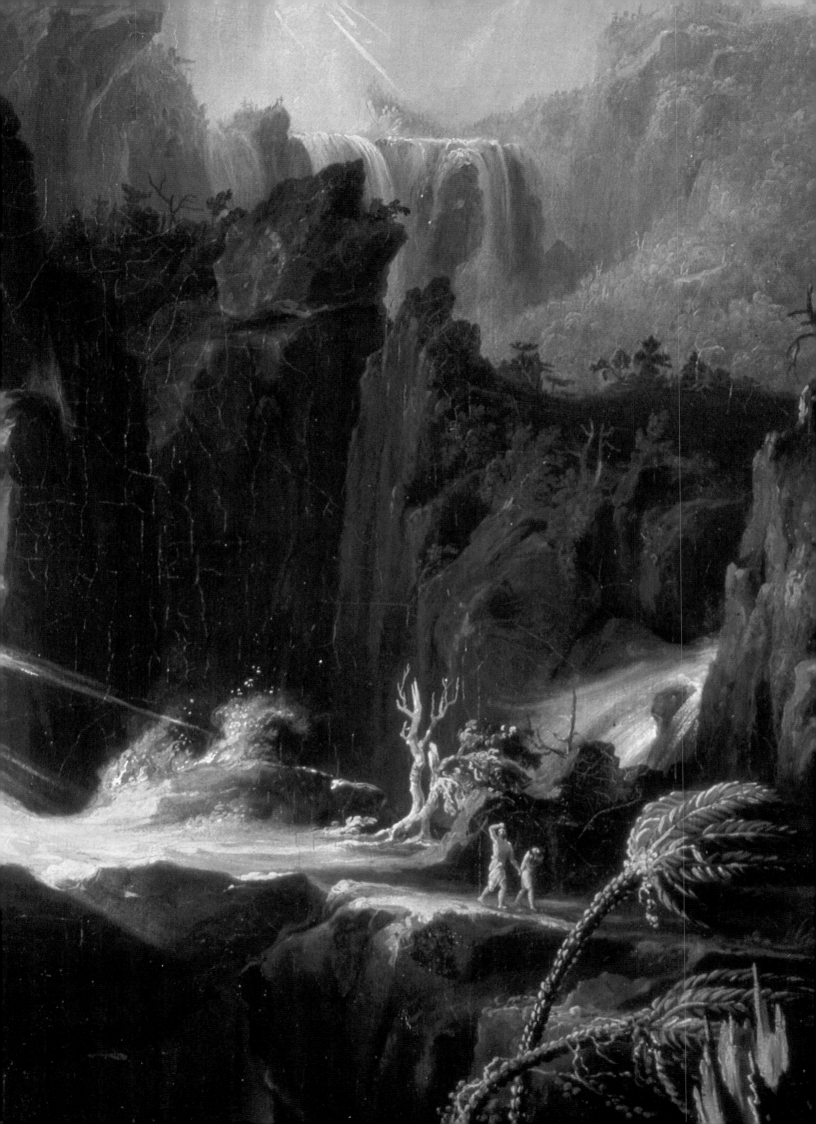

(Gen. 2:25) Then God warned that they might eat of every tree in the garden but the Tree of Knowledge of good and evil. The consequence of eating from this Tree was death. Eve, however, at the prompting of the serpent, tasted its fruit and offered some to Adam. Then they "knew that they were naked; and they sewed fig leaves together and made themselves aprons." (Gen. 3:7)

After God discovered they had eaten from the Tree of Knowledge, he cursed them. Eve was named as the mother of all living, and after clothing them with garments of skin, God banished them from the Garden of Eden. The story of Adam and Eve resembles in many ways later stories of Christ: His descent into limbo between His death and resurrection were seen as corresponding to the Expulsion of Adam and Eve from the Garden of Eden.

Iconography

The Fall was depicted as early as the third century—for instance upon the walls of the catacombs of St. Januarius, Naples, where Adam and Eve are shown trying to cover themselves with leaves.

God is sometimes portrayed commanding his first man and woman to leave the Garden; or, alternately, an angel holds aloft a flaming sword to usher them out. Eden is usually depicted as separated from the rest of the world by a wall, as in Jacopo della Quercia's relief (1414–1419) on the Fonte Gaia in Siena.

Throughout the Early Christian era Adam was portrayed without a beard, but medieval artists began rendering him as a more mature man, sometimes with a beard. Depicting Adam and Eve gave artists a rare opportunity to create human nudes, and beginning in the Renaissance the psychological interplay between man and woman was favored over the symbolic content of the theme.

Expulsion from the Garden of Eden

detail; Thomas Cole, 1827. Gift of Mrs. Maxim Karolik for the M. and M. Karolik Collection of American Paintings, 1815–1865, Museum of Fine Arts, Boston.

Here, Adam and Eve have literally been engulfed by a strange and unfamiliar world, and the viewer feels both terror and pity for them. Despite the fact that the American public preferred realistic depictions of nature, Cole's idealistic painting followed the principles of beauty according to the dictates of his own feelings and imagination.

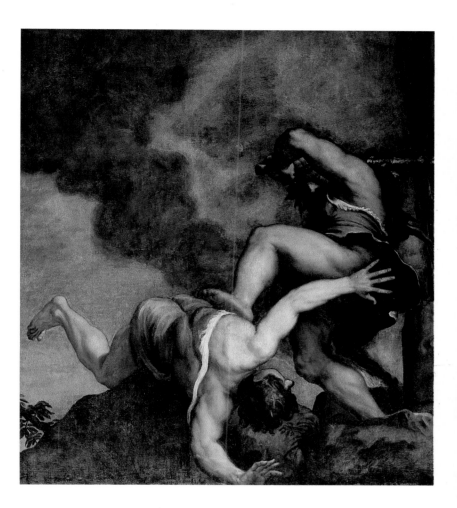

The serpent is variously shown either in the tree, or standing on its tail—reflecting God's curse upon the vile creature that ever afterward it would have to crawl on its belly. At other times the devil takes on a pseudo-human body or head along with its serpent form, as in the Hugo van der Goes' painting of 1472.

Cain and Abel

The story of Adam and Eve's sons, Cain and Abel, is told in the fourth chapter of the Book of Genesis. Abel tended sheep while Cain tilled the ground, and both offered sacrifices to God, who responded by having "regard for Abel and his offering, but for Cain and his offering he had no regard." (Gen. 4:4–5)

Cain became angry. God rebuked him, saying that Cain must master the sin "couching at the door." Cain responded by taking Abel into the fields and killing him. God then cursed Cain and "put a mark" on him. Then Cain went to live in the land of Nod, east of Eden.

Cain and Abel

Titian, 1477–1576; fresco; 9 ft. square (27 m square). Sacristy, Santa Maria della Salute, Venice.

The Old Master Titian (Italian, c. 1490–1576) created exuberant Renaissance compositions that were rich with color, inspiring both Peter Paul Rubens and Velázquez. Titian had a classical sense of style, focusing on the beauty of nature and female nudes; in addition he was much sought after as a portrait painter.

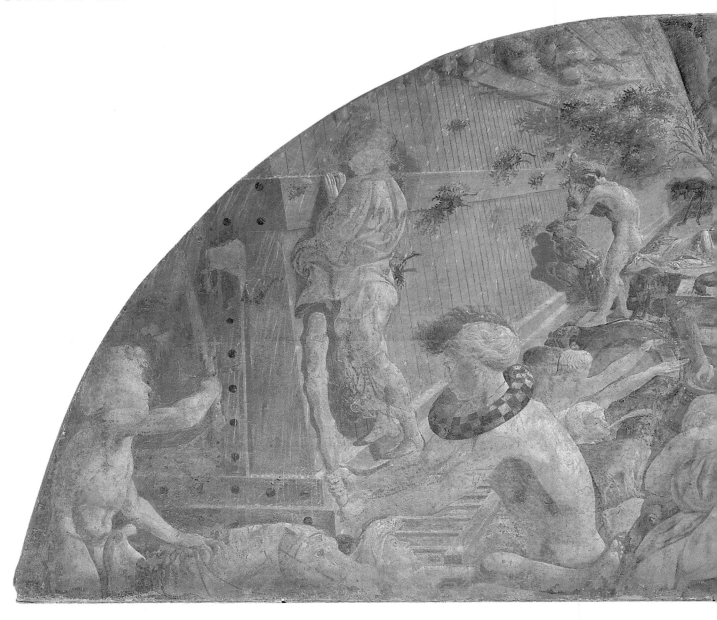

Iconography

From the fifth to the thirteenth centuries, the theme of Adam and Eve with their children often appears in manuscript illuminations. Usually the scene portrays the education of the children, or the brothers helping Adam in the fields. Other scenes depict the brothers burying their father; sometimes Eve is depicted consoling Abel while Cain turns away.

Since the weapon used is not mentioned in the Bible, artists found themselves with great leeway in their depiction of Abel's murder, depicting stones, clubs, hoes, or even the jawbone of an ass like Samson. Abel is never armed; in some renderings this story has correspondences to the one of Judas betraying Christ.

The Flood

After the time of Cain and Abel, men and women went forth and multiplied. God, though, began to see great wickedness among men, whose "every imagination of the thoughts of his heart was only evil continually." (Gen. 6:5)

Only Noah found favor in the eyes of God. He was thus commanded to build "an ark of gopher wood," and take in two of every living thing on earth, along with his wife and descendants. After seven days, "the waters of the flood came upon the earth." (Gen. 7:10) The rain fell for forty days and nights, covering even the highest mountains. Then God made a wind blow over the earth, and the waters subsided.

Noah sent out a dove, but it soon returned to him. He did this every week until the dove

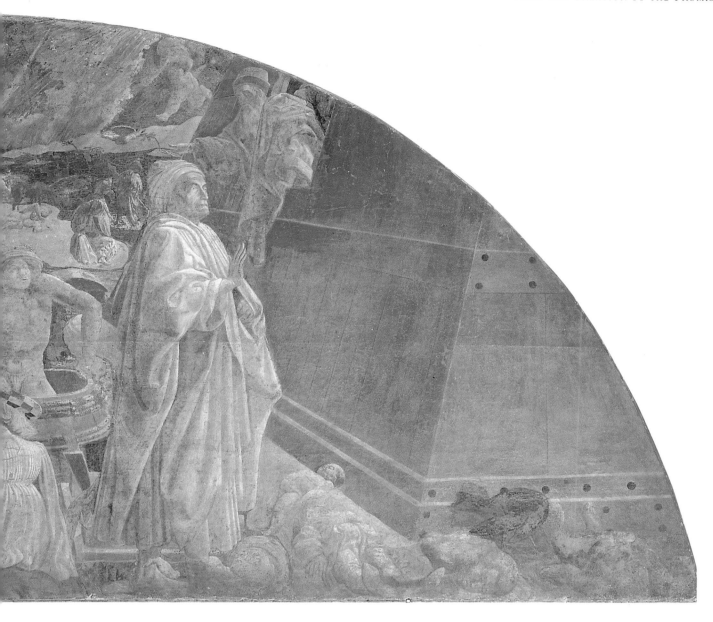

returned with a fresh olive leaf; then it did not return at all. When the waters had dried, Noah removed "the cover of his ark" and let the animals loose.

Iconography

Noah has invariably been portrayed as an old man with a long beard—in keeping with the Bible which states he is six hundred years old at the time of the flood, and nine hundred fifty at his death.

Both the building of the Ark and the loading of the animals two by two have been rendered countless times throughout history. In Early Christian art the Ark is usually portrayed as a large chest, but in the middle ages artists began illustrating it as a large boat.

Deluge

Paolo Uccello, c. 1446–1447; fresco. Santa Maria Novella, Florence.
Paolo Uccello (Italian, 1397–1475) created dreamlike works of art, and utilized geometrical shapes to convey perspective. As an artist of the early Renaissance, he was particularly concerned with the relationships among objects within a composition.

Paolo Uccello's *The Flood* (c. 1445–1447, Florence) depicts the start of the great Flood, with people drowning while only the Ark floats. Usually, however, artists represented either the retreat of the Deluge, with Noah sending out his dove, or else the landed Ark, with the animals venturing out once more to the earth.

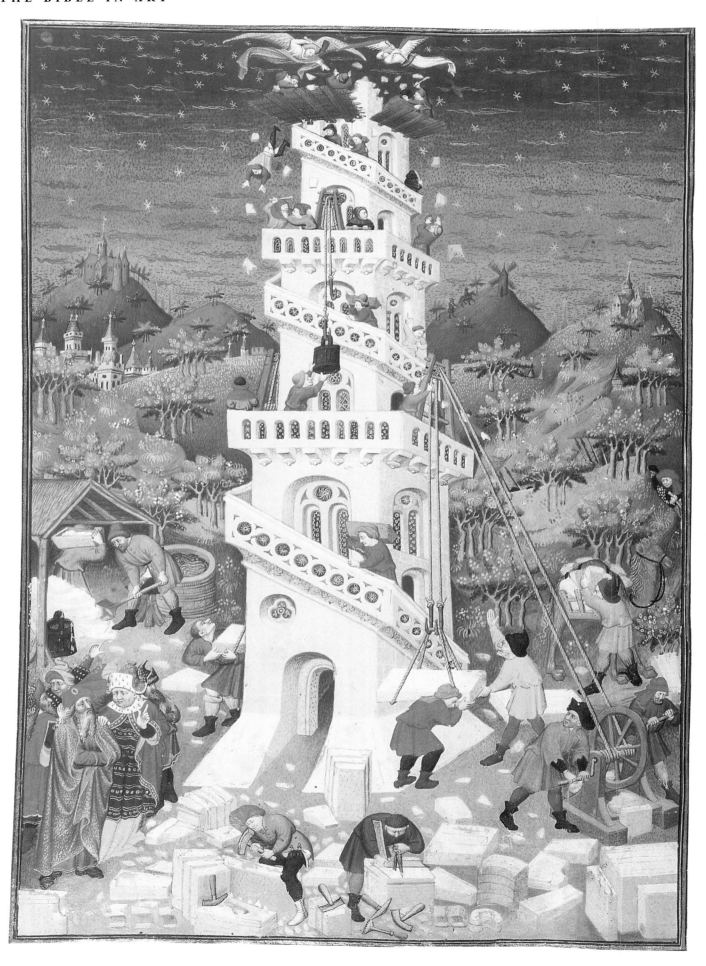

The Tower of Babel

From Noah's three sons, Shem, Ham, and Japheth, were descended the nations of the Middle East. Then, in the land of Shinar, the descendants of Shem began to make bricks hardened by fire. They decided to build a city and "a tower with its top in the heavens . . ." (Gen. 11:4)

They were determined to make a name for themselves, and the Lord, in some dismay, saw that "nothing they propose to do will now be impossible for them." (Gen. 11:6) God then decided to make things harder for man by confusing their languages. Thus the people became scattered across the land, and eventually abandoned the building of their tower.

Iconography

In medieval depictions, the Tower is either rectangular or circular, with a staircase spiraling on the outside. In the Netherlands, and in seventeenth-century Germany, it is sometimes shown as a pyramid.

The scale is usually off in the earlier depictions, with man apparently too large in relation to the edifice—as in the Bedford Book of Hours (c. 1424). In later depictions, the proportions are more in keeping with the construction of a vast tower.

The destruction of the Tower is not described in Genesis, but artists clearly felt free to show lightning bolts and windstorms striking it—unless, that is, angels or God himself were depicted felling the condemned edifice.

Abraham

The life and deeds of Abraham took place around 2000 B.C., and are recounted in the Book of Genesis, chapters 11 through 26. Abraham receives his name (meaning "Friend of God") when he leaves the Mesopotamian town of Ur,

The Building of the Tower of Babel

Bedford Book of Hours, c. 1424; illumination.
The British Library, Department of Manuscripts, London.
In the middle ages the artist known as the Master of the Duke of Bedford created sumptuously decorated manuscripts. His illustrations often run wild, lacking the usual restraint of Parisian painting common during the International Gothic period.

and moves with his wife Sarah and nephew Lot to Palestine.

Sarah was too old to conceive, so she gave Agar, her slave, to Abraham—and from them was born Ismael. God then informed Abraham that Sarah would have a boy and he would be named Isaac. After a visit from three strangers, Sarah conceived and gave birth to their son.

Sarah then drove Agar and Ismael into the desert, while Abraham's faith was put to the ultimate test when God demanded Isaac as a sacrifice. At the last moment, with the wood laid and the boy tied, when Abraham held the knife poised, God relented and allowed Abraham to sacrifice a ram instead. (Gen. 22:12)

Lot is closely linked with his uncle Abraham, since he went with Abraham to live in Mesopotamia. The best-known aspect of Lot's story is the destruction of Sodom and Gomorrah. (Gen. 19:24–29) After bargaining with God for the saving of a nearby city his family could easily flee to, Lot was instructed by God not to look behind him as he fled. But Lot's wife could not keep from peeking and, when she did so, she became a pillar of salt.

Iconography

In Byzantine art, and later, in thirteenth-century German art, Abraham is shown seated on a throne, with Isaac and Jacob (Isaac's son) on either side. Similarly, the mosaic on the dome of the Florentine Baptistery (thirteenth century) evokes an analogy between these three patriarchs and the Trinity. This interpretation of the scene occurs as early as the fifth-century fresco in the nave of the Basilica of S. Maria Maggiore in Rome. Much later, in Andrei Rublev's *The Holy Trinity* (c. 1410), the center angel represented God the Father.

The sacrifice of Isaac is the most commonly painted scene of the Abraham life cycle. One of the earliest renderings is in the frescoes of the Synagogue in Dura–Europos (c. 250). Both Lorenzo Ghiberti and Filippo Brunelleschi depicted the scene in the competition panels for the doors of the Florence Baptistery (1401).

Usually, the destruction of Sodom and Gomorrah is shown on the left-hand side of the composition, with Lot and his daughters fleeing into the countryside on the right. Lot's wife is either gray or white to denote salt; later she is rendered at the moment of transformation, occasionally with her head still lifelike.

Abraham and Lot Fleeing from Sodom
Raphael, c. 1508; oil on canvas; 54 x 40 in. (137 x 101 cm). Logge, Vatican, Rome.
Raphael (Italian, 1483–1520) was the master of creative borrowing, and he reworked and transformed many of the characteristics of the great artists of the High Renaissance such as Leonardo da Vinci, Michelangelo, and Perugino. This striking rendition of the destruction of Lot's wife reveals Raphael's deep reverence for past narrative traditions.

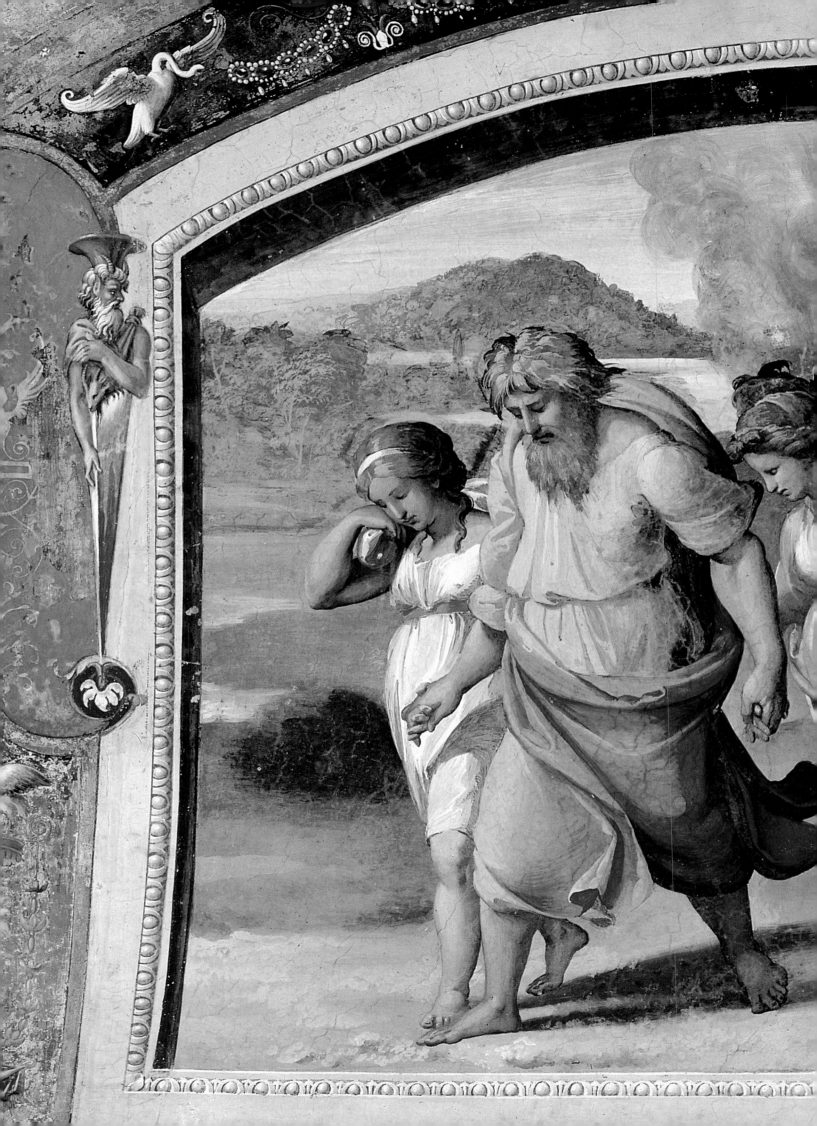

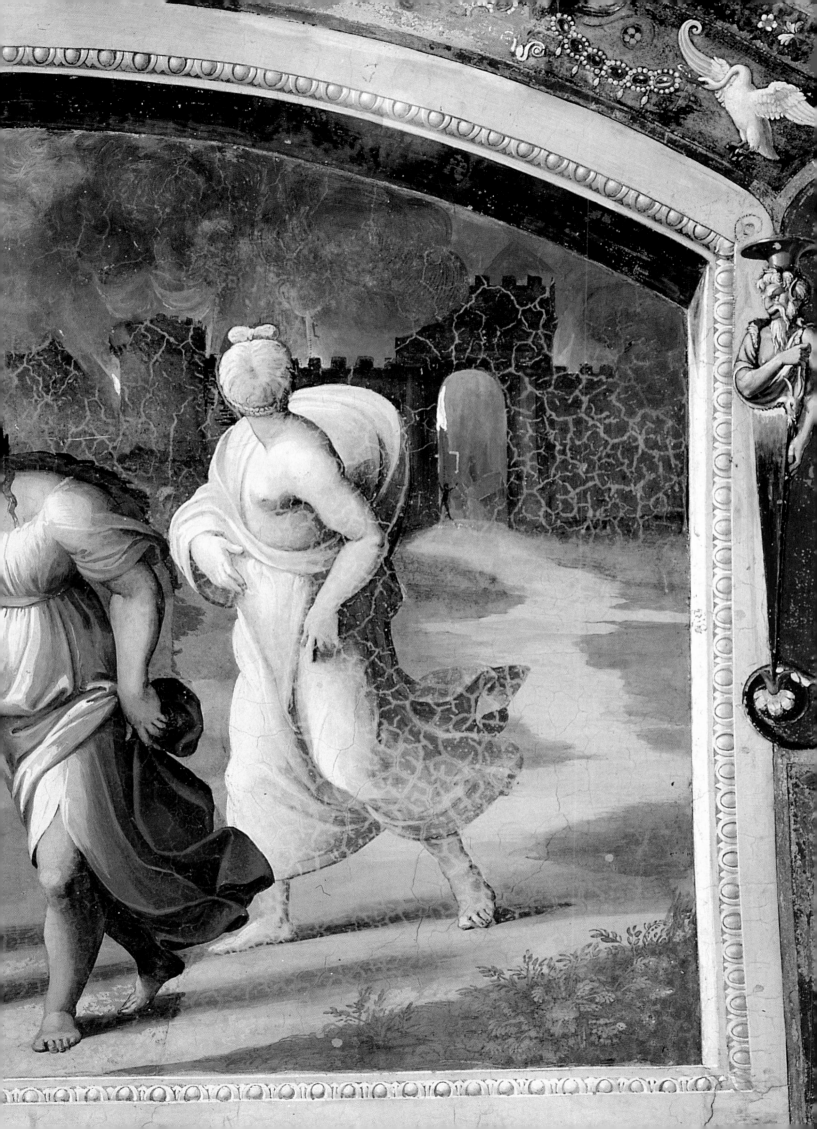

The Story of Jacob and Esau;

*Lorenzo Ghiberti, Baptistery doors (panel of the **Gates of Paradise**), 1401; gilded bronze; 21 x 17 1/2 in. (53 x 44 cm). Bargello, Florence.* Lorenzo Ghiberti (Italian, c. 1378–1455) entered a competition for the second set of bronze doors for the Baptistery at Florence, along with Filippo Brunelleschi and Jacopo della Quercia. Ghiberti was awarded the job because his Gothic style was similar to that of Andrea Pisano's first set of doors.

Jacob

Isaac married Rebecca, who bore twins, Jacob and Esau. When Isaac was old and blind, Rebecca tricked him into blessing their second son, Jacob, instead of Esau. Jacob then ran away from his angry brother, and he dreamed of a ladder, with the top reaching to Heaven. (Gen. 28:12) Then God appeared to Jacob and promised him all the land around him.

When he reached Haran, Jacob served his uncle Laban for seven years, in order to marry Rachel. Instead he was given Leah as his bride, and had to serve another seven years to get Rachel as his second wife.

As Jacob journeyed though the desert to reconcile with Esau, he fought with an angel for an entire night. (Gen 32:24) Afterward, God renamed him Israel (meaning "Power with God"). Jacob later adopted

and blessed his son Joseph's two sons, Manasseh and Ephraim, and from these sons were born the Twelve Tribes of Israel, which Moses later led out of Egypt and into the Promised Land.

Iconography

Jacob is variously rendered at all ages of his life—he is portrayed as young when he and Esau are presented to their father Isaac for the blessing; he appears too as an older man with a beard, when he in turn blesses his son's sons. Traditionally, Jacob crosses his hands to bless his children, as in Rembrandt's version, while Holbein the Younger depicted a more casual grouping in his 1526 woodcut. Isaac is usually shown identifying Jacob by touch, while he wears the kidskin over his forearm. Ghiberti depicts Isaac seated as he gives the blessing (1403), while earlier versions show Isaac lying on a bed.

Many artists have illustrated Jacob's dream of the ladder—an image which particularly lent itself to landscape compositions, such as Michael Willmann's *Landscape with Jacob's Dream* (c. 1690). Also, Rembrandt did a drawing on this theme, and paintings were done by José de Ribera in 1643 as well as Marc Chagall (1973).

In Early Christian art, when Jacob wrestles with the angel, the angel is depicted without wings. By the middle ages this theme regularly appears in frescoes and reliefs in churches and monasteries. Rembrandt developed it into a vigorous composition in 1659, as did Eugéne Delacroix in 1861, while Paul Gauguin painted quite a distinct stylistic version (1881).

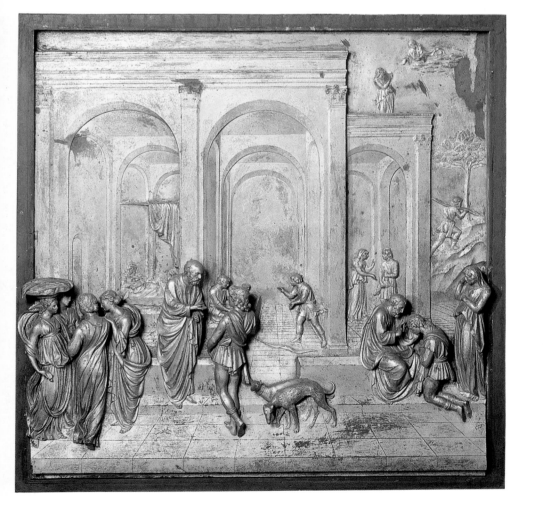

Jacob Wrestling with the Angel

detail; Eugène Delacroix, 1861. St. Sulpice, Paris. Delacroix's greatest ability was as a colorist, and this detail conveys the monumental struggle between Jacob and the Angel in fluid contours created by contrasting hues. The energetic brushwork is reminiscent of Rubens and contributes to the dynamic quality of the painting.

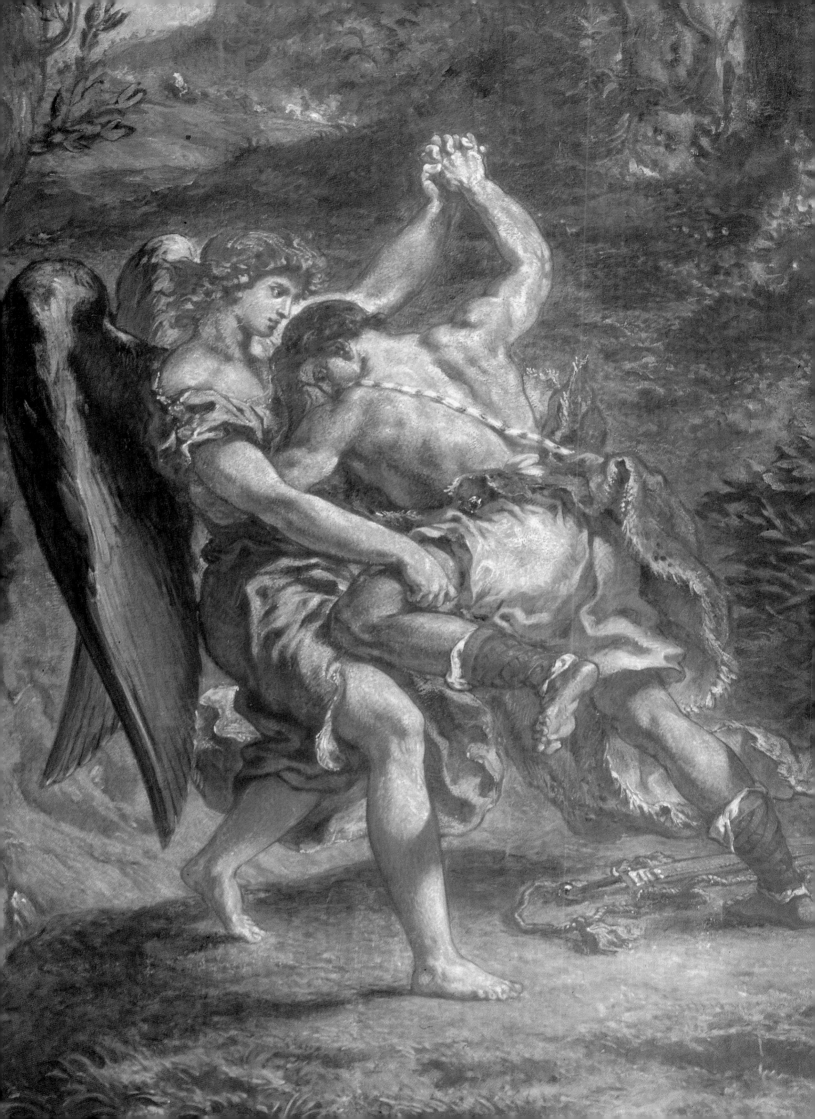

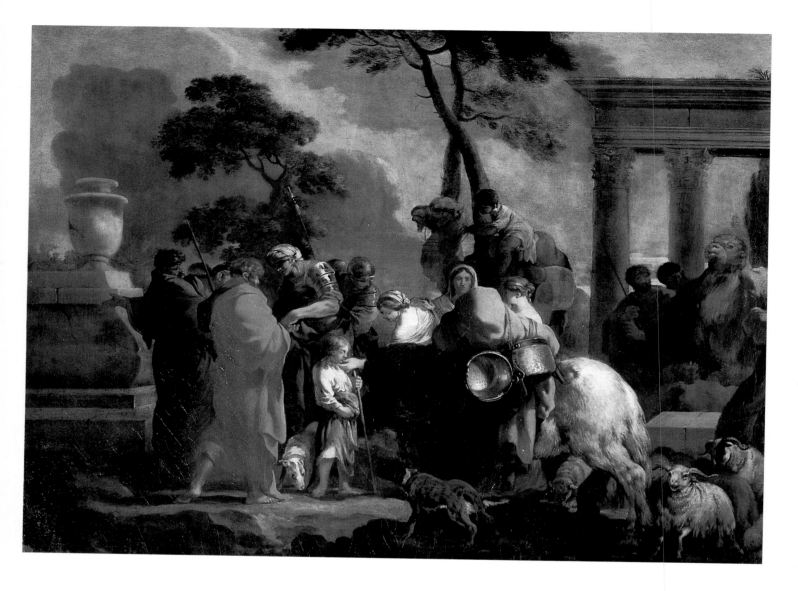

Joseph

Joseph was the son of Jacob and Rachel, and was his father's favorite. Joseph tells his brothers of the dream he had that reveals his parents' preference for him. (Gen. 37:5) This naturally causes his brothers to grow jealous and they sell Joseph as a slave.

Joseph is taken to Egypt, and there he spurns the advances of the wife of his master, Potiphar. Eventually, Joseph begins interpreting the dreams of the Pharaoh, accurately predicting famines. (Gen 41) Jacob leads the Twelve Tribes of Israel into Egypt and becomes a high-ranking official of the Pharaoh's government.

Iconography

Joseph is profusely portrayed in Byzantine manuscripts, as well as in the earlier frescoes at the Synagogue at Dura-Europos (c. 245). He is sometimes shown in series of Patriarchs and Prophets, and is usu-

The Selling of Joseph into Slavery

Sébastien Bourdon, c. 1637; oil on canvas,
89 x 71 in. (221 x 180 cm). The British Museum, London.
Sébastien Bourdon (French, 1616–1671) imitated the styles of several painters, including Claude Lorrain and Nicolas Poussin. From 1652 to 1654 he lived and worked in Sweden as Queen Christina's court portrait painter. Among his other works is *The Fall of Simon Magnus*, which he painted for the cathedral in his native city of Montpellier.

ally depicted as a young man.

The attempted seduction by the wife of his master takes on more erotic tones during the baroque period (seventeenth century). Rembrandt painted Joseph in several different scenes, and Mola also produced a cycle of his life in 1657.

Moses

After Joseph died the Egyptians feared the people of Israel, so they made them ". . . serve with rigor, and made their lives bitter with hard service." (Exod. 1:13–14) The Pharaoh even ordered that the male children of the Hebrews should be cast into the Nile River. Yet a woman of the house of Levi chose to float her son in a basket of reeds, in the place where the daughter of the Pharaoh came to bathe.

The daughter of the Pharaoh took the baby as her own, naming him Moses, "Because I drew him out of the water." (Exod. 2:10) Moses grew to prosperity as the Pharaoh's grandson until he killed an Egyptian. Then he was forced to flee to Midian.

There, God appeared to Moses as fire within a bush "and lo, the bush was burning, yet it was not consumed." (Exod. 3:2) Moses was charged by God with returning to the Pharaoh, and taking the tribes of Israel out of Egypt.

Moses convinced the Pharaoh of his purpose with a series of ten plagues inflicted upon Egypt, which included swarms of frogs and Nile water turning to blood. The final plague, the death of every firstborn Egyptian son, was the origin of Passover, when the Hebrews marked their doors with lamb's blood in order that their sons would be spared.

The Israelites were chased to the Red Sea by the Pharaoh, so Moses "lifted up his rod" and divided the waters, through which the people of Israel could now pass. The Pharaoh's chariots were consumed by the water; Moses continued and led the people through the desert.

When they reached Mount Sinai, "the Lord called Moses to the top of the mountain, and Moses went up." (Exod. 19:20) Moses received Ten Commandments on tablets of stone, and instructions on how to build the golden Covenant of the Ark, with two angels facing each other.

Meanwhile, at the foot of the mountain, the Israelites had created an idol of a golden calf. When Moses returned from the mountain, he destroyed both the calf and the tablets. It was not until some time later that God finally gave Moses another two tablets offering the Laws for His people. The stories of the Exodus and the Laws handed down to Moses are told in the Books of Exodus, Leviticus, and Deuteronomy.

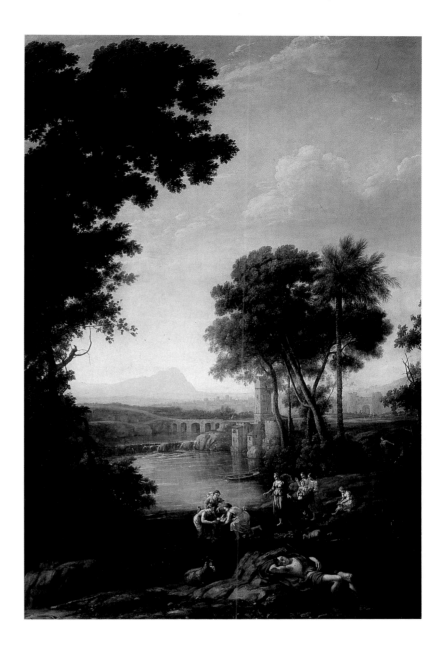

Landscape with the Finding of Moses

Claude Lorraine, c. 1638; oil on canvas; 62 1/2 x 46 in. (160 x 118 cm). Prado, Madrid.
Claude Lorrain (French, 1600–1682) was a master of landscape painting during the Rococo period. Compared to his contemporary Nicolas Poussin's serene compositions, Claude Lorrain created fantasy landscapes of asymmetrical curves and counter-curves that evoked dreams and great legends of the past.

Iconography

In Early Christian art, Moses is shown as a young, beardless man. Examples of him thus can be seen in the catacombs as well as the mosaics of S. Maria Maggiore, Rome (fifth century). By the middle ages, Moses appeares aged along with the rest of the Patriarchs. Moses usual-

Moses Guides the Children of Israel through the Red Sea

Nicholas of Verdun, 1181; enamel on gilded copper, Verdun Altar. Sammlungen des Stiftes, Klosterneuburg, Austria. Nicholas of Verdun (c. 1150–1025) was a goldsmith whose style is characterized by graceful, curving figures and soft drapery reminiscent of Greek sculptors of the fourth century, B.C.

His style influenced Gothic artists well into the thirteenth century.

ly ranks as first among the Old Testament hierarchy.

Interestingly, from the twelfth century onward Moses is at times shown with horns—as in Michelangelo's sculpture for the Tomb of Pope Julius II (1513–1516). St. Jerome's Latin translation of the Book of Exodus—which states that after Moses came down from Mount Sinai, he "did not know that the skin of his face shone because he had been talking with God." (Exod. 34:29)—was responsible for this intrigue. The Hebrew verb for "shine" was mistranslated, as it is similar to the word for "horn."

The finding of Moses as a baby in a basket of reeds was also a popular subject for artists: both Orazio Lomi Gentileschi and Nicolas Poussin illustrated this scene in the 1620s. The mosaics in the Basilica of S. Maria Maggiore begin with Moses' rescue and recount his eventful life. Sandro Botticelli, too, produced a life cycle of Moses, in the Sistine Chapel (c. 1482).

The Adoration of the Golden Calf *and* Moses Destroying the Tablets of the Law

Ingeburgh Psalter, 1210; illumination. Musée Conde, Chantilly. The *Ingeburgh Psalter* was illuminated during the Romanesque period, and it displays the slow-moving tendency toward realism. Artists then were incorporating certain aspects of rendering clothing with a more consciously human form and expression.

Moses

Michelangelo, 1513–1515; marble; height 92 1/2 in. (235 cm). S. Pietro in Vincoli, Rome. Michelangelo (Italian, 1475–1564) sculpted this statue of Moses for the tomb of Pope Julius II, but the project was never completed as planned. Like many of Michelangelo's figures of the time, this work is dynamic in composition, as if wresting free of the confinement of marble.

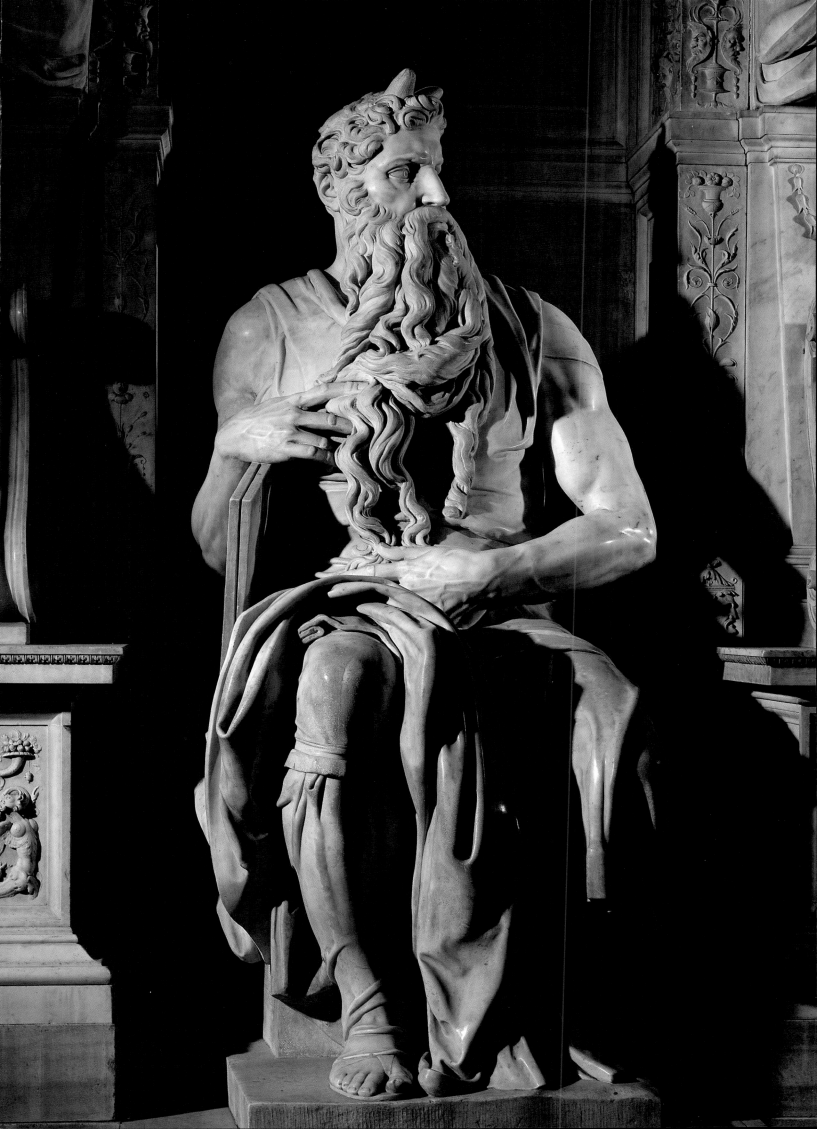

The Gathering of the Manna

The Master of the Manna, c. 1470; oil on canvas.
52 1/2 x 40 1/4 in. (133 x 102 cm).
Musée de la Chartreuse, Douai.

During the middle ages, the miracle of the Manna
from Heaven was often depicted as a prefiguration
of the institution of the Eucharist, when Christ
blessed the bread and wine at the Last Supper.

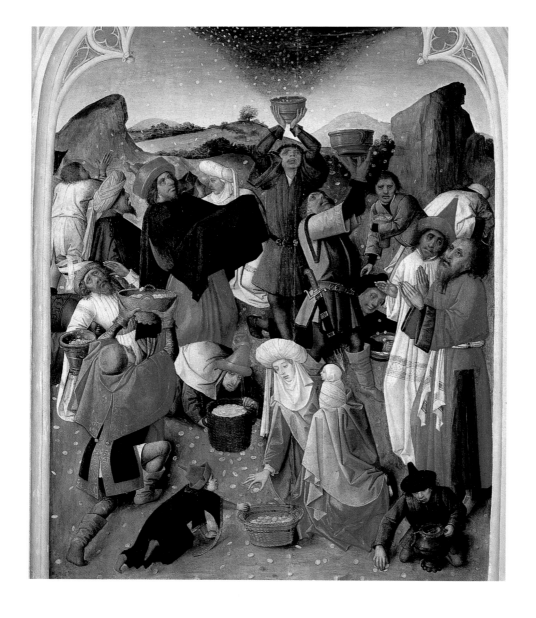

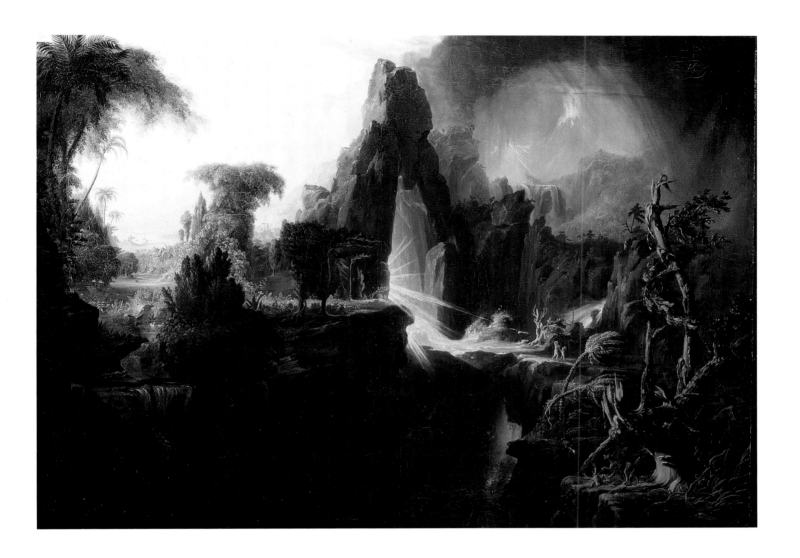

Expulsion from the Garden of Eden

Thomas Cole, 1827; oil on canvas; 39 x 54 in. (99 x 137 cm). Gift
of Mrs. Maxim Karolik for the M. and M. Karolik Collection of
American Paintings, 1815–1865, Museum of Fine Arts, Boston.
Thomas Cole (American [English-born], 1801–1848) painted
during the Romantic period and was an artist who often left
aside detail in favor of a search for the beautiful or sublime. Cole
attempted to capture the deep feelings of nature, and to "impress
the spirit of the entire scene upon the mind of the beholder."

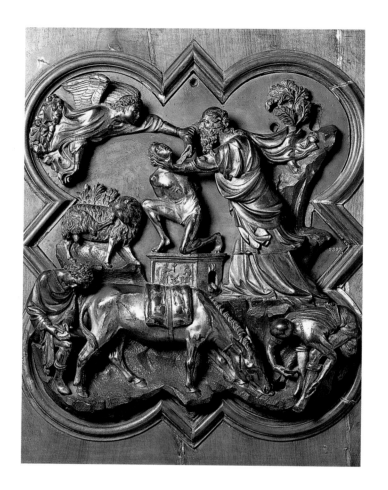

The Sacrifice of Isaac

Filippo Brunelleschi, Baptistery doors, 1401; gilded bronze; 21 x 17 1/2 in. (53 x 44 cm). Bargello, Florence.

Filippo Brunelleschi (Italian, 1377–1446) was the originator of Italian Renaissance architecture in Florence. His development of spatial unity according to the canons of linear perspective enabled him to create sculpture reliefs that were quite realistic.

Jacob Wrestling with the Angel

Eugène Delacroix, 1861; mural. St. Sulpice, Paris.

Eugène Delacroix (French, 1798–1863) launched Romanticism in France as a controversial art style. This mural at St. Sulpice shows the artist's use of powerful harmonics and contrasts of color, resulting in an intense composition. Delacroix's work was diametrically opposed to the Neoclassical restraint of his well-known contemporary, Jean Ingres.

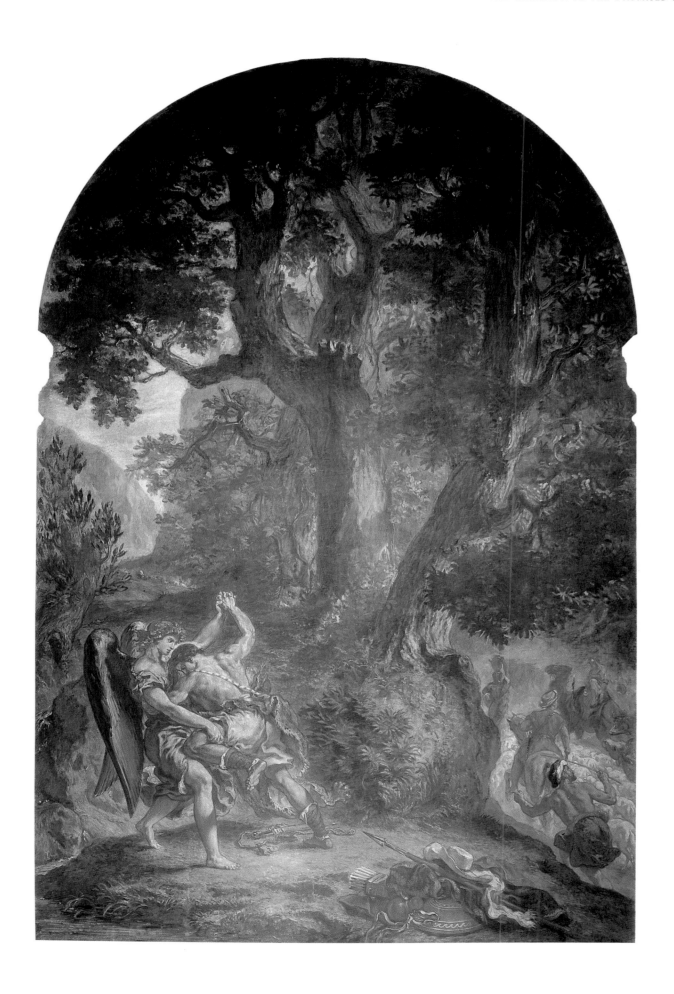

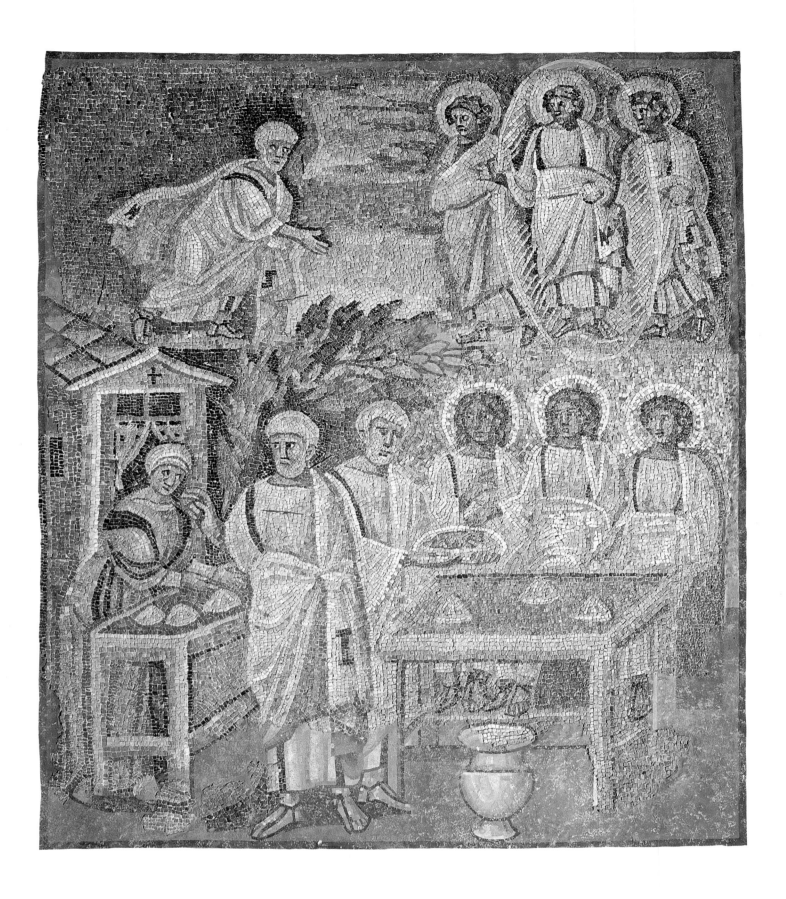

Abraham and the Three Visitors

Unknown artist, fifth century; mosaic. Santa Maria Maggiore, Rome.
The mosaics in Santa Maria Maggiore are unusually well
preserved. This Old Testament scene appears in the nave. As
with other Early Christian art, the figures are well molded by
affects of shading, but the middle and far distances are more
sketchy and are similar to reliefs on contemporary sarcophagi.

The Fall of Jericho

Raphael, 1518–1519; fresco. Logge, Vatican, Rome.
Raphael (Italian, 1483–1520) was the most stringent defender
of Classicism in art, creating beautifully harmonious composi-
tions that defined his figures in spatial terms. Raphael painted
this scene as one of a grand series of frescoes at the Vatican.

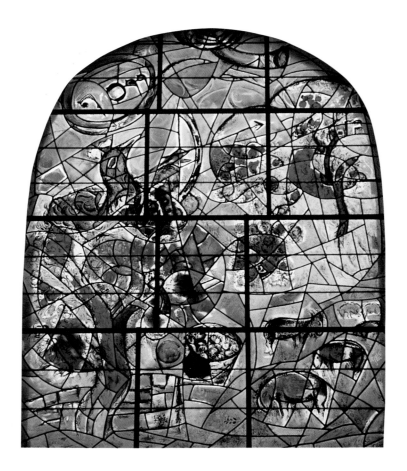

The Twelve Tribes of Israel

Marc Chagall, 1961; stained glass. Hadassah Medical Center Synagogue, Jerusalem.
Marc Chagall (Russian, 1887–1985) moved to Paris in 1910, yet
most of the artist's work reveals his nostalgia for his Russian Jewish
heritage. Chagall weaves enchanted images from Russian folk tales
and Jewish proverbs into fantastical scenes that evoke dreamlike
memories among the splintered sense of space left by Cubism.

Jacob's Blessing

Rembrandt, 1656; oil on canvas; 5 ft. 8 1/2 in. x 6 ft. 11 1/2 in.
(178 x 211 cm). Staatliche Kuntsammlungen, Gemaldegalerie, Kassel.
Rembrandt van Rijn (Dutch, 1606–1669) painted numerous religious subjects,
intending to depict the reality of the contact with God rather than merely an
interpretation of Christian doctrine. The intimacy of the grouping in this painting
creates a tangible mood of kinship, something the viewer could identify with personally.

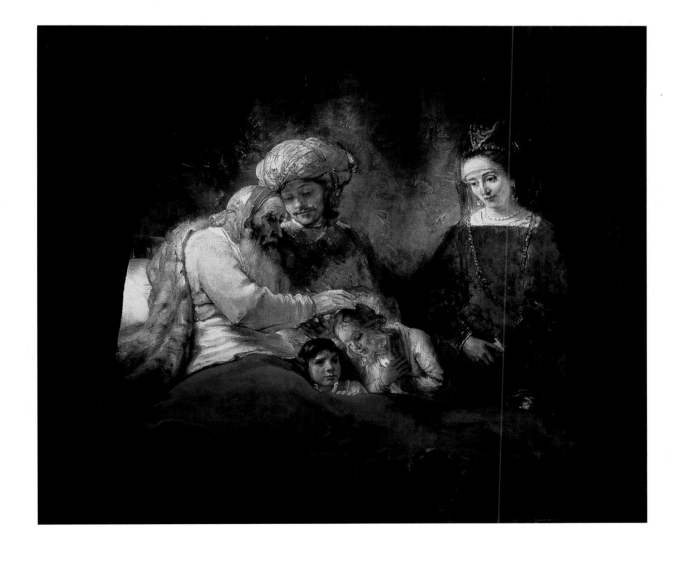

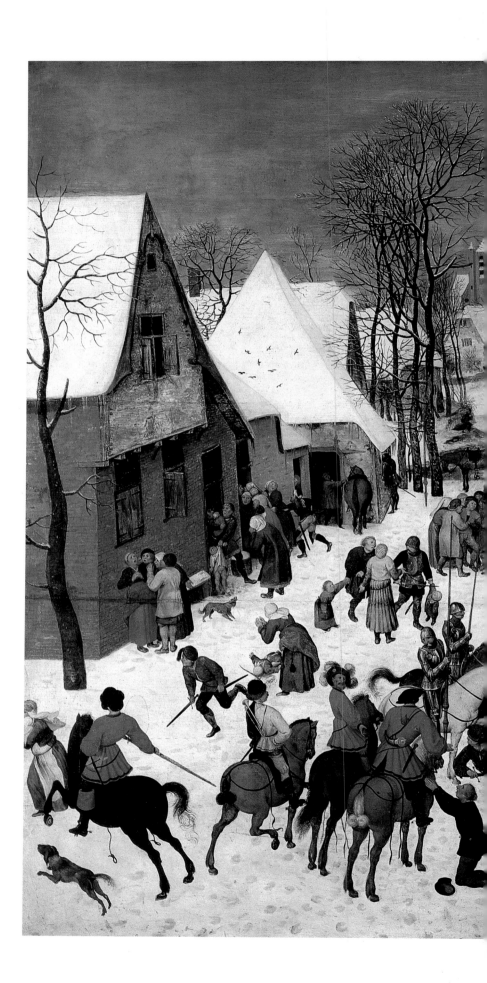

Massacre of the Innocents

Pieter Bruegel, the Elder, c. 1565;
oil on oakwood; 45 x 62 1/2 in.
(116 x 160 cm). Gemaeldegalerie,
Kunsthistoriches Museum, Vienna.
Pieter Bruegel, the Elder (Flemish,
1525–1569), was a popular northern
moralist who created epic meditations
on human foolishness in marvelously
detailed landscapes that were influenced
by Renaissance classicism. His son
Pieter Bruegel, the Younger (1564–1637),
often copied his father's works and
became known for his own works
on the subject of the nether regions.

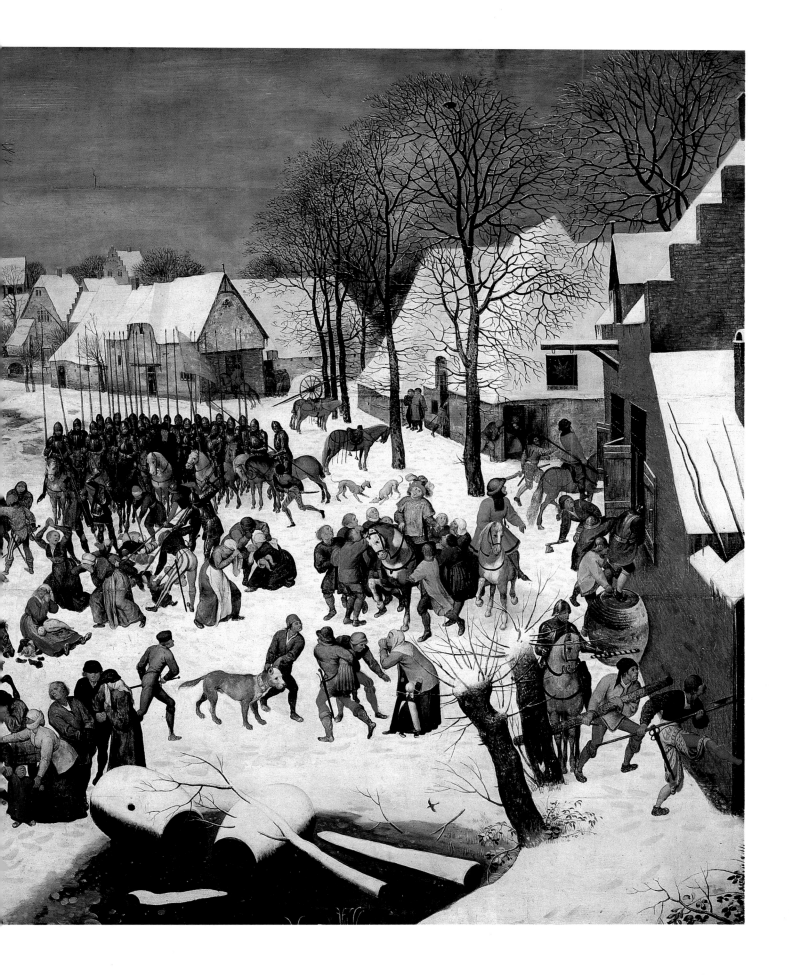

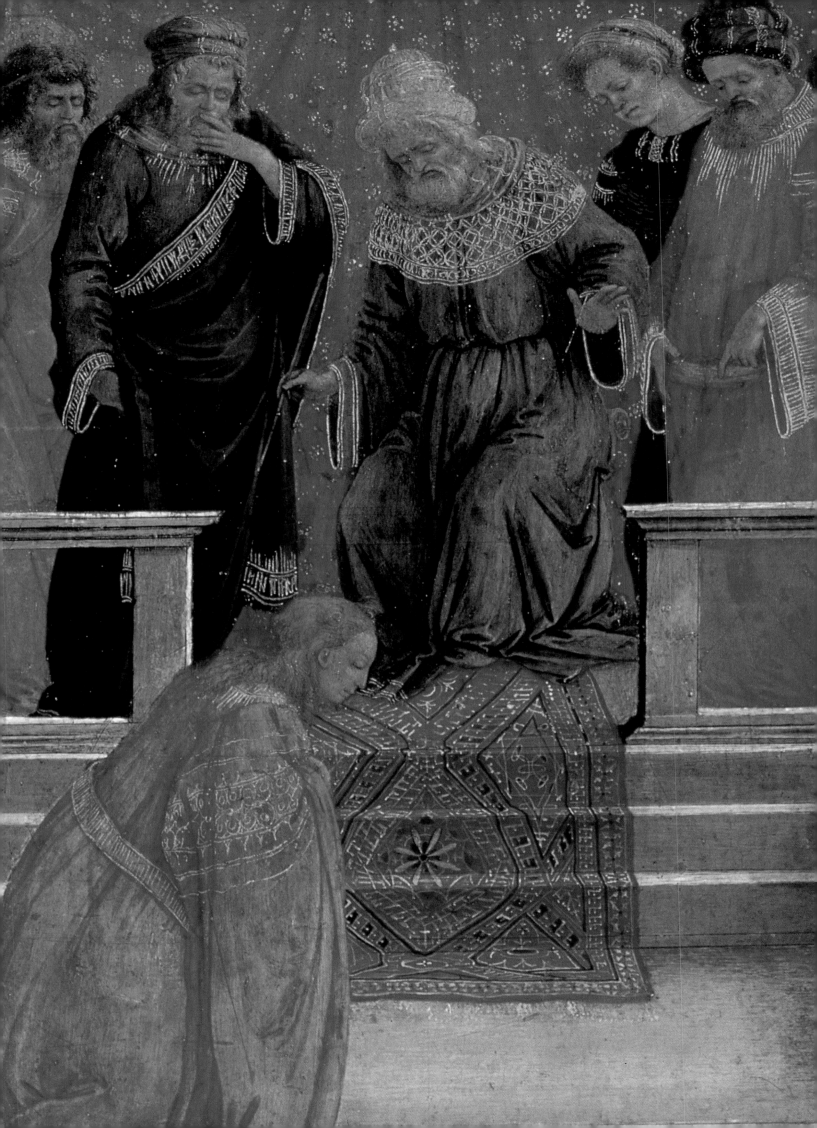

CHAPTER TWO

PEOPLE OF THE OLD TESTAMENT

Samson

Samson was born of Manoah, one of the Judges, during the time when the Philistines ruled the Israelites. Manoah and his wife were told by God that they would bear a son, and that "no razor shall come upon his head" because he would be the one to deliver the Israelites from the Philistines. After he was grown, Samson fell in love and married a Philistine woman. On his way to her, he killed a lion with "the Spirit of the Lord mightily upon him." (Judg. 14:6)

Samson was a great warrior and hunter—catching "three hundred foxes" with which to burn the wheat fields of the Philistines; carrying the gate of the city of Hebron to the top of a hill; and killing great numbers of men, from the thirty men of Askelon to "a thousand men" of Ramathlehi, using only the jawbone of an ass.

However, Samson did not have much luck with women. Samson's Philistine wife betrayed him to her countrymen by telling them the answer to the riddle he posed. Then there was Delilah, to whom the lords of the Philistines said, "Entice him, and see wherein his great strength lies . . ." (Judg. 16:5)

Esther Before Ahasuerus

detail; Filippino Lippi, c. 1440–1450.
Musée Conde, Chantilly.
The elegant style of the fifteenth century is expressed through the idealized beauty and ornate costuming of the figures; Esther even has the high forehead that was much valued in Lippi's era.

Samson "mocked" Delilah three times, lying about ways in which he could be overpowered. But she kept asking and finally, "vexed to death," Samson told her that a razor had never touched his hair.

Delilah aided in the shaving of Samson's "seven locks of his head," then the Philistines took him and gouged out his eyes. Imprisoned in Gaza, Samson was "made sport of" before the Philistines. Then, calling on the Lord, Samson grasped the two main pillars of the temple of Dagon, and "he bowed with all his might; and the house fell upon the lords and all the people that were in it." (Judg. 16:30) Samson in his vengeance and with the will of God died along with the Philistines.

Iconography

Because Samson had colossal strength, his figure is naturally incorporated—in the architecture of the middle ages—into pulpit supports, capitals, and door lintels. His aspect is also linked to the ancient Greek and Roman depictions of Hercules.

He is usually shown as a well-formed man with long hair, sometimes bearded. From the fifteenth century onward, Samson is often shown naked, as in Ghiberti's panel in the Baptistery doors, Florence. Dürer shows him dressed in a lion skin,

The Capture of Samson

Rubens, 1609–10; oil on cradled panel; 19.6 x 26 in. (50.4 x 66.4 cm). Robert A. Waller Memorial Fund, 1923.55, The Art Institute of Chicago. Peter Paul Rubens (Flemish, 1577–1640) was inspired by mythology and religion, and presented his scenes in a lively, sensual, baroque style. His formal style and the objects in his paintings seem to blend into one another as the figures meet, their intentions and actions belied by the swirling unity of the whole.

43

harking to the lion he had killed. In depictions of the fight with the lion, he is either shown suffocating the beast or cutting its throat.

Samson's contest with the lion is seen as an analogy to other well-known Christian struggles, such as Christ's temptation in the desert. The cutting off of Samson's hair and the mocking by the Philistines is sometimes seen as an analogy to the Mocking of Christ before the Crucifixion.

In the middle ages, the figure of Delilah was often seen as analogous to that of Eve, who was seen as responsible for the Fall of Man. She is usually shown shearing Samson's hair herself as he sleeps, for instance in Andrea Mantegna's portrait. Peter Paul

Rubens shows the Philistines binding Samson's arms as Delilah cuts his hair (1609), while Rembrandt portrays the Philistines approaching after Samson has already been weakened by Delilah (1636).

Life cycles of Samson are depicted as early as the fourth century, in the catacombs of Via Latina, Rome. Samson cycles were also popular in sixteenth-century Flemish painting.

Ruth

Ruth was the daughter-in-law of Naomi, and after her husband died she insisted on staying with Naomi. They both returned to Bethlehem, where Ruth was forced to "glean in the fields after the reapers." (Ruth 2:3)

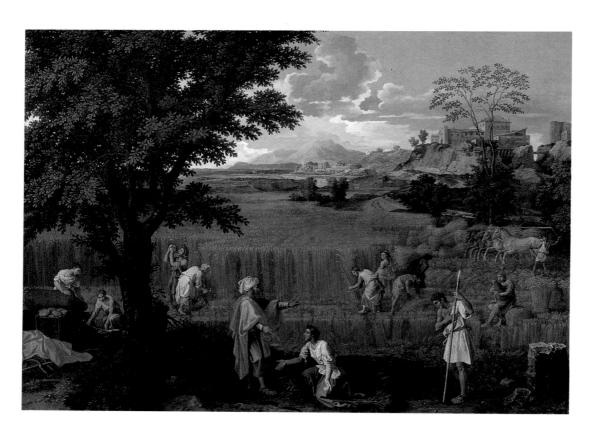

When Ruth "happened to come" to the fields owned by Boaz, he saw the young Moabite and told his reapers to leave plenty of wheat and barley for her. Boaz praised Ruth for what she had done for her mother-in-law. (Ruth 2:11)

Naomi urged Ruth to go and lie at the feet of Boaz as he slept on the threshing floor, adding, "he will tell you what to do." This apparently worked because Boaz took Ruth as his wife, and she bore Obed, who was the father of Jesse, the father of David.

The Summer, or Ruth and Boaz

Nicolas Poussin, 1660–1664; oil on canvas;
46 x 62 1/2 in. (118 x 160 cm). Louvre, Paris.
Nicolas Poussin (French, 1594–1665) was the greatest master of seventeenth-century French Classicism. This biblical scene, completed late in the painter's career, shows the growing tendency of artists such as Poussin to value depictions of landscape for their own sake.

Samson Fighting the Lion

Unknown artist, c. 1200; sculptural capital from the pillar
of the East Chapel, the Cathedral at Speyer (Germany).
The Romanesque architectural ideal integrated ornamental design with structural function. Since Samson was considered to be a symbol of great strength, the biblical narrative of Samson and the Lion was often incorporated into the design of cathedrals of that period.

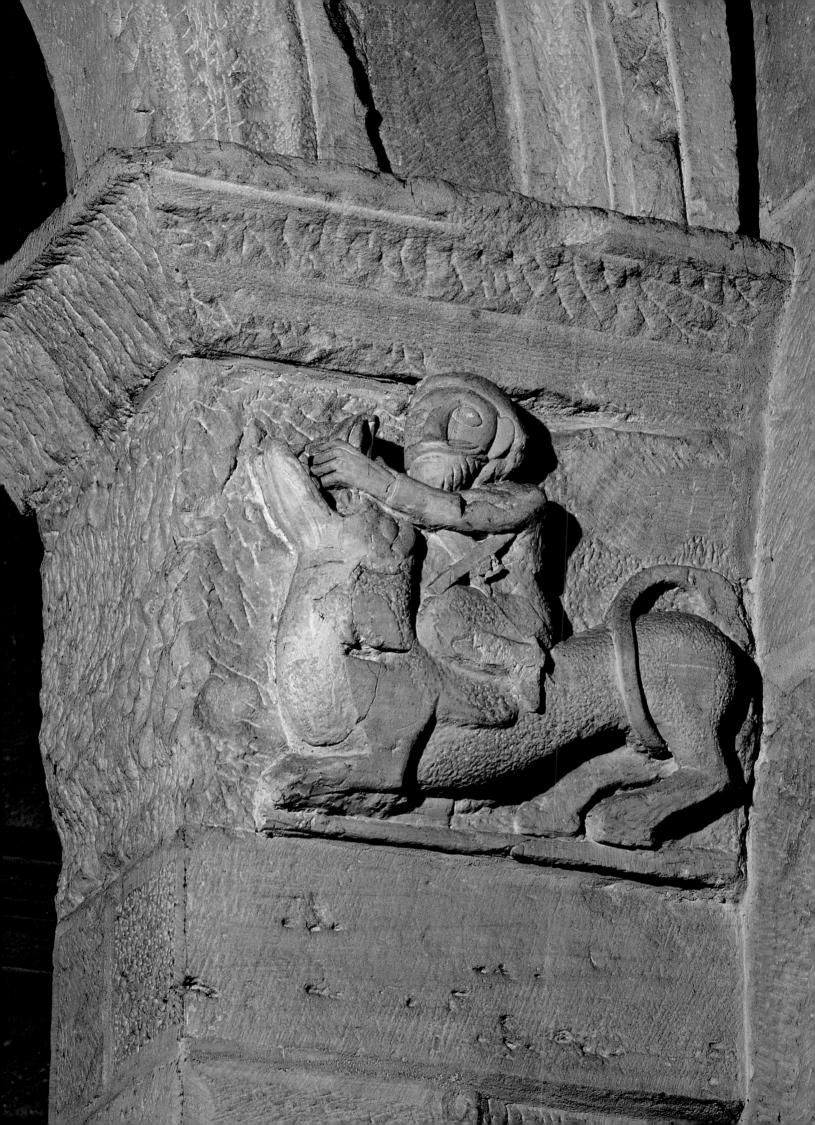

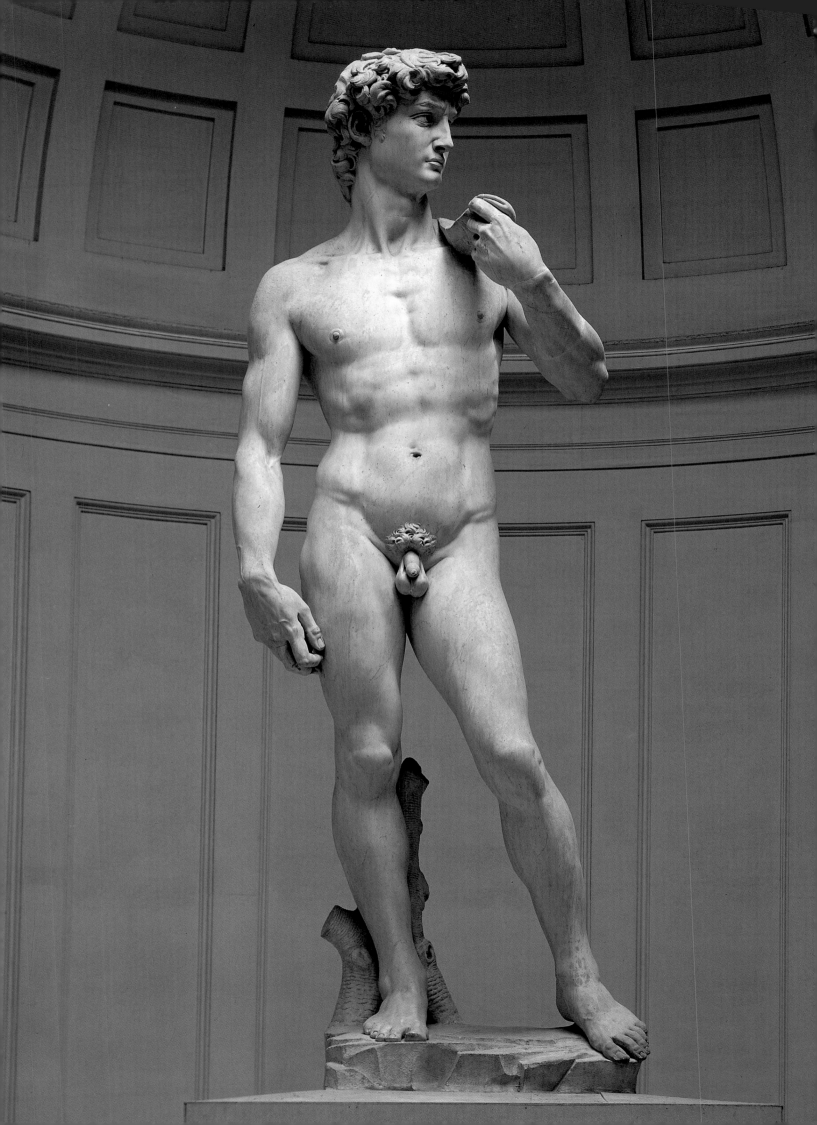

Iconography

Ruth does not appear in Early Christian art. The first depictions of her story are found in manuscript illuminations completed during the middle ages. Twelfth-century illustrations even show Ruth and Boaz lying in awkward perspective on the threshing floor.

In the thirteenth and fourteenth centuries, the Journey of Ruth and Naomi to Bethlehem is shown, for example, in the stained-glass window of the Sainte-Chapelle, Paris. Rembrandt depicts Ruth gleaning in the fields, while Poussin painted four canvases of the Ruth story, emphasizing in each a season of the year (1660–1664).

David

David was the last son of Jesse, born around 1000 B.C. He was appointed the first King of Israel by Samuel. When Saul consulted a medium, asking her to "bring up Samuel for me," (1 Sam. 28:11) Samuel informed Saul that the Lord was displeased, and that under his leadership Israel would once again fall to the Philistines.

When David was a young man, he played his harp well for Saul, soothing his spirit. Later, David took up a "staff in his hand, and chose five smooth stones from the brook" to fight Goliath, the Philistine giant. (1 Sam. 17:40) David struck Goliath in the forehead, felling him, then he cut off the giant's head with his own sword.

After Saul killed himself during a losing battle with the Philistines, David unified the kingdom of Israel by capturing Jerusalem. He constructed a royal palace, and brought the Arc of the Covenant to his capital city.

As a musician, David accompanied himself when singing his psalms, and he is generally considered to be the author of the Book of Psalms. Though he was married many times over, he coveted Bathsheba, the wife of his commander, after he saw her bathing. Bathsheba became David's wife, and she bore him the child called Solomon.

The Tree of Jesse is the depiction of Christ's genealogical descendance from the father of King David, the first king of Israel. Traditionally, the leaders of the Church considered Jesus' mother Mary to be the descendant of Jesse. In the Book of Revelations, Jesus calls himself "the root and offspring of David." (Rev. 22:16)

Iconography

The well-known figure of David is represented by many types of work and by numerous artists. In the art of the catacombs, David appears as a young shepherd boy, accompanied by his father Jesse and three of his brothers, as Samuel chooses him to be King. This scene is also represented in the frescoes in the Synagogue at Dura-Europos (c. 245); and, during the High Renaissance, Raphael painted it in the Logge in the Vatican (1518–1519).

By the late middle ages, David is usually portrayed as a prophet or knight, announcing the coming of the Messiah. David as a musician is depicted either as a young man soothing Saul with his harp, or as an aged King, composing his psalms. Because of his musical associations, David became a patron of church choirs and is figured frequently on the shutters of church organs, and in manuscripts such as the *Psalter of Westminster Abbey* (twelfth century).

The slaying of Goliath was a popular theme among artists. Usually David was shown as a boy, just before or just after the battle. Caravaggio portrayed David as victor, holding his large sword in one hand and Goliath's head in the other. Giovanni Bernini's version (1623) shows David just at the moment of flinging the fatal stone from his slingshot.

Themes of Bathsheba bathing are analogous to a later story of Susanna in the Bath. Cornelius van Haarlem depicts Bathsheba with a black maidservant, as David spies on her (1594). Many of the best painters of biblical scenes rendered this theme with great success: Poussin in 1633, Rubens in 1635, and Rembrandt in 1643 and again in 1654.

The Tree of Jesse has been represented in a variety of ways, and can be linked to the Tree of Life in Genesis. The Bible of Manfred (eleventh century, Vatican Library, Rome) shows a tree growing from Adam's side as he sleeps. This is an early prototype of the Tree of Jesse, with patriarchs appearing in the upper branches. In some depictions Christ is shown at the top, enthroned in majesty, as in the sixteenth-century painting by Jan Mostaert and a twelfth-century ceiling mural in S. Michaels, Hildesheim.

Under the influence of the cult of the Immaculate Conception, the Virgin Mary began replacing Christ at the top of this tree of life, such as on the tympanum of the main door of Rouen Cathedral (1513), as well as the Church of SS. Gervais and Protais, Gisor (sixteenth century).

Left:
David
Michelangelo, 1501–1504; marble; height 14 ft. 3 in. (4.3 m), Galleria dell'Accademia, Florence.
Michelangelo Buonarroti (Italian, 1475–1564) sculpted this statue of David for the officials of the Florentine republic as a symbol of youth, passion, and virtue. The size of the hands and arms are enlarged, drawing the viewer's eye to the icons of David's battle—the sling and the stone.

Solomon

As the second King of Israel, Solomon the son of David was renowned for his wisdom. He reportedly wrote the Books of Proverbs, Ecclesiastes, and the Song of Solomon. He had many wives and was occasionally led into idolatry by them, yet he also built the Temple in Jerusalem to house the Arc of the Covenant.

An example of the wisdom of the Judgment of Solomon concerned a conflict between two prostitutes, each claiming to be the mother of a child. Solomon considered this, then ordered that the child be cut in half, each woman to be given a share. The first woman proved herself the true mother by immediately begging that the child be given to the other woman rather than halved as Solomon ordered. "Give the living child to the first woman," Solomon concluded, "and by no means slay it; she is its mother." (1 Kings 3:27)

The Queen of Sheba's visit to Solomon is told in the first Book of Kings (10:1–13), and is later retold by Jesus (according to Matt. 12:42; Luke 11:3) as representing the coming of the Day of Judgment. In Kings, Sheba showers Solomon with many gifts because of his "wisdom and prosperity." This act is sometimes seen as parallel to that of the Magi's Adoration of the Christ child in Bethlehem.

Iconography

Solomon's Temple of Jerusalem was a popular subject for artists, shown, for example, as a Gothic cathedral by Jean Fouquet in a manuscript illumination (fifteenth century). One depiction—by I. Messager, *The Temple of Solomon*—shows the perfect perspective rendering of segments of low cloisters (seventeenth century).

The exalted Queen of Sheba is usually depicted standing in front of Solomon, wearing her crown, but from the twelfth century onward Solomon is shown paying homage to the Queen as she sits upon a throne. Another variation was illustrated by Piero della Francesca (1460), with the Queen kneeling in adoration of the cross. She is portrayed at times as a black woman, though her journey from Arabia to Solomon is rarely illustrated.

Construction of the Temple of Jerusalem Under the Order of Solomon

*Jean Fouquet, c. 1468, from the **Antiquites Judaiques**; illumination. Bibliothèque Nationale, Paris.* Jean Fouquet (French, c. 1420–1481) was the master of the French Renaissance, well known for portraiture as well as manuscript illuminations. Painting in miniature gave his style precision and sharply focused color; he may have studied the work of the Limbourg Brothers while he was apprenticed in Bourges.

The Tree of Jesse

*detail; **Ingeburg Psalter**, 1210. Musée Conde, Chantilly.* The placement of each figure in its own roundel reflects the influence of the stained glass work in the great Gothic cathedrals. The luminous colors on the illumination also evoke the quality of light shining through a pane of colored glass.

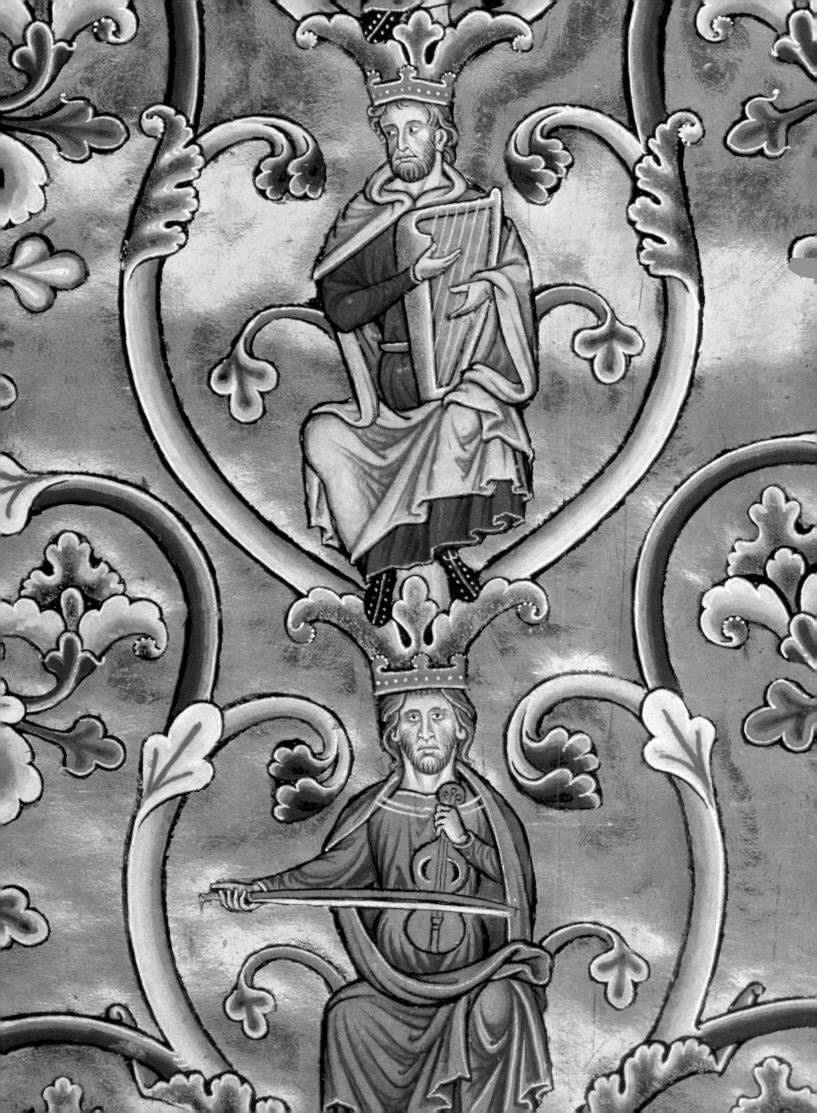

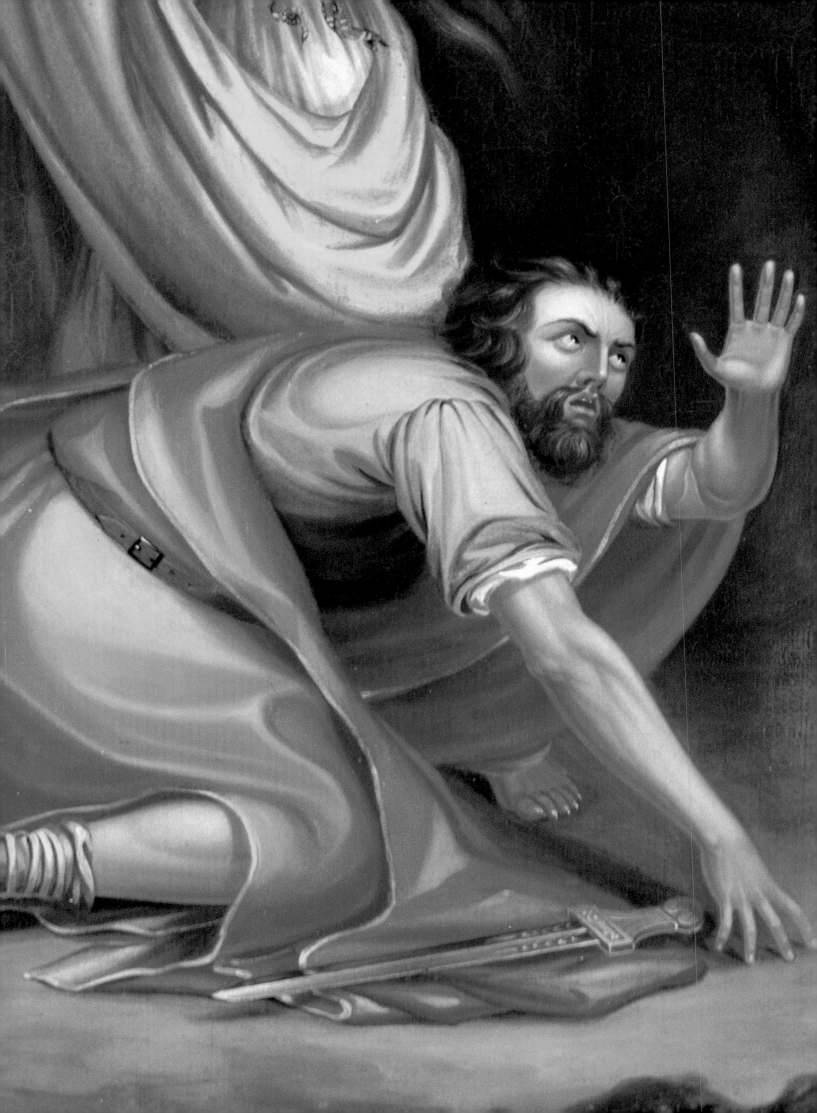

Elijah

Several generations after David ruled as King of Israel, King Ahab married Jezebel of the Sidonians, who encouraged the worship of foreign idols.

The Prophet Elijah prepared a trial between himself and the priests of Baal, who were brought to Israel by Jezebel. He summoned fire to light his sacrifice, and he predicted that Jezebel would be torn apart by dogs in the vineyards of Jezrael. After many years of prophesying, Elijah did not simply die—he was lifted into the heavens by God in a chariot of fire, while Elisha was left behind to be the next prophet.

Iconography

Elijah is shown invariably as an elderly bearded Prophet. As a symbol, Elijah is seen as being in accordance with St. John the Baptist, heralding the coming of Christ.

The Carmelites consider Elijah the founder of their order due to his victory over the priests on Mount Carmel. The Carmelites commissioned many series of Elijah's life for their monasteries (a seventeenth-century cloister in Barcelona; a Carmelite Church in 1483; frescoes by Gaspard Dughet in 1647).

The prophet's assent in the chariot resembles ancient Greek and Roman reliefs of the sun god Helios or Apollo, and can be seen depicted in the catacombs of Via Latina (fourth century, Rome) or the door of the Church of S. Sabina (fifth century, Rome).

Esther

King Ahasuerus ruled over the land from India to Ethiopia, known as Persia. When he brought the

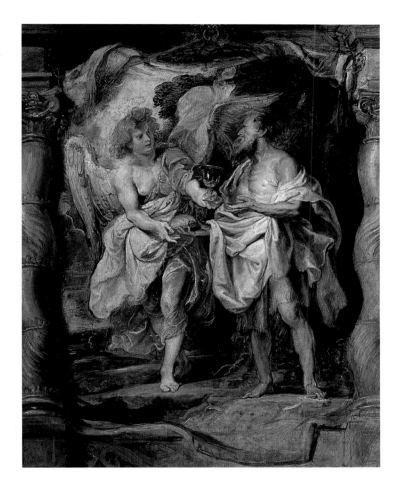

The Prophet Elijah Receives Bread and Water from an Angel
Peter Paul Rubens, c. 1608; oil on canvas; 54 x 40 in. (137 x 101 cm). Musée Bonnat, Bayonne. Peter Paul Rubens (Flemish, 1577–1640), the foremost Flemish painter of the seventeenth century, has here rendered in vivid, rich detail one of the many miracles in the life of the Prophet Elijah, who ultimately ascended to Heaven in a chariot of fire enveloped within a whirlwind.

"beautiful young virgins" of the land to his harem in Susa, his capital, the king "loved Esther more than all the women." (Esther 2:17)

When Esther obeyed her adopted father, a Hebrew man known as Mordecai, she risked her life by going unannounced to King Ahasuerus to ask for clemency for the condemned Jews. The king relented, and halted the massacre of the Jews by his vizier. This event was the origin of the Jewish holy day of Purim (the Feast of Lots), which celebrates Esther's saving of her people.

Iconography

Esther is usually portrayed as a beautiful, wealthy queen, despite her humble mission. On the ceiling of the Sistine Chapel, Michelangelo juxtaposes the figure of Esther with that of Judith, who also is renowned for the deliverance of her people.

Most often, the composition of this theme portrays Esther kneeling at the feet of the king. The clemency of the king is displayed by the lowering of his scepter. There are also depictions of Esther at her meeting with Mordecai—for instance, Botticelli's Renaissance-era painting.

Saul and the Witch of Endor

detail; William Sidney Mount, 1828. The Smithsonian Institution, National Collection of Fine Arts, Washington, D.C. This depiction of Saul reveals Mount's affinity for realistic genre scenes and portraiture. Here, Saul is shown as a real man, and in spite of the fact that he is kneeling, his dignity remains intact. The precision of the contours and detail in this painting reflects Mount's admiration for Ingres' work.

Job

The Book of Job is the story of God and the devil testing the piety of a wealthy man. A series of catastrophes take away Job's servants, his flocks, and his children. Then the devil strikes him with leprosy. In the end, "the Lord restored the fortunes of Job, when he had prayed for his friends," giving him twice as much as he had before. (Job 42:10) Job's wife went on to bear seven sons and three daughters, replacing those that were lost in the contest.

Iconography

The earliest appearance of Job as the subject of artwork is at the Synagogue at Dura-Europos (c. 245), in Roman catacomb paintings. His suffering is seen as prefiguring Christ's Passion cycle—from the Agony in the Garden and the subsequent Mocking and Crucifixion to the ultimate Redemption.

The most common way Job is depicted is as an old man with a beard and long hair, sitting "in dust and ashes," as in Hans Grien's etching *Job on the Dungheap* (c. 1530). Around the sixteenth century, it became more common to depict Job alone in his struggles, rather than with his wife. In the seventeenth century Job's suffering is emphasized, as in Georges de La Tour's version of this theme (c. 1650) and William Blake's *Satan Smiting Job with Sore Boils* (c. 1826).

Satan Smiting Job with Sore Boils

William Blake, c. 1826, watercolor. Tate Gallery, London. William Blake (English, 1757–1827) was a poet and painter who created and published his own books using engraved text and hand-colored illustrations. Blake greatly admired the art of the middle ages and his books were intended as successors of the illuminated manuscripts of that period.

Prophets

During a peaceful stretch in Israel, the prophet Jeremiah predicted the coming of a devastating enemy. His many visions of the Lord's warnings fill the Book of Jeremiah, including the fact that the King of Babylon would rule Israel. (Jer. 34:2)

Between 605 and 585 B.C., the armies of Nebuchadnezzar, King of Babylon, laid waste to both Syria and Palestine. After the destruction of Jerusalem, Jeremiah was taken to Babylon as a prisoner, where he died after a long life.

The Prophet Ezekiel also lived among the captive Jews taken to Babylon. The Book of Ezekiel describes his powerful visions of the Four Evangelists, allocating as symbols man, lion, ox, and eagle. (Ezek. 1:4–14) Ezekiel prophesied the ultimate vanquishing of the enemies of Israel.

Iconography

Jeremiah is usually depicted, familiarly, as an old, white-haired, bearded prophet. In the medieval period, he was occasionally shown wearing a turban. Fra Angelico placed the twelve prophets alongside the twelve disciples in his *Scenes from the Life of Christ*, 1450.

A capital in the Basilica of Vezelay (twelfth century) shows Jeremiah being thrown into a dungeon full of mire. Manuscript illuminations depicted Jeremiah's lamentations near Jerusalem while the city is being sacked in the distance, as did Rembrandt in his version of this scene (1630).

Since the twelfth century, frescoes of this prophet's visions began appearing in Catalan churches. Ezekiel is shown frequently upon a throne, accompanied by the four "likeness of the Glory of the Lord." Raphael, in the Renaissance, painted a version of this ever-popular theme (1518) with God taking a central position in the composition, hovering over the four animals. Ezekiel's visions can be seen as foreshadowing the Revelations of St. John the Evangelist.

Daniel

Gianlorenzo Bernini, 1650; marble. Santa Maria del Populo, Rome. Gianlorenzo Bernini (Italian, 1598–1680) had an remarkable ability to manipulate marble into pliable folds and complex undulations. He was known for his lifelike portraiture busts, which focused on creating an illusion of reality rather than an idealization of nature.

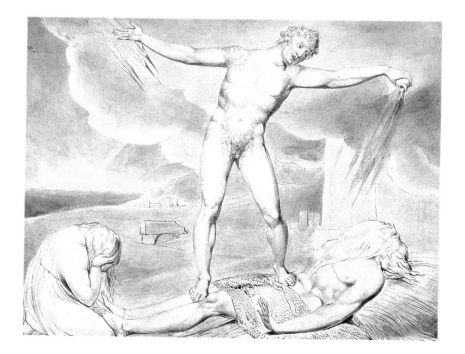

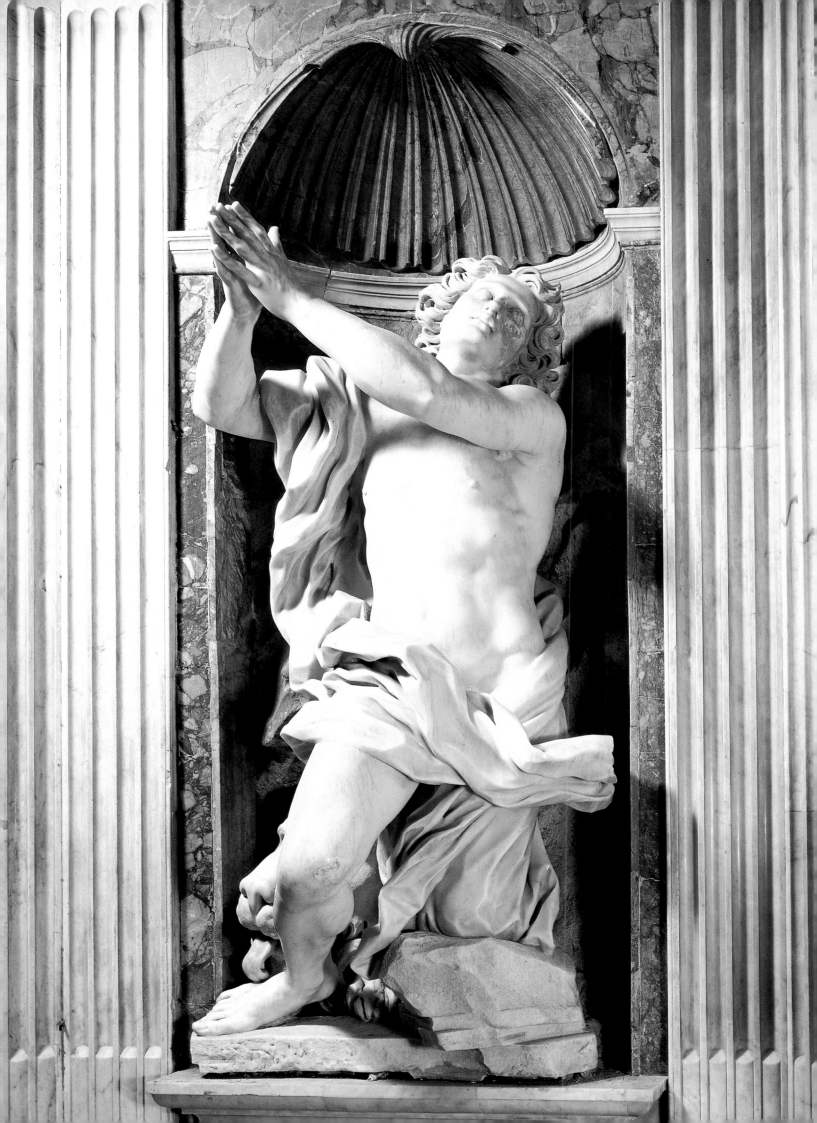

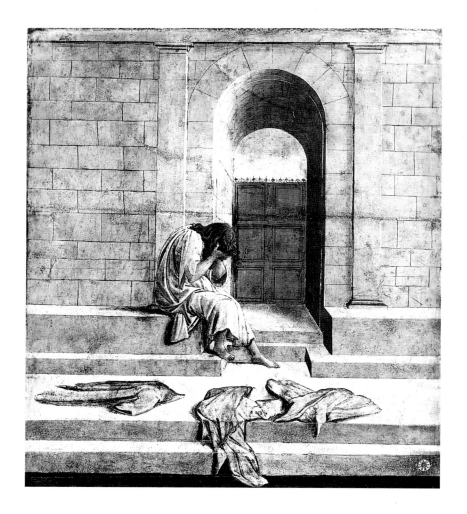

Mordecai Lamenting Before the Gates of the Palace

Sandro Botticelli, c. 1490; panel; 24 5/8 x 36 in. (62.5 x 91.4 cm). The Collection of Pallavincini, Rome. Sandro Botticelli (Italian, 1445–1510) was trained by Fra Filippo Lippi, and was considered to be the master of the High Renaissance in depicting grace and beauty. His paintings evoke the sense of low relief rather than deep space, lending his voluptuous figures a floating, ethereal sensation.

Daniel

The Book of Daniel recounts the life of a prophet who was also taken to Babylon during King Nebuchadnezzar's reign. Unlike the other prophets, Daniel was brought into a series of kings' courts, where he interpreted dreams and other signs from God. At a feast for King Belshazzar, Daniel translated the words that appeared on a wall, prophesying the death of Belshazzar. The king was assassinated that night, and King Darius took over. (Dan. 5)

Daniel was then thrown into the lions' den for worshiping God, breaking the royal command that all prayers must be addressed to King Darius. But the Lord sent an angel who "shut the lions' mouths," and Daniel was once more embraced by King Darius and "prospered" under his reign. (Dan. 6:16–28)

Iconography

Daniel in the lions' den is shown as early as the third century, in the catacombs of Callista, and in SS Peter and Marcellinus, Rome, where his ordeal was seen as in accordance with Christ's descent to Hell before the Resurrection. The theme was also popular on Romanesque capitals, illuminated manuscripts, and frescoes, such as those in the Lower Church at San Clemente, Rome (c. 1080).

Belshazzar's feast is less frequently illustrated. In the eleventh century, it is depicted in the *Apocalypse de St. Sever*, Paris, and on the main floor of the Cathedral of Amiens (thirteenth century). Rembrandt's interpretation of this theme (1635) incorporates the Christian symbolism of Belshazzar as the Antichrist.

Jonah

The Book of Jonah describes the life of a man who was ordered by the Lord to go to Nineveh to preach to its wicked citizens. Filled with fear of his appointed task, Jonah tried to run away on a Phoenician ship. (Jon. 1:3)

The sailors struck a bargain with God and threw Jonah overboard. The sea calmed, and a "great fish" swallowed up Jonah. He remained in the belly of the fish for three days and nights. After much praying, Jonah was cast back out onto dry land, where he repented and went to preach to the people of Nineveh, obtaining in the process God's forgiveness.

Iconography

The legend of Jonah was depicted often on catacomb frescoes and sarcophagi as a symbol of rebirth. His being tossed into the sea is a favored scene early on, and later Rubens (1618–1619) depicted a memorable version.

In the Gospel according to Matthew, the story of Jonah is compared directly to Christ's Entombment and Resurrection. Both Jonah and Jesus were held three days and nights—Jonah in the whale, Jesus in the heart of the earth. Nicolas of Verdun rendered this scene on the Klosterneuberg Altarpiece, in 1181.

Jonah and the Whale

J. B. Flannagan, 1937; bronze. The Martha T. Wallace Fund, Institute of Fine Arts, Minneapolis. John Bernard Flannagan (American, 1895–1942) was a sculptor who often relied on the original material of the piece to suggest his subject matter. Although this work is crafted in bronze, Flannagan usually used as a medium fieldstone that he found in Ireland, New York, or Connecticut.

Following page:
Jonah Thrown into the Sea
Unknown artist, Roman, 4th century;
sarcophagus. Lateran Museum, Rome.
The compositions on the oldest
surviving Christian sarcophagi are barely
distinguishable from pagan, Greco-Roman
renderings. Toward the fourth century, the
narratives became concerned with telling
the biblical story, and religious sensitivity
began to override the Classical style.

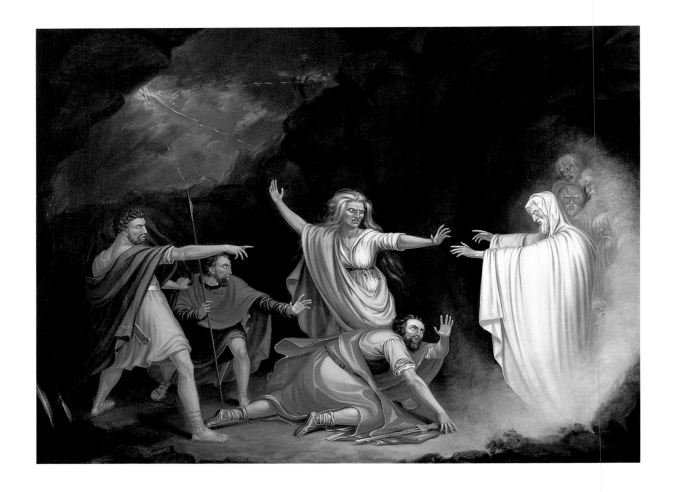

Saul and the Witch of Endor

William Sidney Mount, 1828; oil on canvas; 35 7/8 x 48 in. (96 x 122 cm).
The Smithsonian Institution, National Collection of Fine Arts, Washington, D.C.
William Sidney Mount (American, 1807–1868) created "truly American"
paintings of genre subjects and landscapes. This early work was one of the
few he rendered in the history-painting genre, a form of painting which
he subsequently gave up because it had, he said, "no root in the people."

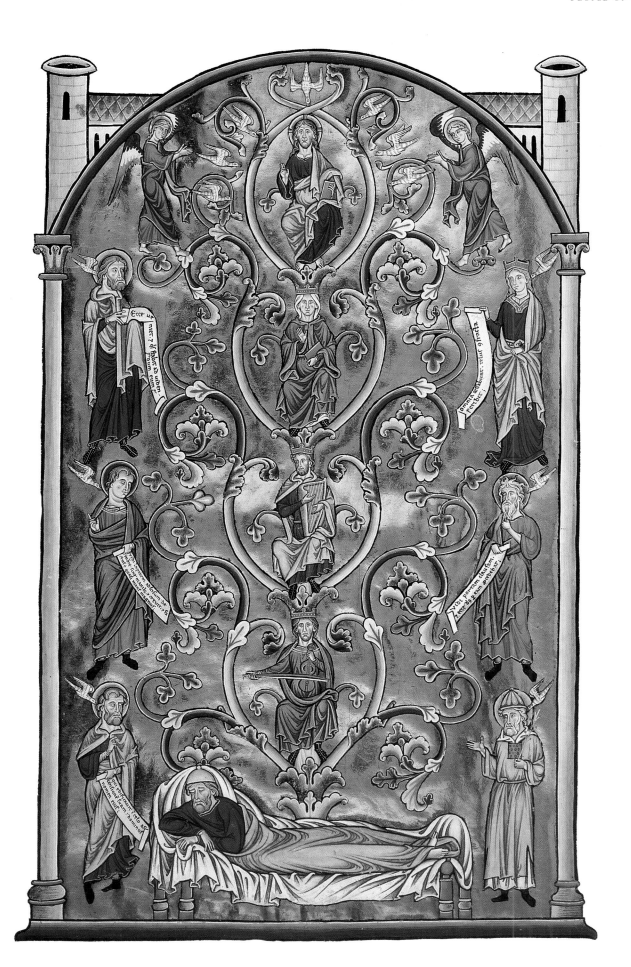

The Tree of Jesse
Ingeburg Psalter,
1210; illumination.
Musée Conde, Chantilly.
In the middle ages,
French manuscript
painting was character-
ized by graceful, curv-
ing figures and soft,
looping drapery ren-
dered in a series of
troughs and ridges.
This figure style was
useful in the explo-
ration of new forms
of realism, which
would culminate
in the International
Gothic style.

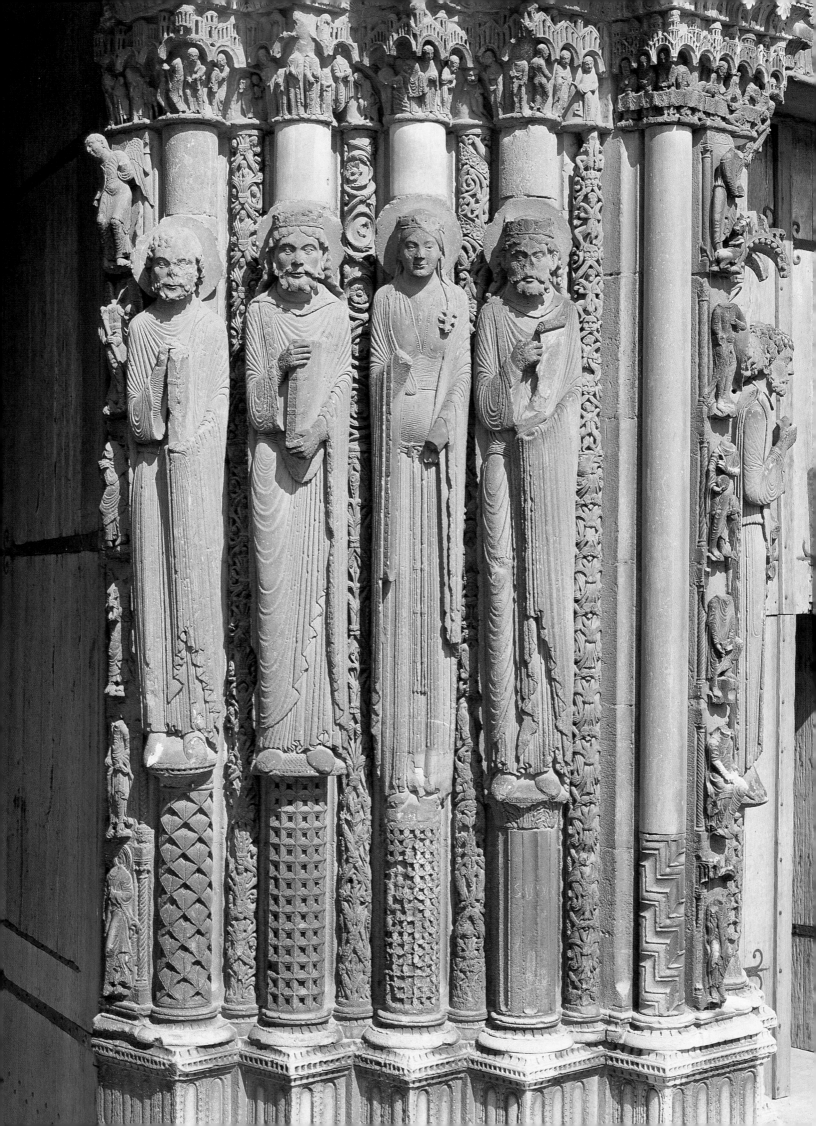

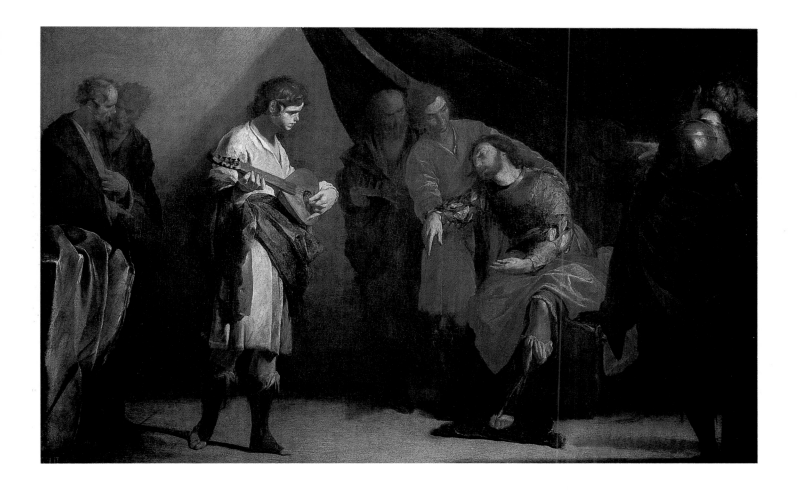

David Playing Before Saul
Bernardo Cavallino, 1645; oil on canvas;
25 x 41 in. (65 x 105 cm). Gemaeldegalerie,
Kunstihistorishes Museum, Vienna.
Bernardo Cavallino (Italian, 1622–1654)
was a follower of Caravaggio, as can
be seen in his emphasis of lyrical lines
and theatrical gestures. Typical of the
baroque style, the figures are arranged
like actors on a stage, yet the gestures
and narrative details are indicative of the
artist's concern for illustrating the Scriptures.

Jeremiah
Unknown artist, c. 1145; stone sculpture on the pier
supporting the archivolt of the right-hand wing of the
Royal Door, Chartres Cathedral, Chartres.
During its long period of construction,
Chartres Cathedral underwent a transition in
sculptural style. The Royal Door in the West
Portal contains some of the earliest works,
such as this sculpture of the prophet Jeremiah.

The Blinding of Samson

Januarius Zick, c. 1771;
oil on canvas; 62 x 53 1/4 in.
(160 x 136.5 cm).
City Galleries, Augsburg.
Januarius Zick (Dutch,
1730–1797) was a contem-
porary of Rembrandt,
and his use of theatrical
dramatics were typical
of the baroque period.
Like Rembrandt, Zick
incorporated rich costumes
into his paintings. The
intense spotlighting of
the figures is derivative
of Caravaggio's work.

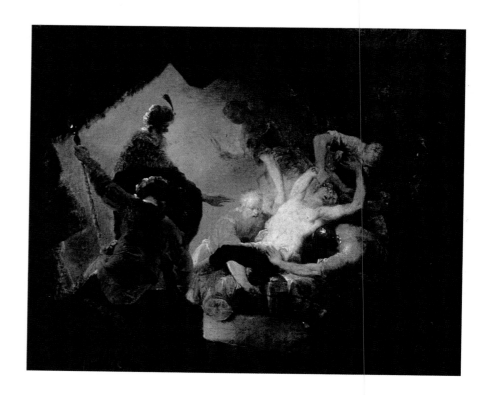

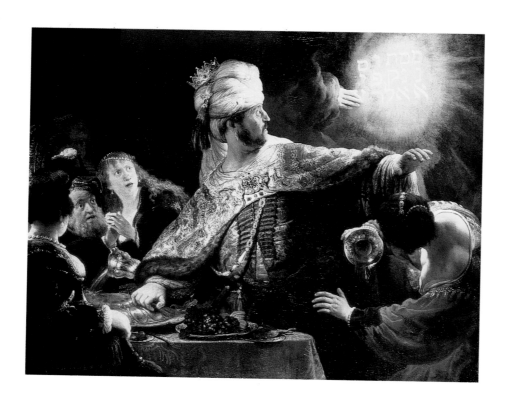

Belshazzar's Feast

Rembrandt, c. 1635; oil on
canvas; 31 x 40 1/2 in.
(79 x 103 cm).
National Gallery, London.
Rembrandt van Rijn
(Dutch, 1606–1669)
focused primarily on
gesture to illustrate the
action and intention of
his subjects. In this way
the artist could group large
numbers of figures within
one composition without
losing the liveliness and
unity of the piece. Always,
for Rembrandt, the
true beauty of man
was found in the face.

The Vision of Ezekiel

Raphael, c. 1512; oil on canvas; 8 ft 8 1/2 in. x 6 ft. 11 in.
(2.7 x 2.1 meters). Galleria Palatina, Florence.

In this painting Raphael (Italian, 1483–1520) pays clear
homage to Michelangelo's figures on the Sistine Chapel. Yet
where Michelangelo's depiction of the figures seems to surge
forward, Raphael creates a more serene composition, his angels
taking on expressions of sweetness rather than fierce nobility.

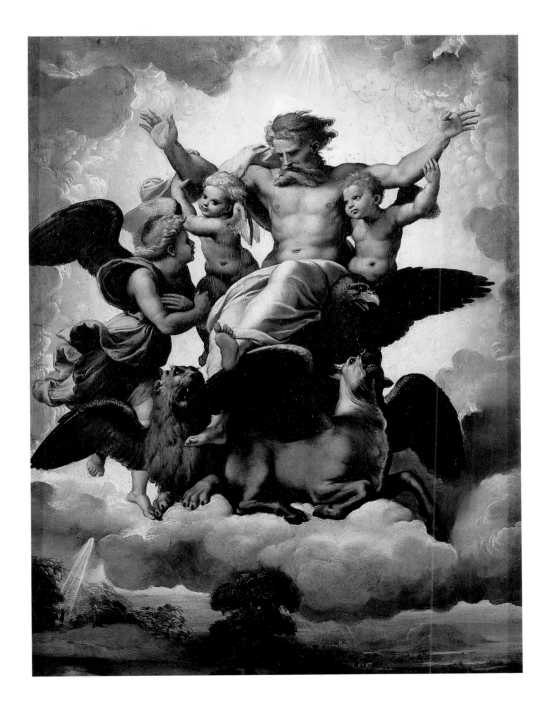

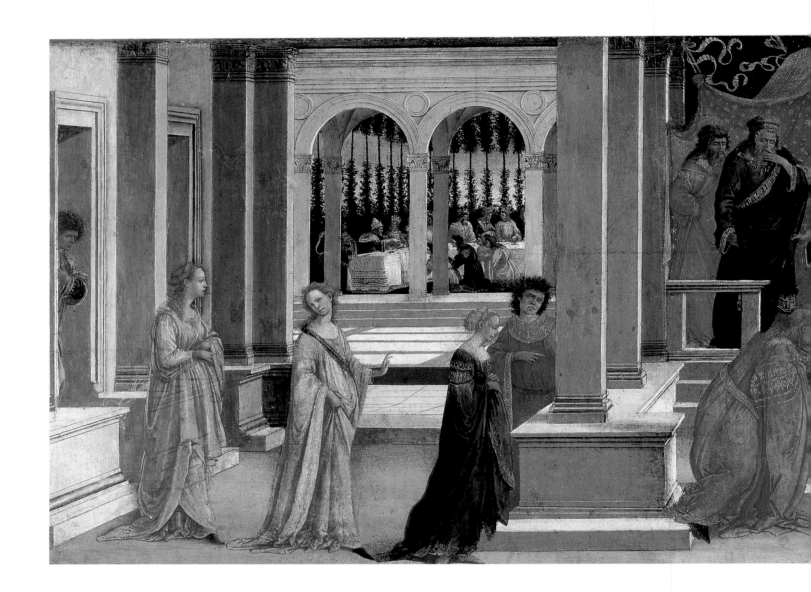

Esther Before Ahasuerus

Filippino Lippi, c. 1440–1450; panel;
6 ft. 1 1/2 in. x 8 ft. (1.9 x 2.4 m). Musée Conde, Chantilly.
Fra Filippino Lippi (Italian, c. 1406–1469) had been inspired by Renaissance
Flemish painters, while his mastery of drapery and movement relied on
the earlier work of Donatello and Lorenzo Ghiberti. Fra Lippi was a monk,
and he painted numerous frescoes in the monastery of S. Marco in Florence.

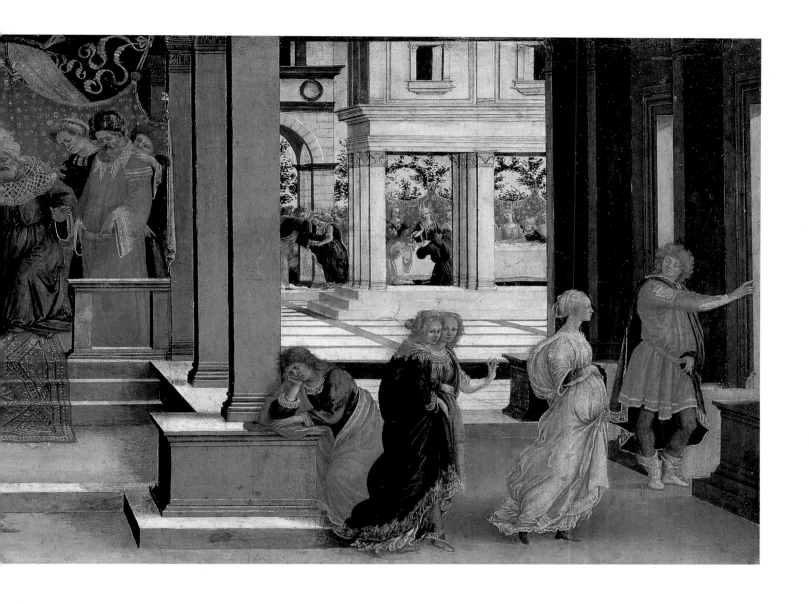

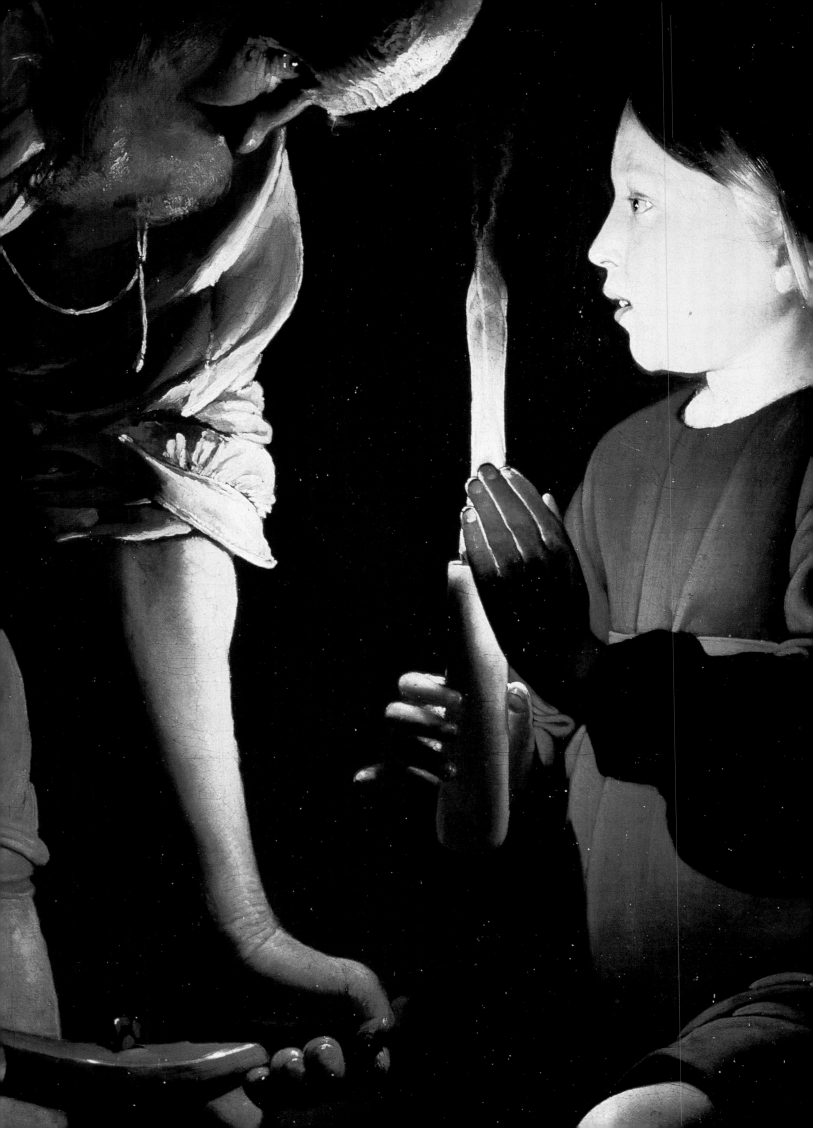

THE COMING OF THE MESSIAH

Mary's engagement and marriage are not recorded in the New Testament; however, the *Golden Legend* (a collection of saints' lives written in the thirteenth century by Jacabus da Varagine) and earlier accounts describe the tale.

The Virgin Mary

When Mary was fourteen the priests gathered the descendants of David who were of marriageable age. Each was to bring a rod, and the man whose rod blossomed into a flower would become Mary's husband. Though Joseph the Carpenter was not young, his rod flowered and thus he was betrothed to Mary.

The Annunciation is described in the Gospel of Luke. First the angel Gabriel appeared to Zechariah and foretold the birth, from his aged wife Elizabeth, of St. John the Baptist. Then Gabriel appeared to the Virgin Mary in Galilee, while she was betrothed to Joseph the Carpenter, and announced, "You will conceive in your womb and bear a son, and you shall call his name Jesus." (Luke 1:31)

Luke also tells the story of Mary visiting Elizabeth, who was her cousin, while Elizabeth was pregnant with St. John the Baptist. At the sight of Mary, Elizabeth felt the baby John move.

Iconography

The oldest depictions of the Annunciation date from the fourth century, in the catacombs of Priscilla

Saint Joseph, the Carpenter

detail; Georges de la Tour, 1645. Louvre, Paris.

In this work, the images are reduced to a geometric simplicity reminiscent of the peasant paintings of seventeenth-century Holland and Flanders, such as those by Pieter Bruegel the Elder. Here, the artist maintains a devotional spirit rather than evoking the Netherlandish sense of humor or satire.

and in SS. Peter and Marcellinus, Rome. In the tenth century the Virgin is usually depicted seated on a throne, listening to the angel. Some artists emphasized her surprise at the good news, as in Simone Martini's version of the scene (1335). A dove is frequently shown over Mary's head as a symbol of the Holy Ghost. Leonardo da Vinci portrayed the angel Gabriel handing Mary a lily (1472–1475), as did Fra Filippo Lippi earlier, c. 1440.

The Annunciation is paired with the Visitation in Early Christian renderings. Usually the Annunciation is shown taking place indoors, while Mary's meeting with Elizabeth is seen occurring outside, such as in the portals of Reims Cathedral (thirteenth century). Domenico Ghirlandaio portrayed Elizabeth kneeling in front of the Virgin, as if paying homage to the unborn Jesus, in his 1486 fresco at S. Maria Novella, Rome.

The flowering of Joseph's rod was sometimes depicted with a dove, the symbol of the Holy Spirit, landing upon it. Giotto painted a series of frescoes on this theme in the Arena Chapel, Padua (1304–1306). Raphael painted the wedding of Mary and Joseph (1504), and Dürer did an engraving of the subject in 1505.

The Annunciation

Rogier van der Weyden, c. 1445; oil on wood, panel; 33.5 x 36 in. (86 x 93 cm). Louvre, Paris.

Rogier van der Weyden (Flemish, c. 1397–1461) illustrates the northern Renaissance tendency to emphasize the realistic details of the setting in devotional art. Yet these details—the prayer book held by the Virgin, the sconce, chandelier, and vase of lilies— are also symbols of Mary's virtue.

The Nativity

Only the Gospel of Luke gives a complete account of the birth of Jesus. (Luke 2:1–20) Matthew recounts that Jesus was born in Bethlehem "in the days of Herod the king," adding that "wise men from the East" traveled to see him. (Matt. 2:1–12)

Joseph and Mary obeyed an edict from Caesar Augustus, and returned to Bethlehem for the census. There, Jesus was born in a stable and placed in a manger because "there was no room for them at the inn." (Luke 2:7) An angel announced the birth to shepherds watching their flocks nearby.

The three wise men from the East learned of the birth of Jesus from the appearance of a star in the heavens. They were sent by King Herod to find the infant, but after delivering their gifts they were warned in a dream not to return to Herod, who intended to harm the baby Jesus.

Iconography

After the fourth century, the iconography of the Nativity increased with nearly every depiction. By the Romanesque period, Mary appears lying on the ground holding the child, who is wrapped in swaddling clothes. Though some depictions show Jesus in the manger, by the thirteenth century Mary is cradling him in her arms.

In the sixteenth century, the scene of the Adoration of the Child by the Shepherds takes predominance, for example in Dürer's Paumgartner Altarpiece (1502), which also includes portraits of the donors. The lamb brought to the Nativity by the shepherds is considered to be a symbol of the coming Crucifixion.

Giotto groups subjects from the Annunciation to the Shepherds together with the Nativity and the Adoration of the Magi in the Arena Chapel, Padua (1304–1306), as does the Master of Hapsburg some time later, around 1500.

The Nativity

*Gentile da Fabriano, 1423; panel; 12 1/2 x 29 1/2 in. (32 x 75 cm). From the predella of the **Adoration of the Magi**, Uffizi, Florence.* Gentile da Fabriano (Italian, c. 1370–1427) was the founder of an Umbrian School of painting which emphasized an elaborate style full of details of costumes and interiors, known as International Gothic. Fabriano was one of the last great exponents of the Gothic style.

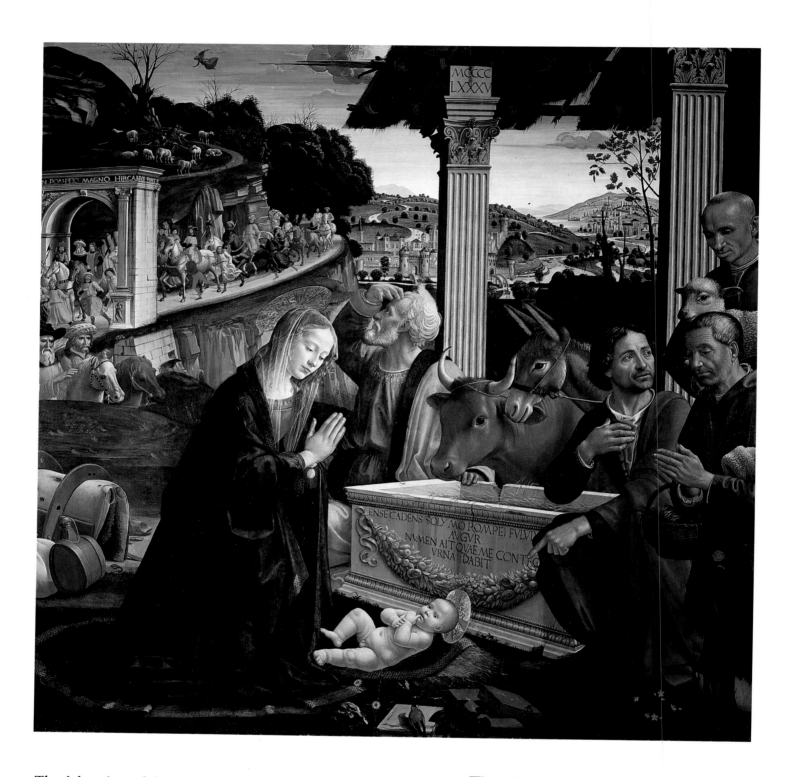

The Adoration of the Shepherds

Domenico Ghirlandaio, 1485; panel,
65 3/4 in. sq. (167 cm sq.). Santa Trinita, Florence.
Like Sandro Botticelli, Domenico Ghirlandaio (Italian, 1449–
1494) was patroned by the Medici during the Renaissance,
and he sometimes depicted Medici followers in his biblical
scenes. He paid particular attention to fashionable dress
and detail, but Ghirlandaio's pleasing sense of color rather
than his compositions give his paintings their dynamism.

The Childhood of Christ

St. Luke documents the traveling of Mary and
Joseph to Jerusalem to present their newborn son
to the Lord at the Temple. Simeon, a just man,
encountered them at the Temple, and he prophe-
sied that this was "salvation." (Luke 2:22–40) Another
prophet, Anna, spoke of the child to those looking
for "redemption in Jerusalem." (Luke 2:38)

The Gospel of St. Matthew tells of the flight of the Holy Family into Egypt. Joseph saw the Lord in a dream, and was warned that Herod sought to kill the baby Jesus. (Matt. 2:13–15) Matthew's brief telling has been embellished by popular accounts, which went on to include the pursuit of the Holy Family by Herod.

Iconography

An early depiction of the Presentation at the Temple is seen in a mosaic on the triumphal arch at S. Maria Maggiore, Rome (c. 432). In Stephan Lochner's version (1447), Simeon is shown as a high priest holding up the Christ child. Rubens created a seminal composition in 1611–1614, and Rembrandt painted the scene twice, in 1631 and 1669. Petr Brandl depicted Simeon alone with the Christ Child in 1731. Rembrandt, too, rendered the scene of Joseph being warned by an angel while he slept (1627).

However, the scene most frequently portrayed is the Flight into Egypt. Many landscape artists, in particular, rendered this theme, including Adam Elsheimer (c. 1609), and Poussin (1657). In 1750, François Boucher painted the meeting of St. John the Baptist and the Christ Child while the Holy Family rested during their flight.

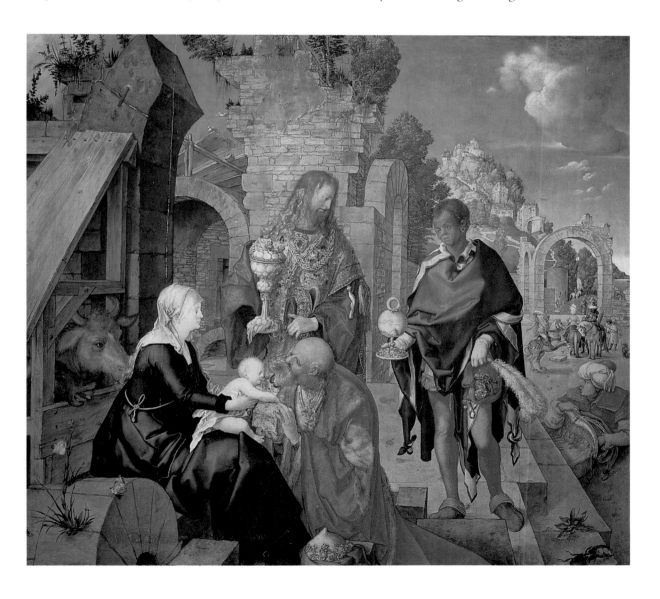

The Adoration of the Magi
Albrecht Dürer, 1504; oil on canvas; 48 1/2 x 40 in. (123 x 102 cm). Uffizi, Florence. Albrecht Dürer (German, 1471–1528) studied under his goldsmith father, then encountered Flemish and Italian painting. This particular painting shows the influence of the artist's trip to Italy in 1494, where he was inspired by Giovanni Bellini's and Andrea Mantegna's handling of space and color.

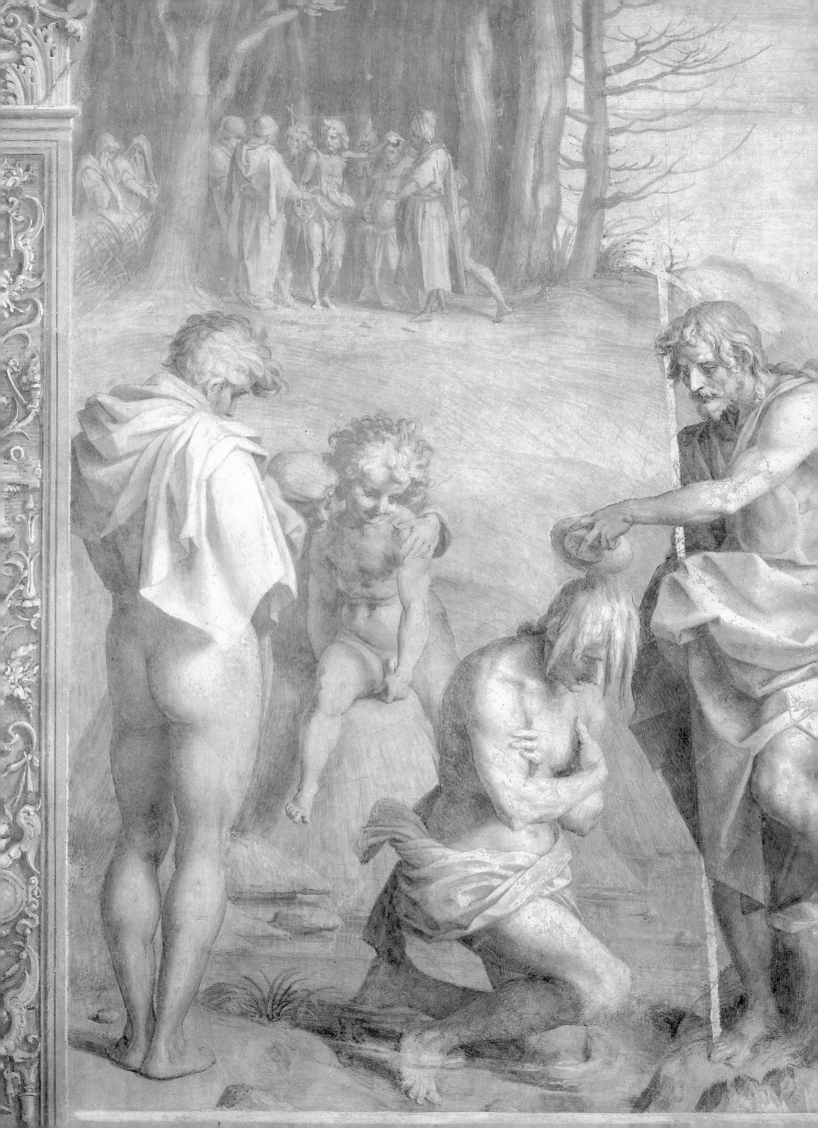

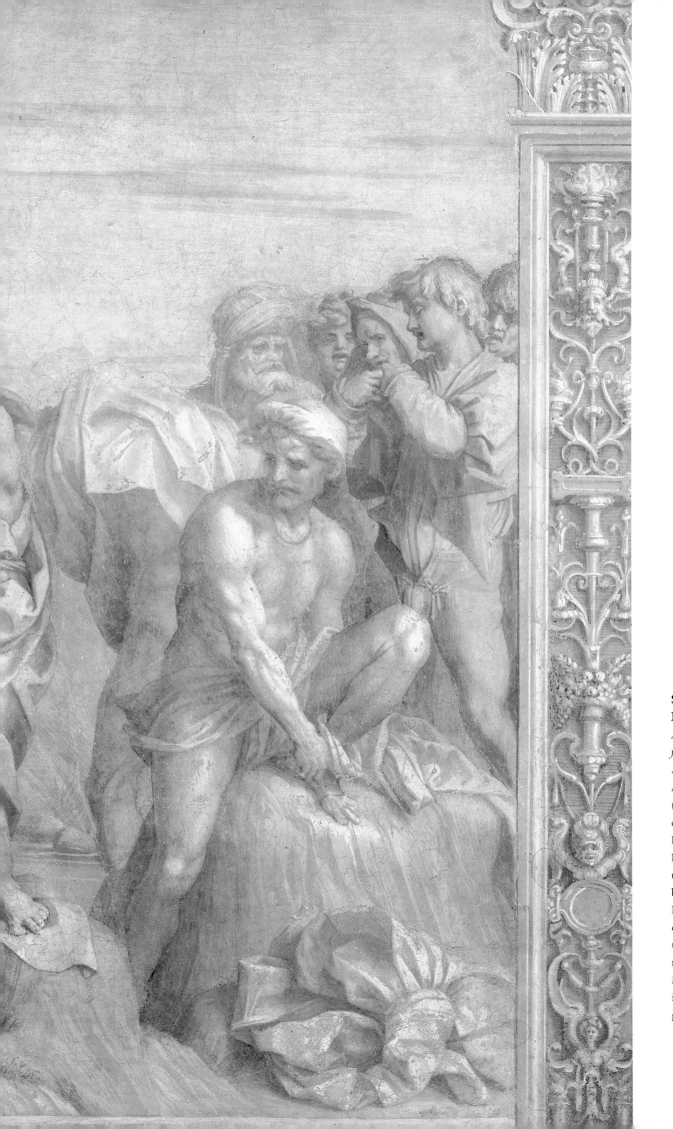

St. John the Baptist

Andrea del Sarto, 1514; fresco. Chiostro dello Scalzo, Florence.

Andrea del Sarto (Italian, 1486–1531) was one of the many fine Florentine artists of the Renaissance who was ultimately overshadowed by Michelangelo, Raphael, and Leonardo da Vinci. Though his figures show a conspicuous reliance on those of Michelangelo, del Sarto infuses them with a singular restrained dignity.

The Four Evangelists Gospel

Of the Palace School, Aachen, c. 800; illumination. Cathedral Treasury, Aachen. The artists who worked for Charlemagne produced a series of splendid devotional manuscripts. This *Gospel Book* was a gift from Angilbert to his monastery at Centula. The colors are harmonious, with lavish goldwork utilized for the details of the costumes and the outlines of the drapery.

St. John the Baptist

Luke tells of John the Baptist's miraculous birth (Luke 1:59–60), but little else is known about him until he began baptizing in the River Jordan around the year 27 A.D.

John baptized people to prepare for one "who is mightier than I." (Luke 3:16–17) And when John baptized Jesus, a voice sounded from heaven, saying, "Thou art my beloved Son; with thee I am well pleased." (Mark 1:11)

Following his baptizing of Jesus, John was imprisoned by Herod for cursing the king's incestuous marriage to Herodias, wife of his brother. When Salome, the daughter of Herodias, danced for her uncle to please Herod and his guests, Herod promised her anything she wished. She requested the head of John the Baptist, and the king presented her with the head on a platter. (Mark 6:22–28).

Iconography

In Byzantine art, John the Baptist is depicted with wings, in keeping with his designation as the "messenger" of God. He sometimes carries a stick topped by a medallion, showing a lamb holding a cross.

John is portrayed as a desert anchorite from the eighth century onward. Much later, in Ercole de'Roberti's early-fifteenth-century interpretation of this theme, John is shown half-starved, wearing a camel-hair tunic. Increasingly, during the Renaissance, John's life as a hermit was emphasized, as in Domenico Veneziano's version (1445).

The dance of Salome was a popular theme in the middle ages, and in the early Renaissance Donatello did a bronze relief of this subject for the Baptistery in Siena. Piero della Francesca painted Salome's dance in his cycle of John the Baptist (1448–1450). Fra Filippo Lippi painted the Dance in frescoes (1452–1464) in the choir of Prato Cathedral. In the sixteenth century, both Titian and Luini treated the theme, and later, Caravaggio rendered the Dance powerfully, with magnificent lights and shadows (1606).

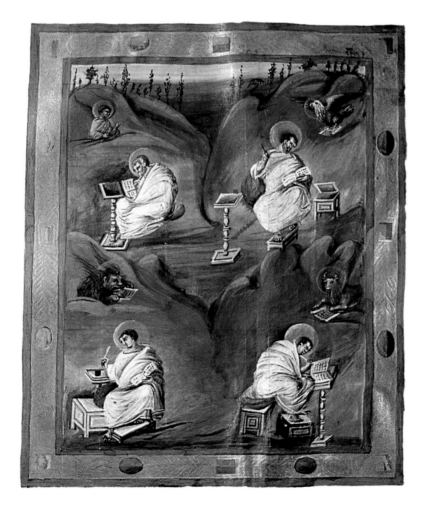

Four Evangelists

Matthew, Mark, Luke, and John were the authors of the Four Gospels of the New Testament, and are called the Evangelists. Matthew and John were apostles to Jesus, while Mark and Luke did not know him, writing their Gospels during the latter half of the first century.

Matthew was a tax collector before being called as an apostle by Jesus. He is depicted in many scenes of Christ's Passion. John also took part in many of the stories of the New Testament, and it fell to him to prophesy the Apocalypse, as told in the Book of Revelations. After the Ascension of Christ, John preached in Ephesus and was lifted up to heaven by an angel.

Baptism of Christ

Pietro Perugino, c. 1480; oil on wood; 9 x 12 in. (23.3. x 30 cm). Gemaeldegalerie, Kunsthistorisches Museum, Vienna. Pietro Perugino (Italian, c. 1450–1523) was the teacher of Raphael, passing on to his talented pupil a sense of classic balance and symmetrical design. Perugino's backgrounds are usually expansive interiors of contemporary architecture, setting the stage for the importance of the pictured narrative events.

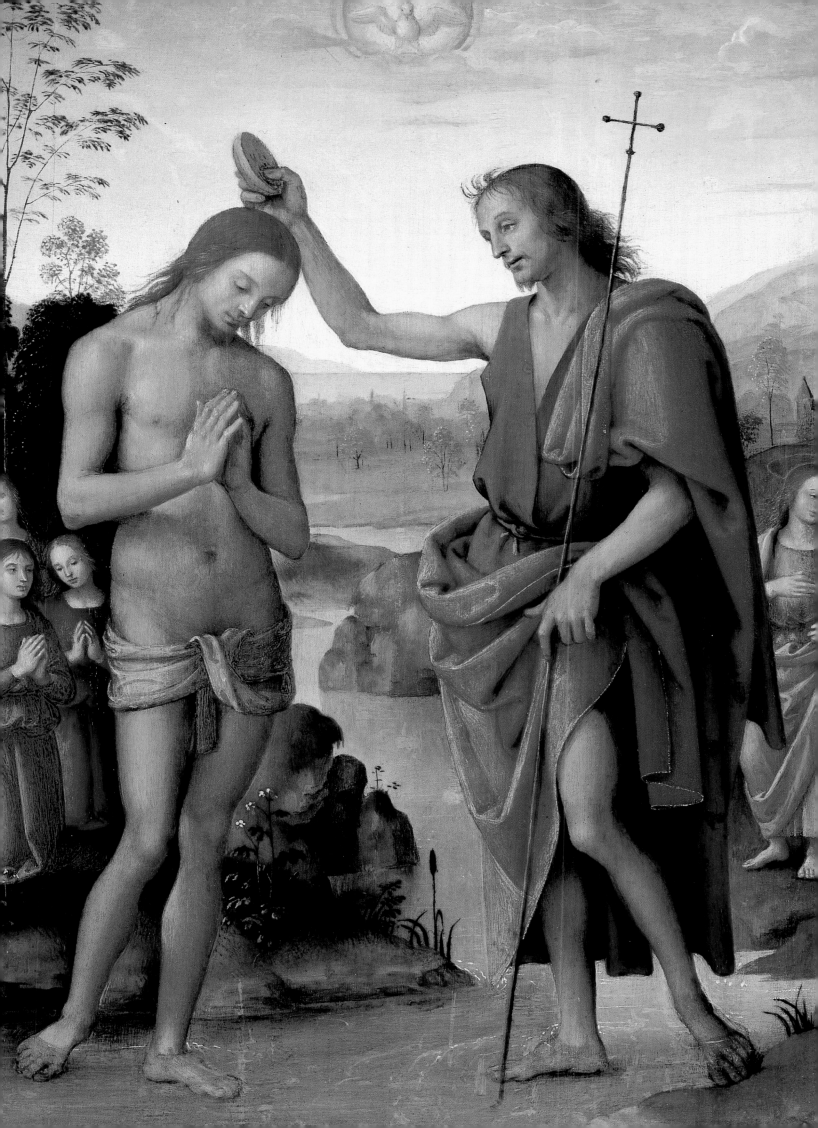

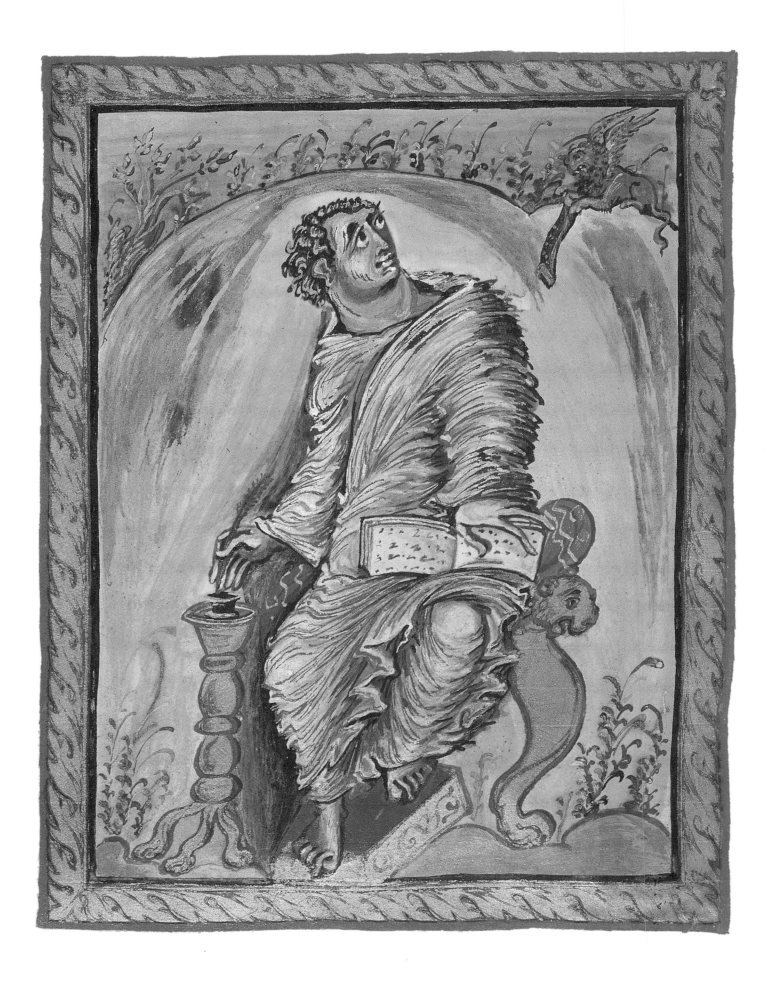

Luke was Paul's companion, as Paul traveled about and preached the teachings of Jesus. Traditionally, Luke was known to paint icons of the Virgin, and he was the patron of painters' guilds in the fifteenth century. He was also known as a physician, and became, additionally, the patron saint of doctors. Mark, the last Evangelist, composed at the request of the Romans the shortest Gospel of the Bible. Mark was the faithful companion to St. Peter, who founded the Christian Church in Rome. Peter sent Mark to Egypt to become the first bishop of Alexandria. Mark was later beaten to death with a club, but the fire which was to burn his body was extinguished by a miraculous rain.

Iconography

The four Evangelists are frequently portrayed as a group. In Early Christian art, they are usually identified by an inscription. Beginning in the fifth century, they are each identified by the symbols prophesized in the vision of Ezekiel. (Ezek. 1:1–28) The sixth-century mosaic in the choir octagon at San Vitale, Ravenna, portrays them as symbols: Matthew with a winged man, Mark with a lion, Luke with a bull, and John with an eagle. They appear sometimes writing on scrolls or carrying books to represent the Gospels. In the *Coronation Gospel* (c. 800), the Evangelists are shown as young men; by the end of the middle ages, only John is depicted as a young man.

John is often included in depictions of the Last Supper, and at the foot of the Crucifixion—as in Matthias Grünewald's version (1511–1517). Giotto did a cycle of John's life in frescoes at Cappella Peruzzi, Florence (1310–1312).

Matthew is usually shown writing at a desk—inspired by an angel, for example, in the ninth-century Grandval Bible. Poussin did a version of *Landscape with St. Matthew* (1643–1644), while Andrea Castagno's version (1442) shows the angel as a child. Caravaggio created dynamic scenes of several different episodes of St. Matthew's life.

Luke is often depicted accompanied by a painting of the Virgin Mary, as in the eighth-century mosaics of S. Maria Maggiore, Rome. Also Rogier van der Weyden (c. 1435), Raphael (c. 1511), and Gercino (seventeenth century) painted portrayals of St. Luke.

Mark was depicted as quite young in the ninth-century Ebbo Gospels, but from the twelfth century he was usually shown as a middle-aged man. After the fifteenth century, Mark's dress took on an Oriental cast, such as in Fra Angelico's portrayal (1433), which shows him preaching to the Romans. The symbolic lion is often winged, and is shown with its mouth open, either roaring or dictating the Gospel to Mark. In Vittore Carpaccio's 1516 painting, the winged lion takes the place of Mark entirely, and itself holds the Gospel book.

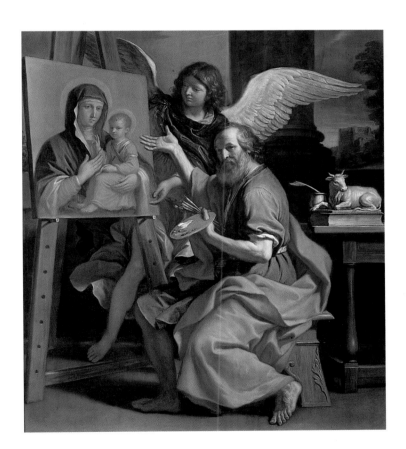

St. Mark the Evangelist
The Ebbo Gospels, c. 816–835; illumination.
Bibliothèque Municipale, Epernay.
Before the prevalence of Ottonian Art, the Reims School created manuscript miniatures with fluid modeling and the classical affects of an ancient Roman statue. This was translated into a uniquely Carolingian style, filled with the vibrant energy of the pose and swirling garments.

St. Luke Displaying a Painting of the Virgin
Guercino, 1652–1653; oil on canvas; 71 x 89 in. (180.3 x 221 cm).
The Nelson-Atkins Museum of Art, Kansas City, Missouri.
Giovanni Francesco Barbieri, called Guercino (Italian, c. 1591–1666), was a follower of Annibale Carracci's anti-Mannerist style. In this painting, the architectural perspective creates the illusion of limitless space, which is enhanced by a Titian-inspired color and light.

The Calling of St. Matthew

Caravaggio, 1597–1598; mural; 11 ft. 1 in. x 11 ft. 5 in. (3.4 x 3.5 m). Contarelli Chapel, S. Luigi dei Francesi, Rome. Michelangelo da Caravaggio (Italian, 1573–1610) was the last in a succession of great Italian masters who vastly influenced art throughout Europe. His religious paintings resonate— through the use artistic methods such as chiaroscuro (strong light and shadow)—with deep, expressive feeling.

The Apostles of Jesus

In addition to the Evangelists Matthew and John, there were ten other Apostles of Christ. After His Ascension, these twelve disciples became His messengers, spreading Jesus' word throughout the lands. Five of them, like Christ, were crucified; Peter and Philip were hung upside down.

St. Peter was considered to be the "rock" or foundation of Christ's church, and was renamed as such by Jesus Himself. He and his brother Andrew were fishermen on the Sea of Galilee, and were the first two disciples called by Jesus: "Follow me and I will make you become fishers of men." (Mark 1:17)

Peter was involved in all the major stories of the Gospels—the Transfiguration, Christ's Agony in the Garden, and Christ's arrest, where he denied Jesus while the cock crowed three times. After the Ascension, Peter eventually went to Rome, where he was martyred during Nero's anti-Christian persecutions.

St. Paul was one of those Roman citizens who participated in the persecution. He was, however, soon thereafter converted to Christ's teachings after being knocked off his horse during a blinding vision of Jesus. Paul served Peter by taking three missionary voyages, and, after many missions and travails, was finally beheaded at the same time Peter was crucified.

Iconography

As early as a fourth-century relief on a sarcophagi, the Apostles frame Christ, six on either side of Him. They were often depicted on the lintels or uprights of cathedrals and churches until the thirteenth century; thereafter, they were portrayed inside, as in the choir of Cologne Cathedral (fourteenth century).

Canonical texts were copiously illustrated with the figures of the Apostles, who were often juxtaposed with the Old Testament prophets, the heralds of Christ's coming. This theme can also be seen in the twelfth-century fonts of Merseburg Cathedral.

Raphael did a series of sketches (1515–1516) for the tapestries of the Sistine Chapel illustrating the various acts of the Apostles, featuring Peter and Paul. Dürer placed Paul in the foreground of his *Apostles* (1526), and episodes of Paul's life and travels appear earlier in frescoes of St. Anselm Chapel, Canterbury Cathedral (twelfth century) and on the dome of St. Paul's Cathedral, London. The conversion of Paul on the road to Damascus (Acts 9:3–9) was depicted by Caravaggio in 1601, and Parmigiano (c. 1520).

The ubiquitous image of St. Peter is found as early as the third century, on a fresco in the Chapel at Dura-Europos (c. 245). He is usually portrayed as an elderly, though fit man with a short bushy beard. Duccio depicted Christ washing Peter's feet (1308–1311), while El Greco portrayed Peter's repentance after the Denial (1580–1585).

Andrew's symbol is the Cross Saltire, on which he was martyred. The saltire is a diagonal cross in the shape of an X. A thirteenth-century stained-glass window pictures Andrew with the more familiar Latin cross, as does Caravaggio in 1607–1610. More traditionally, however, Rubens (1638–1639), El Greco (c. 1590), and Guido Reni (1608) portray Andrew upon a cross saltire.

The Martyrdom of St. Andrew

detail; Jean Fouquet, c. 1455; illumination. Musée Conde, Chantilly. Fouquet's unique mixture of Flemish and early Renaissance elements can be observed in the precise details of his work. The composition is organized so that the figures form closely-knit groups, set solidly upon the ground.

The Marriage of the Virgin

Raphael, c. 1504; panel; 67 x 46 1/2 in. (170 x 118 cm).
Pinacoteca di Brera, Milan.
Raphael (Italian, 1483–1520) shows the influence of his teacher, Pietro
Perugino, in this symmetrical composition of reserved, slender figures.
Raphael's search for poetic harmony was grounded in his study of Italian
Renaissance architecture, and his sense of spaciousness heralded the
growing tendency of the sixteenth-century development of depth-of-field.

The Visitation

Jacopo da Pontormo, 1514–1516; fresco. S. Michele, Carmignano.
Jacopo da Pontormo (Italian, 1494–1557) followed the
Mannerist style of Andrea del Sarto, rejecting the Classical
ideal of the human figure. Instead, Pontormo chose to con-
centrate on those aspects that typified beauty, dignity, and expres-
sion, and he gave his colors a vibrant, almost iridescent quality.

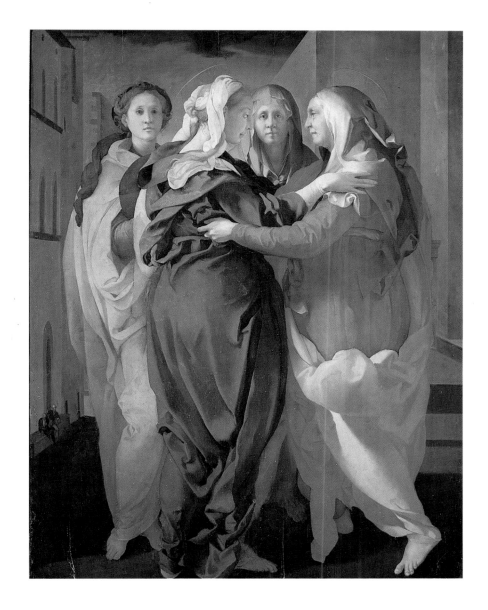

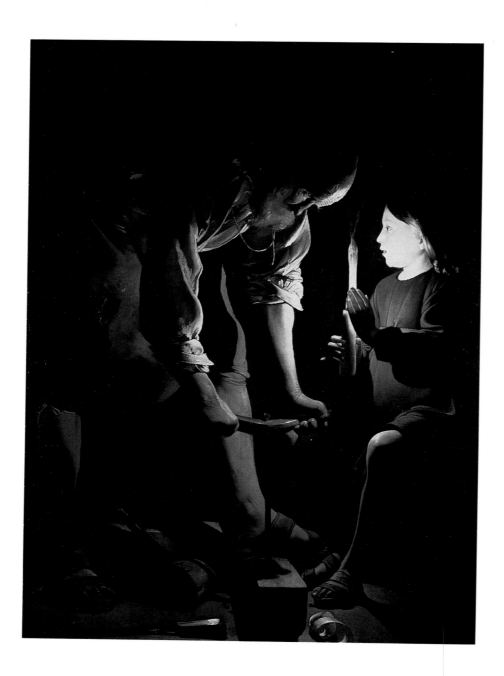

Saint Joseph, the Carpenter

Georges de la Tour, 1645; oil on canvas; 40 x 54 in. (101 x 137 cm). Louvre, Paris.
Georges de La Tour (French, 1593–1652) displayed great charm in his paintings
by depicting the momentous biblical scenes in simple, identifiable settings.
This painting is a good example—the figures have a quiet dignity, and the
scene is depicted at night, which highlights the intimacy of the Holy Family.

The Virgin of the Rocks

Leonardo da Vinci, c. 1482, transferred to canvas,
48 x 78 1/2 in. (122 x 200 cm). Louvre, Paris.
Leonardo da Vinci (Italian, 1452–1519) depicts the youthful Virgin
seated in a dark and gloomy wilderness of jagged rocks. The
shadowy crevice is a symbol of human mortality, while the light
in her face and eyes promises divine intervention from death.

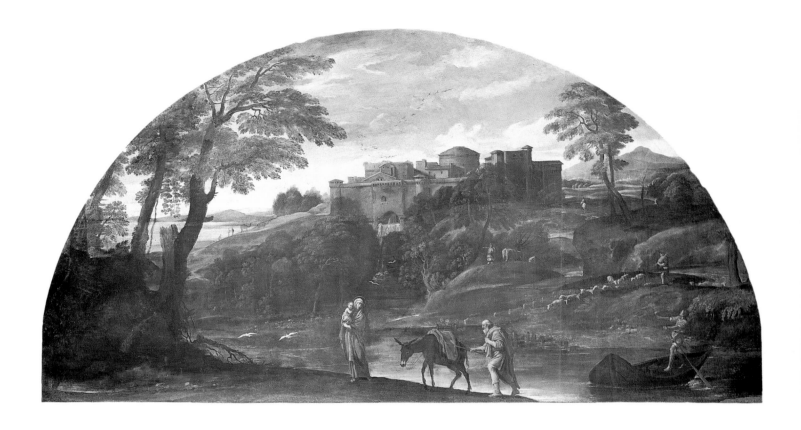

The Flight into Egypt

Annibale Carracci, 1603; oil on canvas; 48 1/4 x 98 1/2 in.
(123 x 250 cm), Doria Gallery, Rome.
Annibale Carracci (Italian, 1560–1609) was a successful con-
temporary of Caravaggio during the period of baroque paint-
ing. Carracci emphasized a sense of proportion while imbu-
ing every scene with a natural vigor. This painting focuses
on an intimate moment as the Virgin Mary turns to
Joseph for reassurance as they leave on their flight into Egypt.

The Presentation in the Temple

Melchior Broederlam, c. 1350; oil on wood, panel. Dijon Museum, Dijon.
Melchior Broederlam (French, d. 1375) was a painter identified with the
International Gothic style. This work incorporates a romanticism, prevalent
in the middle ages, for the end of the age of chivalry, as evidenced by
the rendering of elegant clothes and the exquisite gestures of the figures.

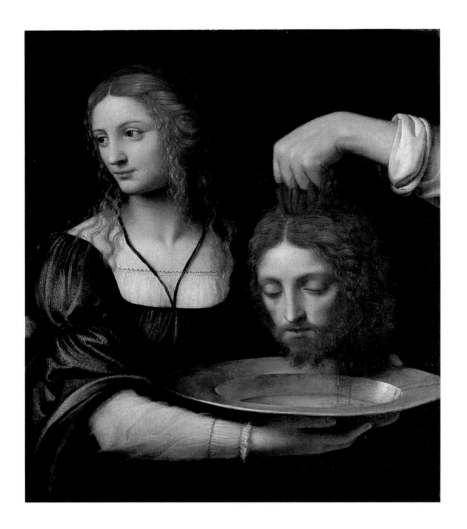

**Salome Holding the Head
of Saint John the Baptist**

Bernardo Luini, c. 1520; oil on canvas; 21 x 24 in.
(55 x 62.5 cm). Louvre, Paris.
Bernardo Luini (Italian, c. 1480–1532), a pupil of
Leonardo da Vinci, was an inventive painter. His landscapes
usually depict infinite views, or torturously worked out
perspective. Though his compositions are stilted, his
expressiveness is reminiscent of contemporary northern style.

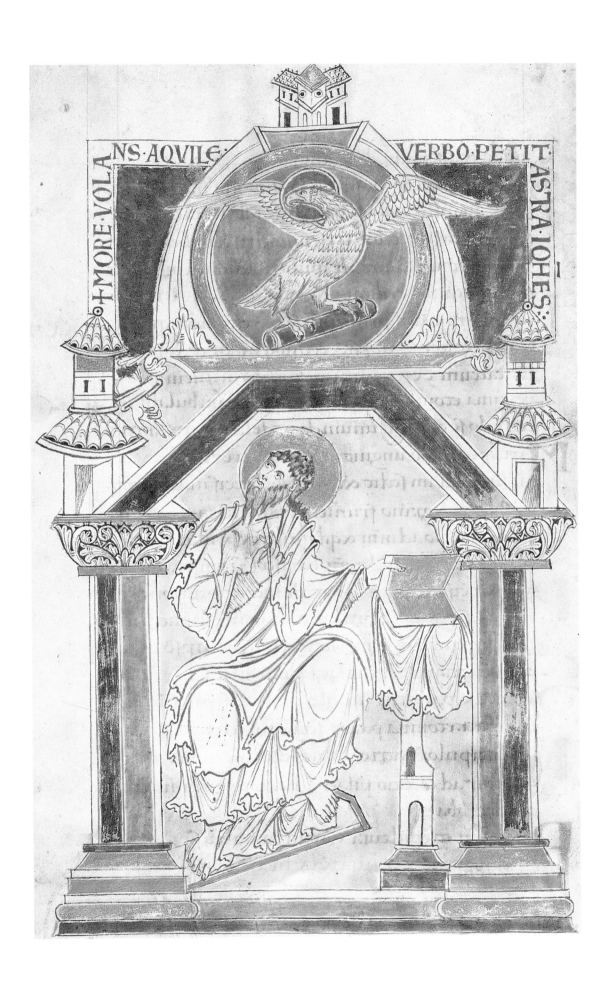

St. John the Evangelist

Gospels, England, end of 10th century; illumination. The Pierpont Morgan Library, New York.

The Romanesque style was born of religious fervor, a freedom gained by abandoning the last of the Classical style's "imitation of nature." Figures are conceived in linear terms, and spatial representation was ignored or treated only as a decorative design.

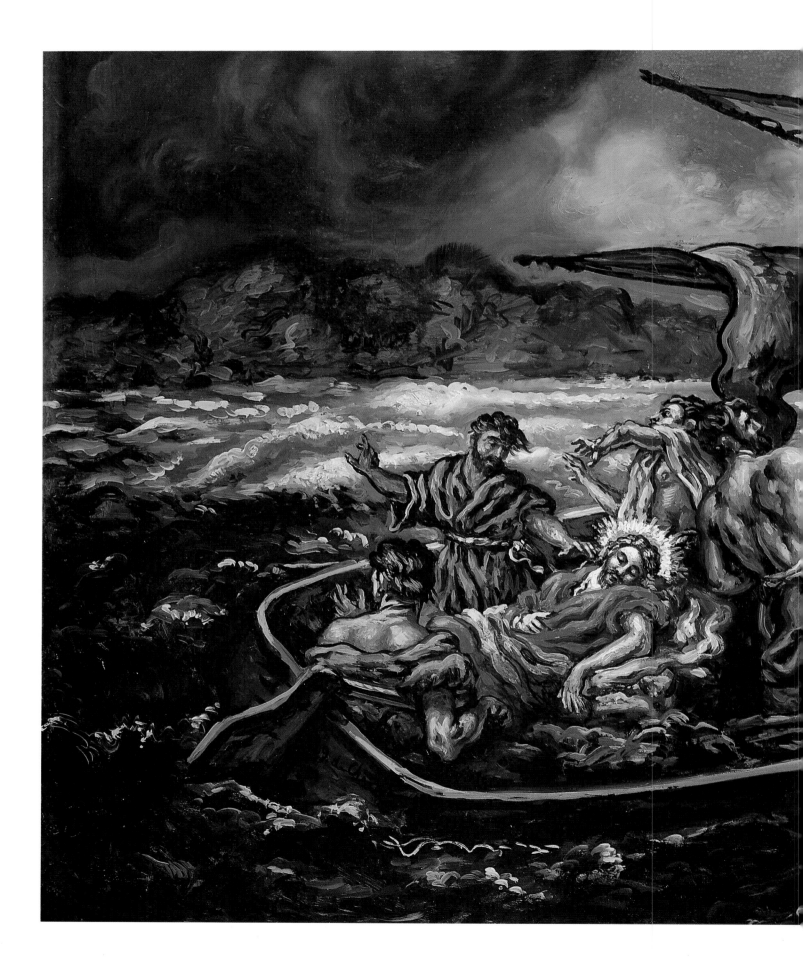

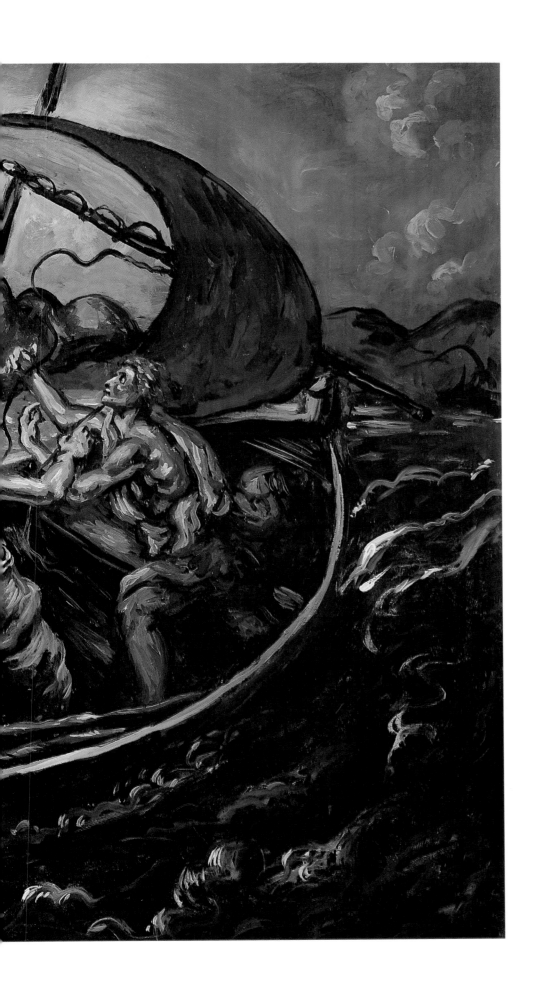

Christ and the Storm

Giorgio de Chirico, 1914;
oil on canvas; 57 1/2 x 47 in.
(146 x 119 cm). Vatican, Rome.
Giorgio de Chirico (Italian,
1888–1978, born in Greece,
developed his enigmatic artistic
vision in Munich, Italy, and
Paris. His powerful works—
what he termed metaphysical
painting—employ steep per-
spective, mannequin-like
figures, and shapes used out
of context to create a mysterious
and desolate atmosphere.

The Martyrdom of St. Andrew

Jean Fouquet, c. 1455, from **Heures d'Etienne Chevalier;**
illumination; Musée Conde, Chantilly.
Jean Fouquet (French, c. 1420–1481) took up the
questions raised by Piero della Francesca's exploration of the
relationship between figures and space. Like Sandro Botticelli,
Hugo van der Goes, and Raphael, rather than concentrate
on illusory composition Fouquet achieved pictorial unity.

The Conversion of St. Paul

Caravaggio, 1601; oil on canvas; 7 1/2 x 5 2/3 ft.
(230 x 175 cm). Santa Maria del Popolo, Cerasi Chapel, Rome.
Michelangelo da Caravaggio (Italian, 1573–1610) reveals
a down-to-earth realism in this painting. Contrary to
tradition, Paul is shown as a simple soldier whose conversion
is a private event. The extreme foreshortening of the figure
and the dominating element of the horse focus the
viewer's eye on the light of inner revelation on Paul's face.

CHAPTER FOUR

CHRIST AS TEACHER AND SAVIOUR

After Jesus was baptized by St. John, He went into the wilderness for forty days where He was "tempted by Satan." (Mark 1:13) Once He returned to Galilee, Jesus began preaching "the gospel of God," gathering His disciples along the way. His miracles drew large crowds out in the country and by the sea, where He continued to preach in parables.

Miracles

According to Mark, Jesus' first miracle was the exorcism of an "unclean" spirit from a man in the synagogue of Capernaum. (Mark 1:32) Yet the miracle at the wedding at Cana, told only in the Gospel of John, (2:1–11) occurs three days after Christ's baptism. The Virgin Mary was at the wedding, and pointed out to Jesus the shortage of wine. Six stone jars were filled with water, but when the steward of the feast tasted the water—it had become wine.

Later, when Jesus and His disciples were in a boat on the sea of Galilee, the wind rose in a great storm. Jesus was woken from sleep by the disciples, and He rebuked the sea, "Peace! Be still!" and the waters calmed. (Mark 4:39) Jesus also walked on water, and at His command Peter did as well. (Matt. 14:28; Mark 6:48)

Jesus was also reported to raise the dead. Lazarus had been dead for four days when he emerged from his burial cave still wrapped in his shroud, after Jesus called to him, "Lazarus, come out." (John 11:38–44)

The Wedding at Canna

detail; Gerard David, 1503; oil on wood, panel. Louvre, Paris. This detail reveals the realism of the interior and the figures, particularly notable in the silverware, brocade, and the buildings seen through the window arches.

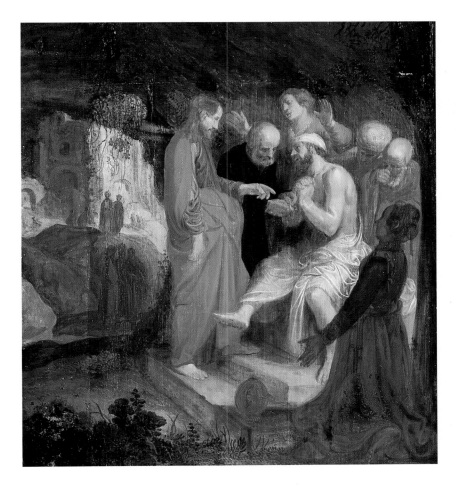

The miracle of the loaves and fishes is recounted in all four Gospels. At Jesus' command, the disciples fed the crowd who had gathered to hear Him preach, and five thousand people were fed from five loaves and two fishes, leaving enough leftover to fill twelve baskets. On another occasion, Jesus fed four thousand people with only seven loaves and a few fish.

Iconography

The miracle of the Wedding at Cana was illustrated many times in Early Christian art, including a fourth-century version that drew an analogy between this wedding and the marriage of Christ to the church. The story is carved on the wooden door of St. Sabina, Rome (c. 430), where it is juxtaposed with the Feeding of the Five Thousand. In Byzantine art, the scene was composed similarly to that of the Last Supper, while Giotto painted the guests seated around a square table in Arena Chapel, Padua (1304–1306).

The Raising of Lazarus

Jan Pynas, 1615; oil on wood, panel; 19 7/8 x 22 3/4 in. (50.5 x 57.8 cm). The John G. Johnson Collection, Philadelphia Museum of Art, Philadelphia. Jan Pynas (Dutch, 1583–1631) echoes Carvaggio's style by silhouetting sculptural figures against a dark background and using light to point to the focus of the composition. His compositions retain a certain Classic serenity; here, Christ seems to perform the miracle with only the slightest motion of his finger.

The oldest rendering of the Raising of Lazarus is found in the catacombs of Callista, Rome, from the third century. It is reminiscent of Greek art in that Jesus points a stick at the tomb, just as Hermes was said to summon up the dead from Hades. Giotto juxtaposed the Raising of Lazarus with the Passion cycle in the Arena Chapel, Padua (1304–1306). Rubens shows Lazarus walking toward Jesus (c. 1624), while Sebastiano del Piombo depicts a befuddled Lazarus with his bindings hanging from his arms and torso (1517–1519).

The miracle of the fishes and loaves appears in fourth-century catacomb art (Domitillia, Rome), and shows Jesus touching the loaves and fishes with a stick. This theme was also incorporated into landscape paintings as well as in compositions that were filled with figures, such as Feti's version of 1621 and Paul Troger's of 1738.

Jesus Healing the Blind of Jericho

Nicolas Poussin, 1650; oil on canvas; 46 x 64 in. (119 x 176 cm). Louvre, Paris. Nicolas Poussin (French, 1593–1665) was briefly, during the 1640s, the court painter for Louis XIII. Afterward, he created works of great psychological insight, despite the painter's excessive love of gesture. The setting here is an interpretation of nature that is both dramatic and classically correct in its symmetry.

The Good Samaritan

Luca Giordano,
c. 1685; oil on canvas;
98 1/2 x 48 1/4 in.
(250 x 123 cm).
Musée des Beaux-
Arts, Rouen.
Luca Giordano
(Italian, 1632–1705)
was famous through-
out Europe for his
paintings. His com-
positions display
an extraordinary
dramatic power,
and his theatrical
sense of style
enabled him to stage
his narrative subjects
to the best effect.

Parables

John's is the only Gospel to tell the parable of the Woman Taken in Adultery. When Jesus was at the temple, the Scribes and Pharisees asked for His judgment on an adulterous woman. The law of Moses demanded that she must be stoned, but Jesus replied, "Let him who is without sin among you be the first to throw a stone." (John 8:1–11)

The parable of the Good Samaritan was employed by Jesus to illustrate the dictates of God to love "your neighbor as yourself." The Samaritan was the only one to help a man who had been beaten by robbers, though a Levite and a priest happened by the man first.

The popular story of the Prodigal Son is recounted only in the Gospel of Luke, and tells of a rich man and his two sons. One son squandered his inheritance and the other stayed home and helped his father. When the errant son returned-

home, his father killed "the fatted calf" for a celebration, "for this my son was dead, and is alive again; he was lost, and is found." (Luke 15:11–32)

Shortly before the Last Supper, Jesus recounted the parable of the Wise and Foolish Virgins. The wise virgins filled their lamps full of oil for their wedding night, then when the groom was delayed they were prepared with light for the feast; the foolish virgins needed to go out and buy more oil. When they returned, the Lord would not let them in, saying, "I do not know you." (Matt. 25:1–13)

Iconography

The oldest illustration of the Good Samaritan is found in a sixth-century Byzantine manuscript, which shows the Christ as Samaritan. This parable has also been compared to the Fall of Man. The Samaritan theme was common from the sixteenth century onward, including J. Bassano (c. 1560) and

Rodolphe Bresdin's engraving (1860). Delacroix (1849) captures the moment when the Samaritan puts the victim "on his own beast," while Rembrandt created a version of their arrival together at the inn (1630).

The Woman Taken in Adultery is shown in numerous manuscripts from the tenth and eleventh centuries. Earlier, the mosaics of S. Appollinare Nuovo, Ravenna (sixth century), link this theme with the woman of Samaria at the fountain. In the nineteenth century the theme had a resurgence of popularity, beginning with William Blake's watercolor (1810).

One of the earliest versions of the Prodigal Son appeared in twelfth-century capitals at St. Nectaire, Puy-de-Dome, France. Dürer engraved a scene of the Prodigal Son among the swine (c. 1495), while Rembrandt completed at least seven drawings, a painting, and a print on this single theme.

The parable of the Wise and Foolish Virgins is depicted early in the fourth century, in frescoes of the catacomb of S. Cyriaca, Via Tiburtina, Rome. The entire parable is illustrated in the Byzantine *Codex Rossanesis* (sixth century), and was a popular subject during the middle ages as it is linked with the Last Judgment. In the seventeenth century, Abraham Bosse incorporated the theme into a contemporary setting, with Louis XIII–style costumes and interiors.

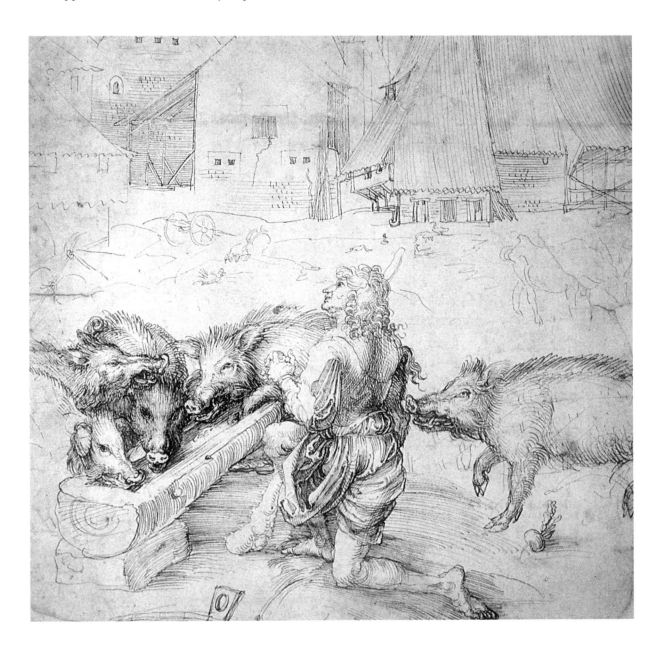

The Prodigal Son
Albrecht Dürer, c. 1520; engraving. British Museum, London.
Albrecht Dürer (German, 1471-1528) followed in the tradition of the artists of the middle ages who admonished viewers against the wages of sin. Dürer lived during the Protestant Revolution in Germany, and his art reflects a willingness to open a dialogue with faith.

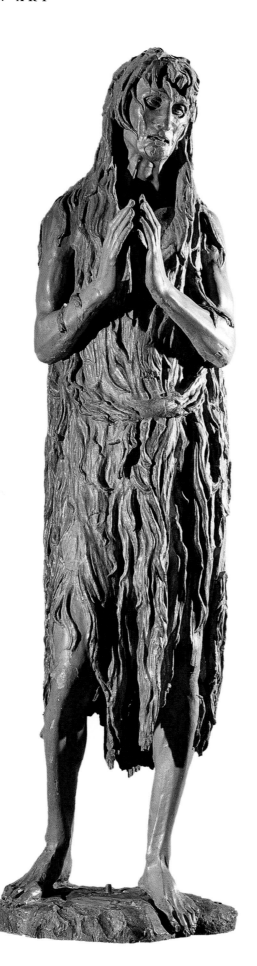

Mary Magdalen

Donatello, 1455; wood with polychromy and gold; height 74 in. (188 cm). Museo dell'Opera del Duomo, Florence. Donatello (Italian, c. 1386–1466) was an early proponent of Renaissance naturalism. His figures often symbolized the human aspect of the Renaissance— illustrated by an impassioned individuality. In this sculpture, the dismal, expressionist rendering runs counter to the rising themes of grace and refinement.

Women of the New Testament

Three women appear in several versions of the events recorded in the Gospels, and from early Christianity their identities have been mingled and questioned.

The story of Mary and Martha is told in Luke. (10:38–42) When Jesus returned to Bethany, where He had raised Lazarus from the dead, He stayed with Lazarus' two sisters, Martha and Mary. Mary sat at Jesus' feet and listened to His teaching, while Martha "was distracted with much serving." When Martha asked why Jesus didn't rebuke Mary for not helping, Jesus said, "you are anxious and troubled about many things," while Mary has chosen the "good portion" which cannot be taken from her.

It is sometimes said that Mary Magdalen was the sister of Martha. She is also mentioned in Luke: "And the twelve were with Him, and also some women who had been healed of evil spirits and infirmities: Mary called Magdalen." (Luke 8:1–2) In addition, Mary Magdalen is considered to be the unnamed sinner who wet Christ's "feet with her tears and wiped them with her hair." (Luke 7:46)

Mary Magdalen was present at the Crucifixion and at the Entombment, and also at Christ's first appearance after his Resurrection. After the Ascension, Mary Magdalen, together with Martha and Lazarus, was said to have traveled to Provence, where all three converted the populace to Christianity.

Iconography

Nicolas Froment portrays Martha kneeling at Jesus' feet, asking forgiveness (late fifteenth century), while Velázquez, in 1619, depicted Christ's visit to the sisters of Lazarus.

Mary Magdalen was typically shown with long beautiful hair, and was often compared to figures of Venus. Jan van Scorel depicted her as a beautiful courtesan in 1529. Conversely, Donatello sculpted Mary as a repentant humble woman (1455), as did Gentileschi, in 1626. Mary is shown as well in numerous paintings of Christ's Crucifixion.

The Last Supper

Leonardo da Vinci, 1495–1498; mural. Santa Maria delle Grazie, Milan.
Leonardo da Vinci (Italian, 1452–1519) illuminated the goals of Renaissance art in the harmony of the real
and the ideal in this masterpiece of Christian art. The brilliant spatial depth and symmetrical composition
is balanced by an individual rendering of each Apostle, permanently defining this most momentous event.

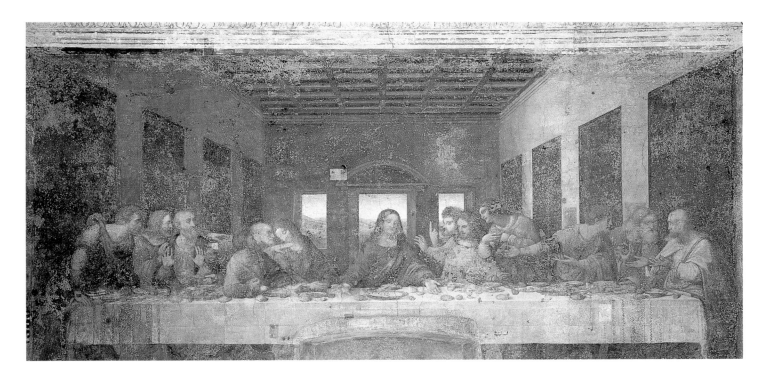

Jesus With His Disciples

The Transfiguration occurred shortly before Christ entered Jerusalem, and was witnessed by Peter, John, and James on top of a high mountain. Christ's face "shone like the sun, and his garments became white as light." (Matt. 17:2) Then they saw visions of Moses and Elijah, and a voice from a cloud said, "This is my beloved Son."

Christ's Entry into Jerusalem is recounted in all four Gospels. Jesus rode into the city on the Sunday before the Passion, and was greeted by crowds who "took branches of palm trees and went out to meet Him." (John 12:13)

Among the best known Christian stories, The Last Supper, too, is told—with very little variation—in all four Gospels. During the Passover meal with His disciples, Jesus revealed that He would be betrayed. Judas asked, "Is it I, Master?" (Matt. 26:25) Then Jesus asked the disciples to eat the bread and the wine, for "this is my body," and the "blood of the covenant, which is poured out for many." (Mark 14:22–24)

Iconography

The celebration of the Transfiguration began in the sixth century in Byzantine manuscript illustrations. The symbol of the Transfiguration is usually a blue circle with gold stars. Some of the earliest depictions of the Transfiguration as well as the Last Supper appear in the sixth century, in mosaics of S. Apollinare Nuovo, Ravenna.

In this Early Christian art, the composition of the Last Supper is portrayed with Christ and the Apostles seated around a semicircular table. In the middle ages, the Apostles sit at a square table, with Christ on the left. Leonardo da Vinci, in his celebrated painting of this scene, placed Christ in a central position (1495–1497).

In Andrea del Castagno's version of the Last Supper, in the refectory of S. Apollonia, Florence (c. 1450), Judas is placed in the foreground, opposite Christ, to foreshadow his impending Betrayal. During the Reformation this theme became even more popular for artists, and in

1648, Philippe de Champaigne's Last Supper shows Christ blessing the wine and bread.

The story of Christ's Entry into Jerusalem is depicted as early as the fourth century, on a Roman sarcophagus. Byzantine mosaics depicted Christ sitting side-saddle as he rode into the city, for example in the Cappella Palatina, Palermo (twelfth century), and Ghiberti's north door of the Baptistery, Florence (1403–1424).

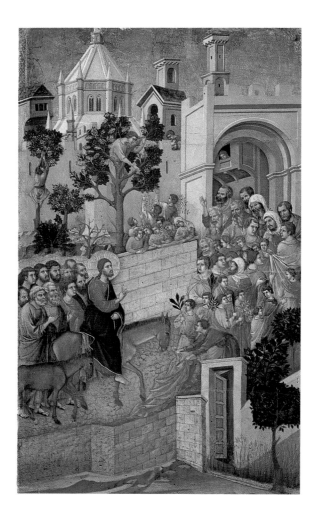

Entry Into Jerusalem
Duccio, 1308–1311; oil on wood, panel. Cathedral Museum, from the Maesta Altarpiece, Museo dell'Opera Metropolitana, Siena.
Duccio de Buoninsegna (Italian, c. 1255–1319) was somewhat more traditional than his contemporary Giotto, as can be seen here by the Byzantine-influenced gold background. Yet the rounder and more expressive figures were typical of the Gothic style; the artist's landscapes, though, became increasingly natural.

The Passion of Christ

The Passion cycle begins with the Agony in the Garden, following the Last Supper, and is recounted by the Gospels of Matthew, Mark, and Luke. Jesus took Peter, James, and John with him into the Garden of Gethsemane, at the foot of the Mount of Olives, where He prayed to God, "all things are possible to thee; remove this cup from me; yet not what I will, but what thou wilt." (Mark 14:36) Luke describes the angel who appears to strengthen Christ.

Judas then betrayed Christ with a kiss, allowing the chief priests to arrest Him. After the death of Jesus, Judas "repented and brought back the thirty pieces of silver" to the priests, who buried the "blood money" in a field. (Matt. 27:3–10) In remorse, Judas went and hanged himself.

During Christ's trial before Pilate, Peter watched as the priests and council gave false witness. Yet when Peter was asked if he was "with Jesus of Nazareth," he denied it "with an oath, I do not know the man." (Matt. 26:57–75) Pilate acquitted Jesus, and sent Him to Herod, where Jesus was mocked and dressed "in a gorgeous robe" before being sent back to Pilate. Upon the demands of the "chief priests and the rulers and the people," Pilate "washed his hands" of the matter, saying, "I am innocent of this man's blood." (Matt. 27:24) Under pressure from the gathered crowd, Pilate released the murderer Barabbas and sent Jesus to be scourged and crucified.

Iconography

Dürer completed a series of the Passion cycle in his etchings of 1515, while Tintoretto (1564–1567) and El Greco (1605–1610) also did entire series on the Passion of Christ.

The Agony in the Garden is almost never found before the eleventh century. In the Renaissance, Andrea Mantegna portrays the angels who come to Christ (1455–1460), while Delacroix (1826) shows a remarkably similar composition in his much later romantic rendering.

In Early Christian art Judas is depicted as no different from the other Apostles, but in the Gothic period Judas began to be portrayed with distorted features and dressed in ugly clothing, as in Giotto's

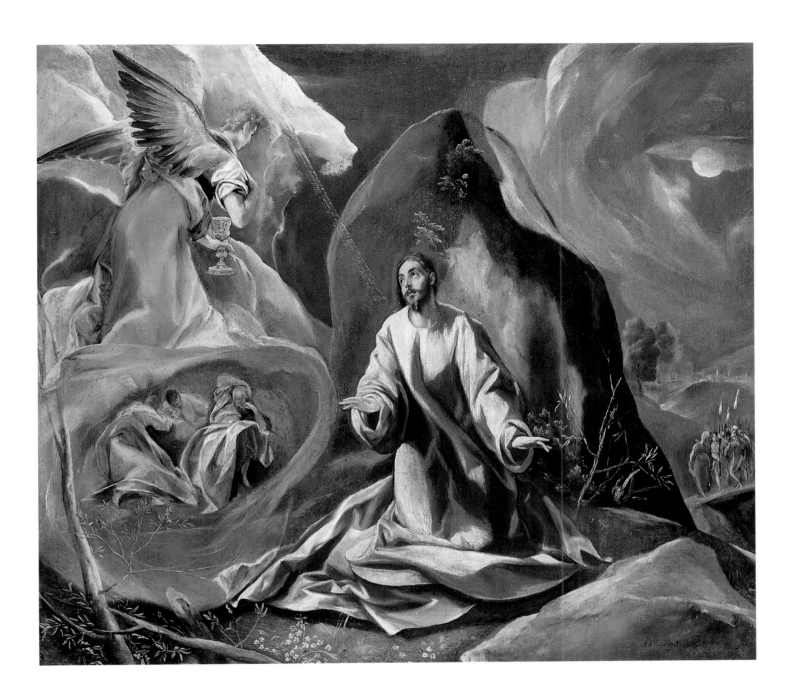

frescoes in the Arena Chapel, Padua (1304–1306). Barna da Siena (c. 1340) pictures Judas accepting his money from the priests, while Rembrandt shows the heartfelt remorse of Judas as he tries to return the coins (1629).

As a subject for artists, Christ's second meeting with Pilate, when the procurator washes his hands of guilt, was more frequently depicted than was the actual trial. Both appear as early as the fourth and fifth centuries, on the door of the Church of S. Sabina, Rome (c. 430) and on the bronze door of the Cathedral at Hildesheim (1008–1025).

Agony in the Garden

El Greco, 1595; oil on canvas; 40 1/4 x 44 3/4 in.
(102.2 x 113.7 cm). Toledo Museum of Art, Ohio.
El Greco (Spanish [Greek-born], 1541–1614) created
magnificently subjective renderings of biblical scenes
in his visionary Mannerist style. The forms and figures
have a transparent glow, as one aspect of the
composition merges into the next, creating a spirited
rhythm that helps illuminate the narrative of the story.

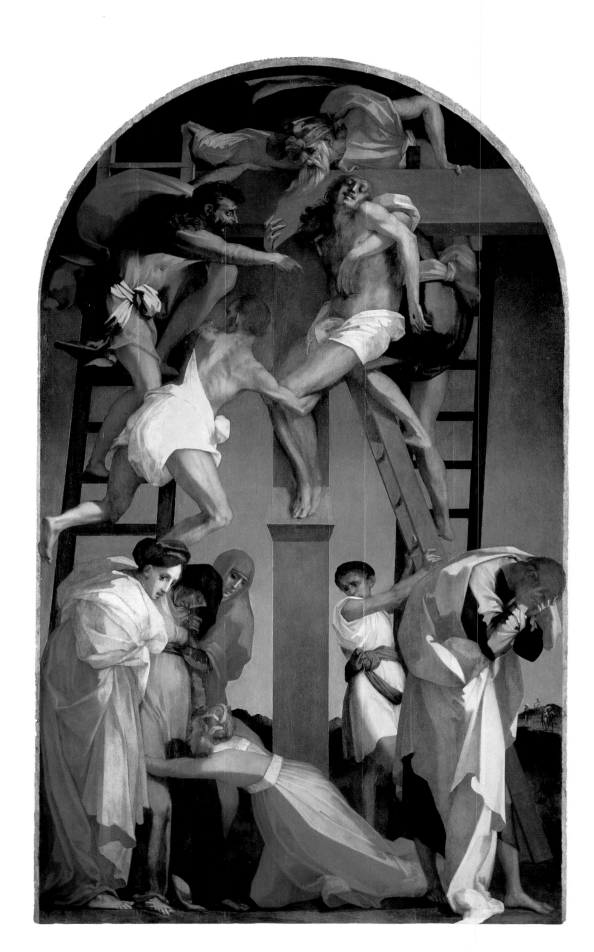

**The Descent
from the Cross**

*Rosso Fiorentino, 1521;
oil on wood, panel. Pinacoteca
Comunale, Volterra.*
Giovanni Battista di Jacopo,
called Rosso Fiorentino,
(Italian, 1495–1540) originally
painted this scene for the
Cathedral of Volterra. There
is no center space, only
foreground figures against a
leaden sky. As with Jacopo da
Pontormo, Fiorentino utilized
the Mannerist tendency to
combine fantasy in color
and form to create disturbing,
tormented works of art.

Crucifixion of Christ

Roman soldiers taunted Jesus, crowning Him with thorns before He was crucified. A sign above His head proclaimed Him "Jesus of Nazareth, the King of the Jews." (John 19:19.)

Jesus was crucified with a criminal on either side, and "the people stood by, watching." According to Matthew, in the ninth hour of the Crucifixion Jesus called out, "My God, my God, why hast thou forsaken me?" before dying. (Matt. 27:46–50) To make sure He was dead, one of the soldiers used his lance to puncture Christ's side.

The Deposition refers to the removal of Christ's body from the Cross, and the Lamentation is the suffering of Mother Mary, Mary Magdalen, and the "other Mary," the mother of Joseph and James.

Iconography

Early Christian art is relatively devoid of scenes of the Crucifixion, except for on the door of the Church of S. Sabina, Rome (c. 430). Most of these renderings show Christ absent of pain, and with His eyes open.

In the middle ages, around the eleventh century, a more pitiful image of Christ emerges, where He is shown dead on the cross and crowned with thorns, as in the stained-glass window of Chartres Cathedral. Giovanni Cimabue also rendered the pathos of the scene in his fresco at Santa Croce, Florence (c. 1280–1285).

Invariably, figures are shown on either side of Jesus' cross, and include Mary Magdalen, the Virgin Mary, St. John the Evangelist, and the soldiers who cast lots for Christ's robe. Both Dürer and Rembrandt did a series of engravings on the subject of the Crucifixion. The Crucifixion theme remained popular even into the twentieth century, with Pablo Picasso's portrayal (1930) and Salvatore Dali's surrealistic composition (1951).

Fra Angelico's version of the Deposition, in the Santa Trinita altarpiece (c. 1440), focuses on the grief of the witnesses, as does Grünewald's Isenheim altar (1511–1516). Rubens (1611) and Rembrandt (1633) rendered scenes of the removal of Christ's body from the cross, as did many artists of sixteenth-century Spain: for instance, Juan de Borgona's fresco in the Chapterhouse, Toledo Cathedral (1509–1511) and Pedro Machuca's version, c. 1520.

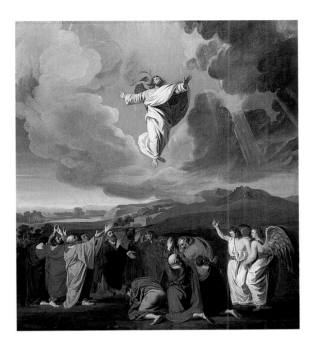

Resurrection

The Resurrection is recounted in each of the four Gospels, though with varied descriptions. Three days after Christ had been entombed in Joseph of Arimathaea's burial chamber, three women—Mary Magdalen, Joanna, and Mary the mother of James—took spices to embalm his body. But they found the stone had been moved from the opening and Jesus was gone. Then "two men stood by them in dazzling apparel," asking, "Why do you seek the living among the dead?" (Luke 24:1–12)

According to the Gospels of Mark and John, Christ appeared to Mary Magdalen near the tomb, as she mourned. Jesus told Mary not to touch Him, "for I have not yet ascended to the Father." (John 20:14–18) Luke describes Christ appearing to the disciples and blessing them, before "He parted from them, and was carried up into heaven." (Luke 24:36–53)

Iconography

In Early Christian art, the Resurrection was usually symbolized by Christ's figure on the Cross. After the eleventh century, narrative scenes of the Resurrection also began to appear. Piero della Francesca pictures Christ victorious, emerging from the tomb (c. 1454), while Dürer depicts Christ standing on top of the tomb (1512). Both Ghiberti's depiction of the subject on the Baptistery doors (1424) as well as

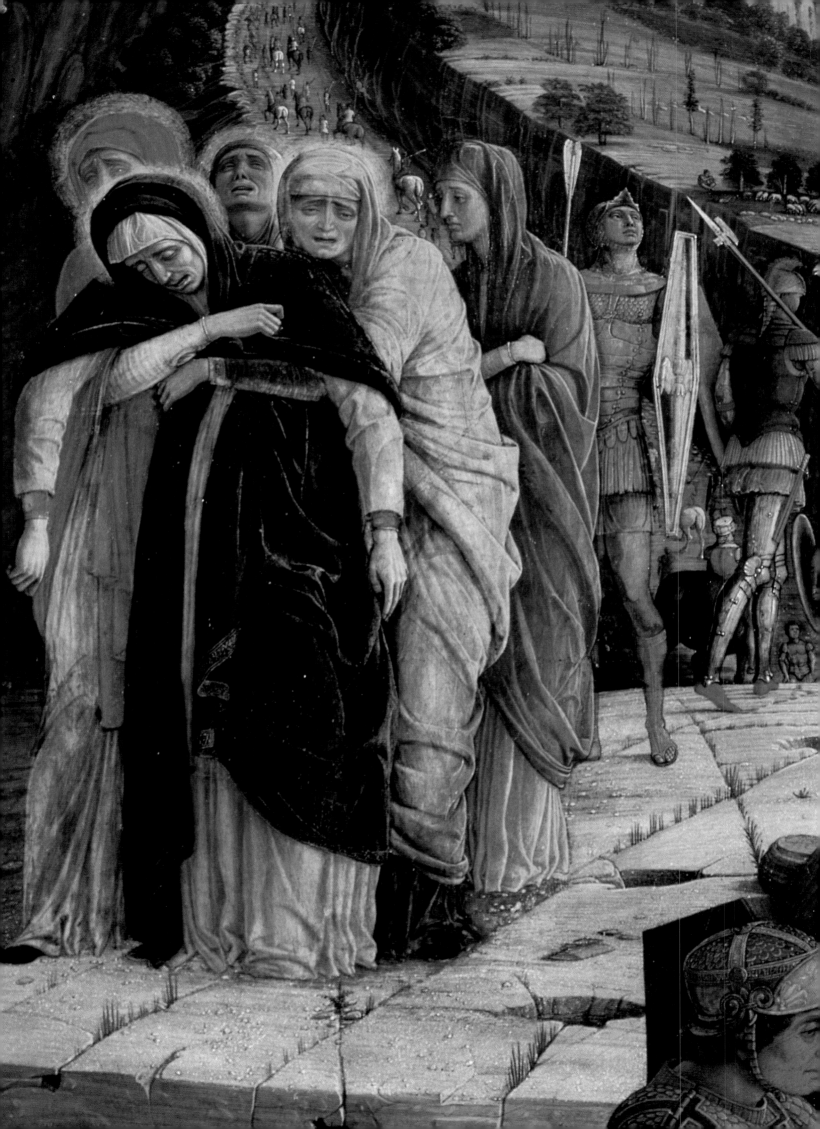

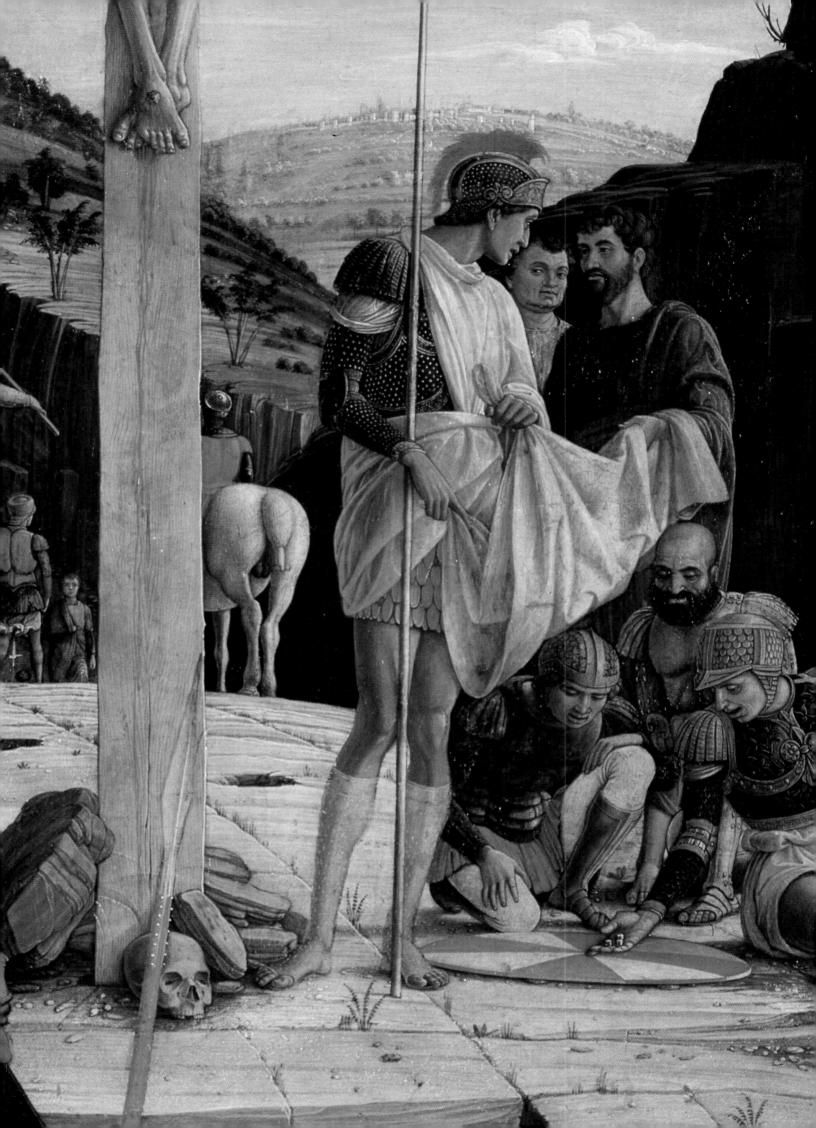

The Raising of the Cross

Peter Paul Rubens, 1609–1610; study for a work executed in oil on panel for the Antwerp Cathedral. Louvre, Paris.
Peter Paul Rubens (Flemish, 1577–1640) painted one of the great masterpieces in art for his native Antwerp Cathedral, the study for which is shown here. His use of color and monumental presentation reflects his recent study in Italy, yet the details of the landscape and still life in the background reveal his northern European origins.

Tintoretto's 1587 version portray Christ hovering in the air.

To illustrate the Ascension, Byzantine art usually depicted Christ seated in the mandorla being lifted up by angels, as seen in the mosaic of St. Sophia, Salonica (ninth century). Sometimes He is accompanied by the symbols of the Four Evangelists and the wheels of fire prophesied by Ezekiel.

On the tympanum of the west door at Chartres Cathedral, Christ appears being carried heavenward by two angels (c. 1145), while after the eleventh century He is more frequently shown rising on His own. Dürer's version of this theme pictures only the lower half of Christ's body (1507–1513), while Renaissance Italian art invariably renders Christ in His glorious entirety.

Revelations

The Book of Revelation is attributed to St. John the Evangelist, as written "to the seven churches that are in Asia." (Rev. 1:4) Apocalypse is the Greek word meaning divine revelation, and John's remarkable vision describes the coming of the end of the world and the return of the Messiah.

First, John saw the Throne of God, with twenty-four elders gathered around Jesus, who was called the "Lamb." Only the one who "by thy blood didst ransom men for God" may open the seven seals of the scroll. (Rev. 5:9)

When Jesus opens the seals, the Four Horsemen of the Apocalypse are called forth, and catastrophes strike the earth. When the seventh seal is opened, seven

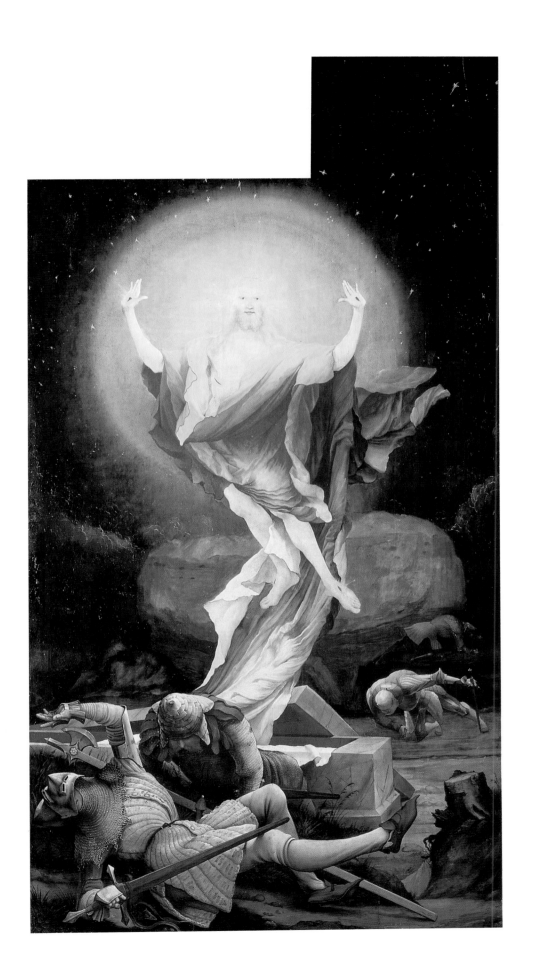

The Resurrection of Christ

Matthias Grünewald, 1510–15; oil on wood, panel. From the Isenheim Altar, Musée Unterlinden, Colmar. Matthias Grünewald (German, c. 1455–1528) painted works of high drama, violence, and mysticism during the northern Renaissance. His sculptural shapes, contrasting colors, and exaggerated gestures prefigured the baroque style, which abandoned realism for expressive affect.

107

The Apocalypse— The Four Angels

Albrecht Dürer, 1497–1498; woodcut. Bibliothèque Nationale, Paris. Albrecht Dürer (German, 1471–1528) took pride in creating woodcuts— a popular form of art that was far more affordable than paintings. Woodcuts were made by cutting away everything from a wood of wood except for the lines upon which the ink was to be rolled. Dürer's skill can be seen in the dense parallel lines and curvilinear embellishments.

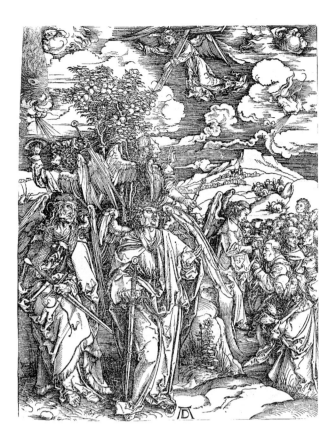

angels blow their trumpets, calling forth plagues of enormous locusts.

A woman appears with a child, and St. Michael and his angels defeat the dragon which threatens them. The woman is given "two wings of the great eagle that she might fly from the serpent into the wilderness." (Rev. 12:14) The serpent/dragon is joined by two beasts, and all those who had been "sealed . . . upon their foreheads" are then taken up to Heaven.

The earth is tormented for a thousand years, until Satan comes out of his prison to "deceive the nations which are at the four corners of the earth . . . to gather them for battle." (Rev 20:8)

The Last Judgment occurs when "the dead, great and small, stand before the throne," and the books are opened, including the Book of Life. All are then to be "judged by what they had done," and those found wanting are thrown into "the lake of fire." (Rev. 20:12–15)

John then saw Heaven and the "new earth," where God will "wipe away every tear from their eyes, and death shall be no more." (Rev. 21:4)

Iconography

In the middle ages, many manuscripts were devoted to the Book of Revelation, such as the

Commentary on the Apocalypse by Beatus, Abbot of Liebana, Spain (tenth century), and the *Apocalypse de St. Sever*, France (ninth century). Cimabue did a fresco series on the Apocalypse in the Lower Church of Assisi (c. 1275), and Dürer made twelve engravings of the theme in 1498.

Usually the Throne of God with the "four and twenty elders" is accompanied by the symbols of the Four Evangelists. The opening of the seals was at times painted in individual scenes, as in El Greco's version of the breaking of the fifth seal (1608–1614).

Churches and chapels were dedicated to St. Michael from the beginning of the sixth century. Depictions of St. Michael are remarkably consistent, such as in Dürer's interpretation (1497–1498), Jacobello del Fiore's version (1421), and Raphael's painting (1505). To differentiate him from St. George, who in legend also fights a dragon, St. Michael is shown standing or hovering in the air; St. George is always on a horse.

The vision of the New Jerusalem told in Revelation is found pictured as early as the fourth century, on a Roman sarcophagus, as well as in a mosaic in the apse of St. Pudenziana (early fifth century). In one of Dürer's engravings, the New Jerusalem is depicted as sixteenth-century Nuremberg, Germany.

The Paradise paintings of Joacham Patinir and the work of Hieronymus Bosch—in, for example, *Garden of Delights* (c. 1505–1510)—were among the first compositions to emphasize the details of the symbols and the panoramic setting as a way to convey the often complex meaning of biblical narrative. The inventiveness of these artists foreshadowed movements in modern art, which emphasized the inherent worth of the art—focusing on composition, color, the juxtaposition of shapes, and pure form. Inevitably yet ironically, this growing concern for style in art coincided with a dramatic decline in the use of biblical narratives as artistic inspiration.

The Garden of Earthly Delights; Hell

detail; Hieronymus Bosch, 1510; panel. Prado, Madrid. Each group of figures in this work has a specific symbolic meaning, and many critics and historians (as well as Freudian analysts) have attempted to interpret them. It has been said that the pig in the habit is meant to represent the part of hell reserved for clerics who indulge in greed and gluttony, however, the meaning of most of these strange creatures remains a mystery to this day.

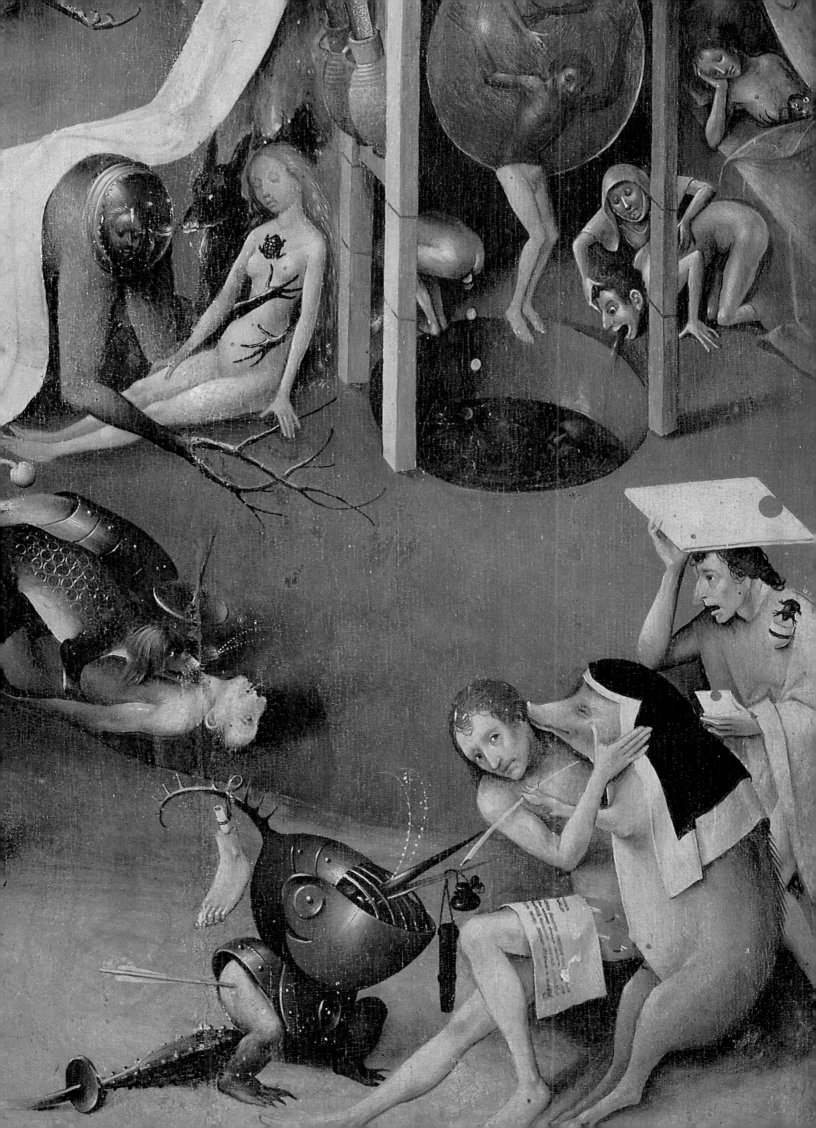

The Apocalypse—St. Michael Fighting the Dragon

Albrecht Dürer, c. 1497–1498; woodcut. Bibliothèque Nationale, Paris.
Albrecht Dürer (German, 1471–1528) published, from the beginning of
1498, his wood-engravings in fifteen parts. These biblical scenes reveal his
technical skill in the physical details of the figures, yet they also show a
sensitivity to the anguish that arises from the conflict of faith and reason.

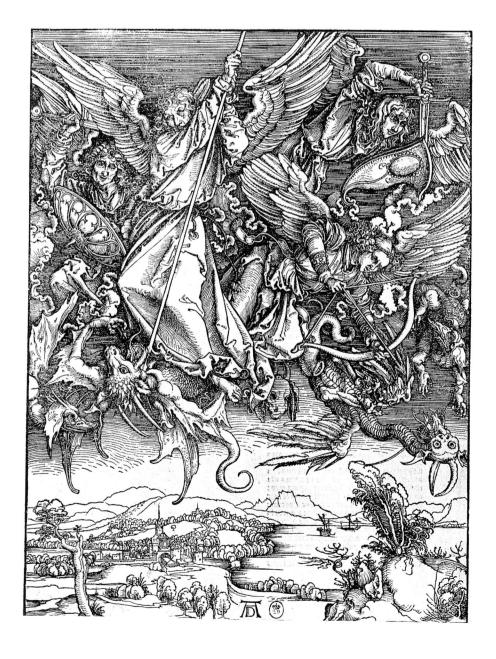

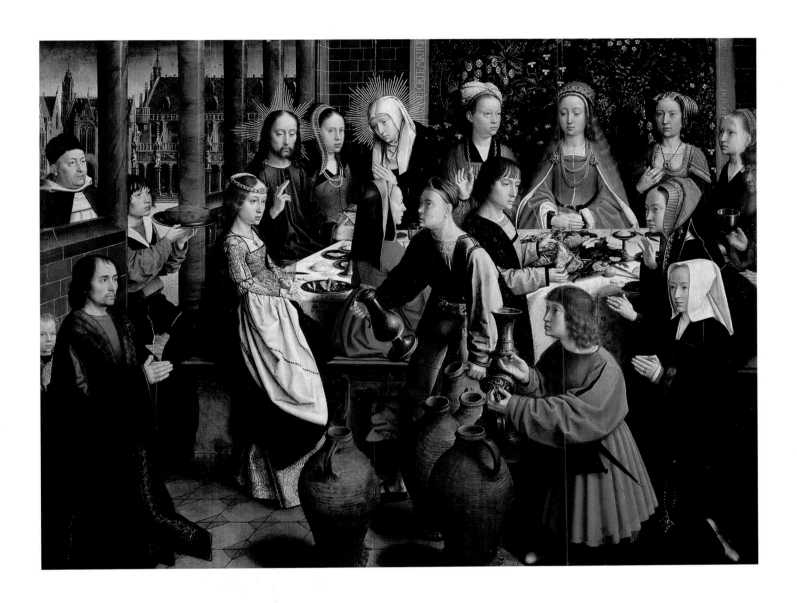

The Wedding at Canna

Gerard David, 1503; oil on wood, panel. Louvre, Paris.

Gerard David (Dutch, c. 1460–1523) brought the first impact of the Italian
Renaissance to northern European art, following in the tradition of Rogier
van der Weyden. There is also here a marked lessening of concern for
the devotional aspects of the scene, typical of the northern baroque style.

Christ and the Woman Taken in Adultery

Nicolas Poussin, 1653; oil on canvas; 46 1/2 x 68 1/2 in. (119 x 179 cm). Louvre, Paris.

Nicolas Poussin (French, 1594–1665) chose harmony as his ideal, both within the forms themselves and in the compositional arrangement of figures. After his long visit to Rome in 1624, Classicism—based on Leone Battista Alberti's theories of Italian architecture—became Poussin's artistic foundation.

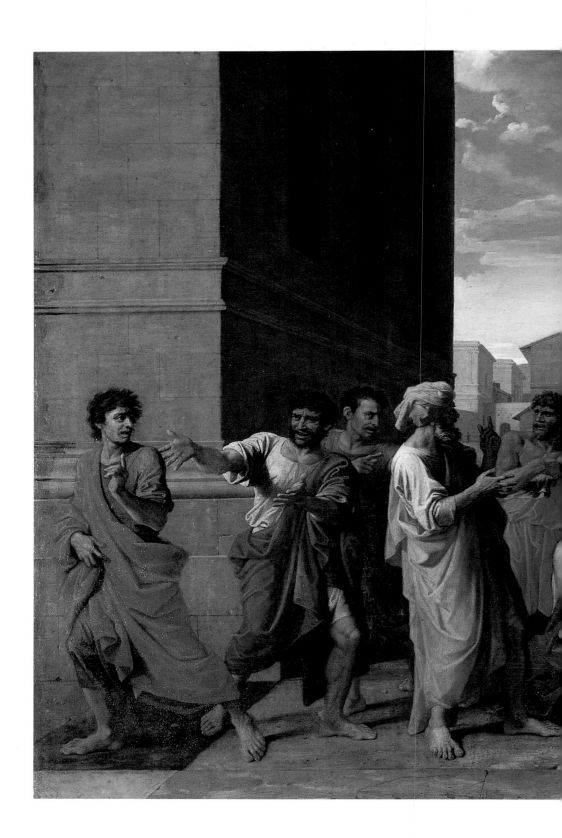

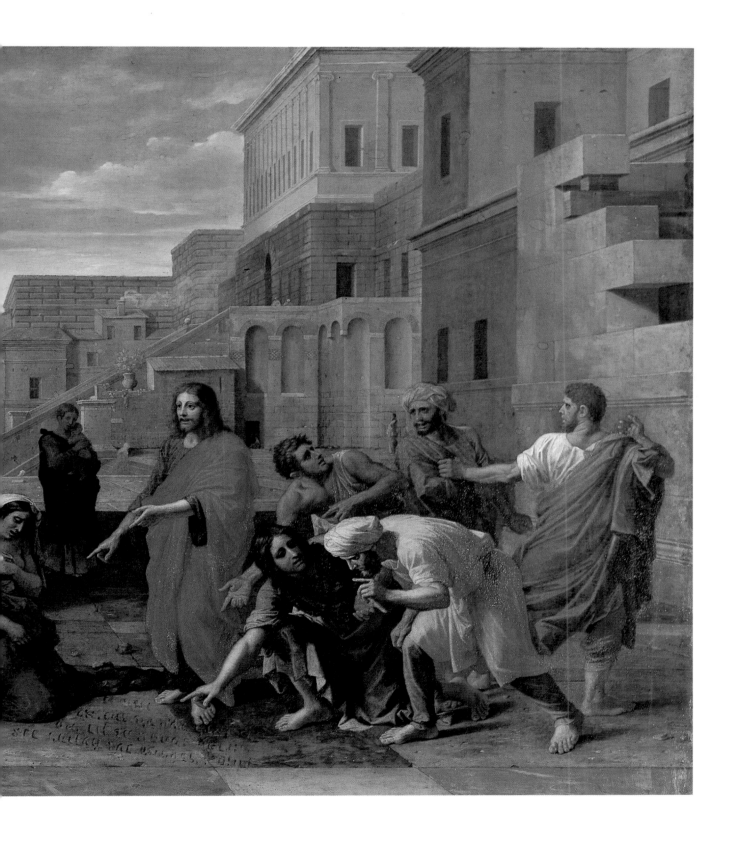

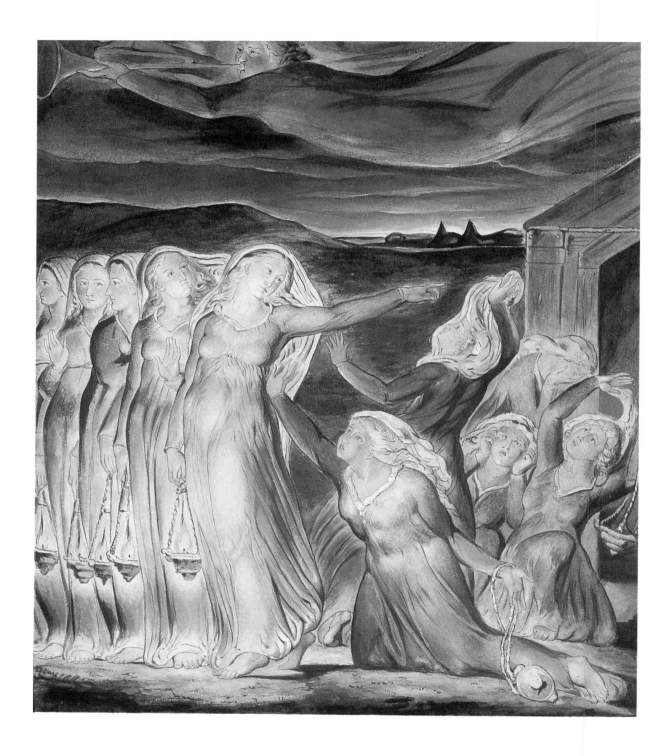

The Parable of the Wise and Foolish Virgins

William Blake, 1822; watercolor; 15 3/4 x 13 1/8 in.
(39.4 x 33.1 cm). Tate Gallery, London.

William Blake (English, 1757–1827)—poet, painter, mystic—was
perhaps the greatest English Romantic artist. He was obsessed
with the Bible and with the poet Dante, and was an admirer
of Michelangelo. Blake's unusual use of tempera color in his
work helped create visionary renderings of symbolic subjects.

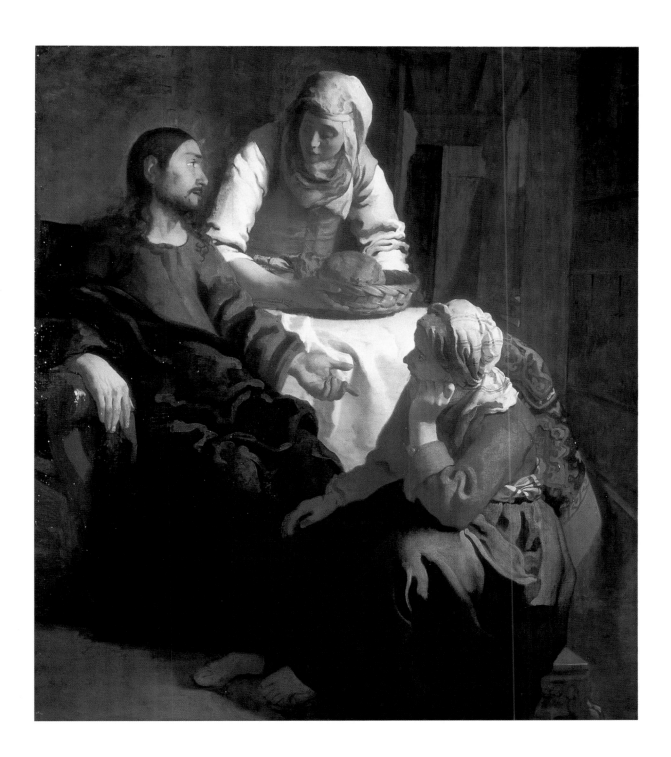

Christ in the House of Mary and Martha

Jan Vermeer, c. 1655; oil on canvas;

62 x 53 1/4 in. (160 x 136.5 cm).

National Gallery of Scotland, Edinburgh.

Jan Vermeer van Delft (Dutch, 1632–1675), a generation

younger than Rembrandt, was a master of harmony and

balance. His works capture a detached moment of tranquility

with an emphasis on the details of his contemporary interiors.

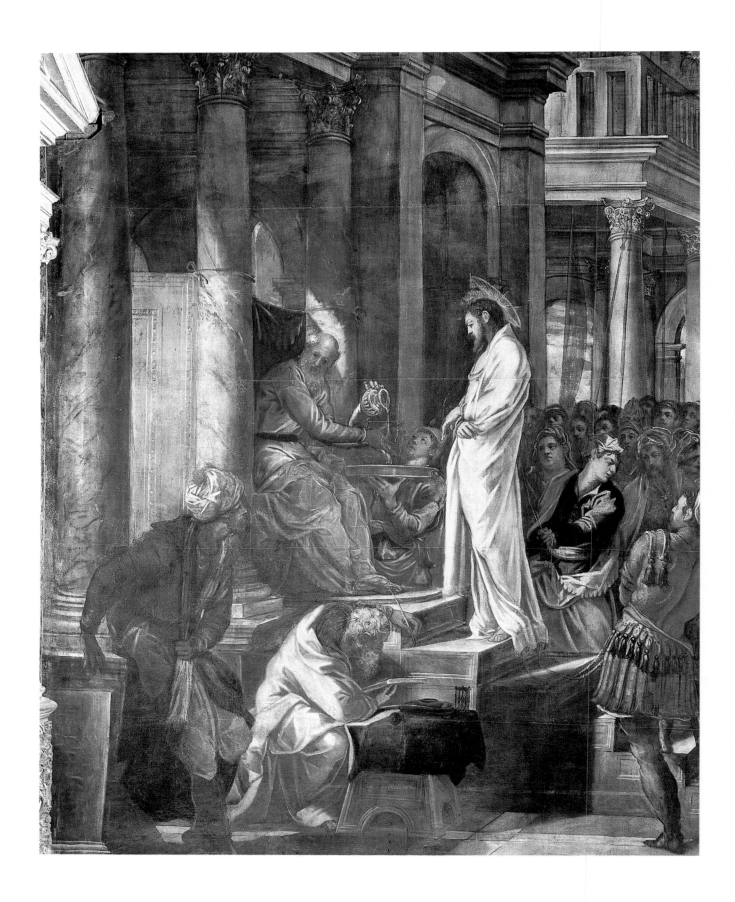

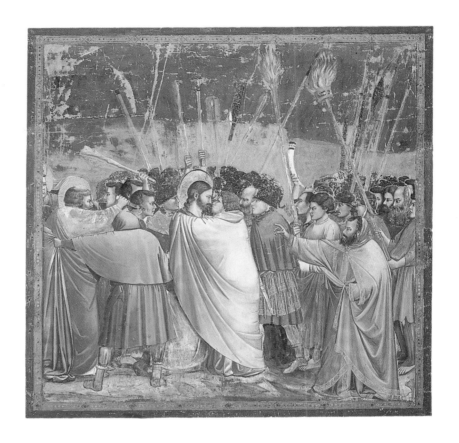

The Kiss of Judas

Giotto, c. 1300; oil on canvas; fresco.
Cappella Scrovegni, Padua.
Giotto (Italian, 1266–1337) reduces the
betrayal of Christ to its essential elements—
Judas' kiss, the reaction of Christ, and the
watching soldiers and Apostles. The action
takes place in the immediate foreground,
reducing the physical setting to a minimum
in order to draw attention to the figures.

Christ Before Pilate

Tintoretto, 1566–1567; oil on canvas; 18 ft. 1 in. x
13 ft. 3 1/2 in. (5.5 x 4 m). Scuola di San Rocco, Venice.
Tintoretto (Italian, c. 1518–1594) painted a total of
forty-eight pictures for the Scuola di San Rocco between
1564 and 1587. His unique spatial concept of Mannerism
allowed him to dramatically foreshorten figures, creating
a pictorial unity throughout the composition.

117

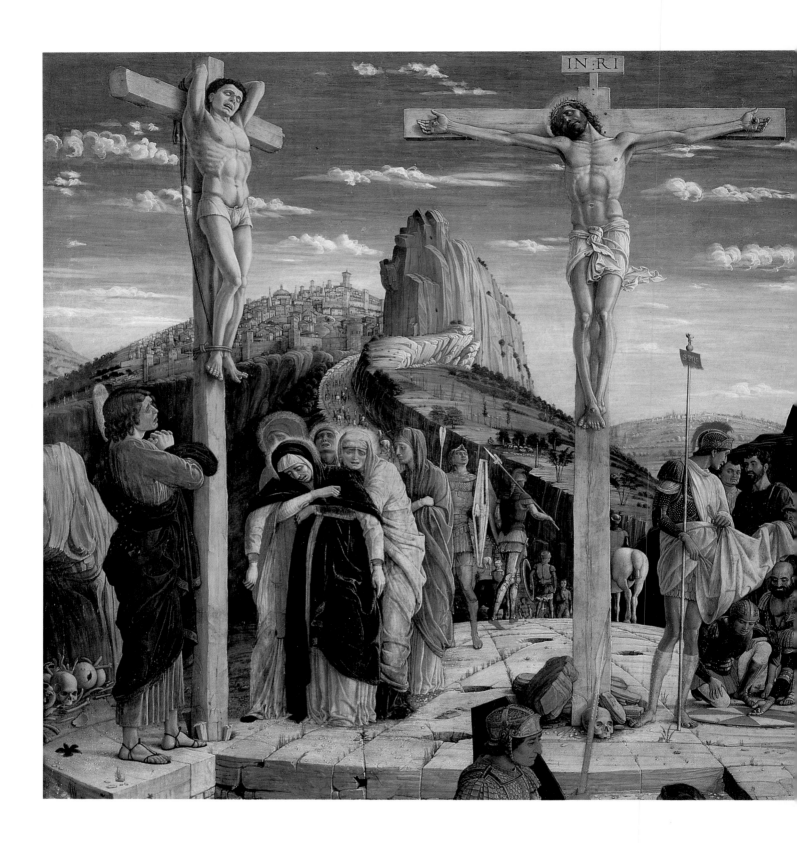

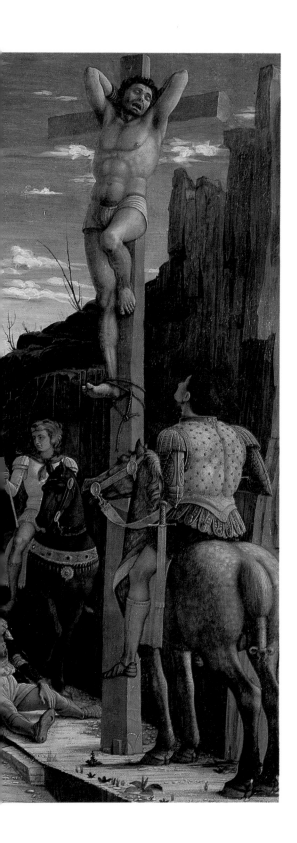

The Crucifixion

Andrea Mantegna, 1456–1459;
from the predella of the Altar
of San Zeno, Louvre, Paris.
Andrea Mantegna (Italian,
1431–1506) was renowned for
his definition of forms and the
consistency of his spatial for-
mation which created a three-
dimensional illusion of reality.
This remarkable work inspired
a series of vivid, pictorial nar-
ratives scenes from masters
and minor artists alike well
into the sixteenth century.

<div align="right">

Following page:
Transfiguration

Unknown artist, c. 550; mosaic.
S. Apollinare in Classe, Ravenna.
The mosaics of Ravenna
mark the transition from a
truly Roman Classicism to
a Byzantine style, enriched
by the local culture. The new
expressionism of the figures
transcends the ideal represen-
tation of the human form.

</div>

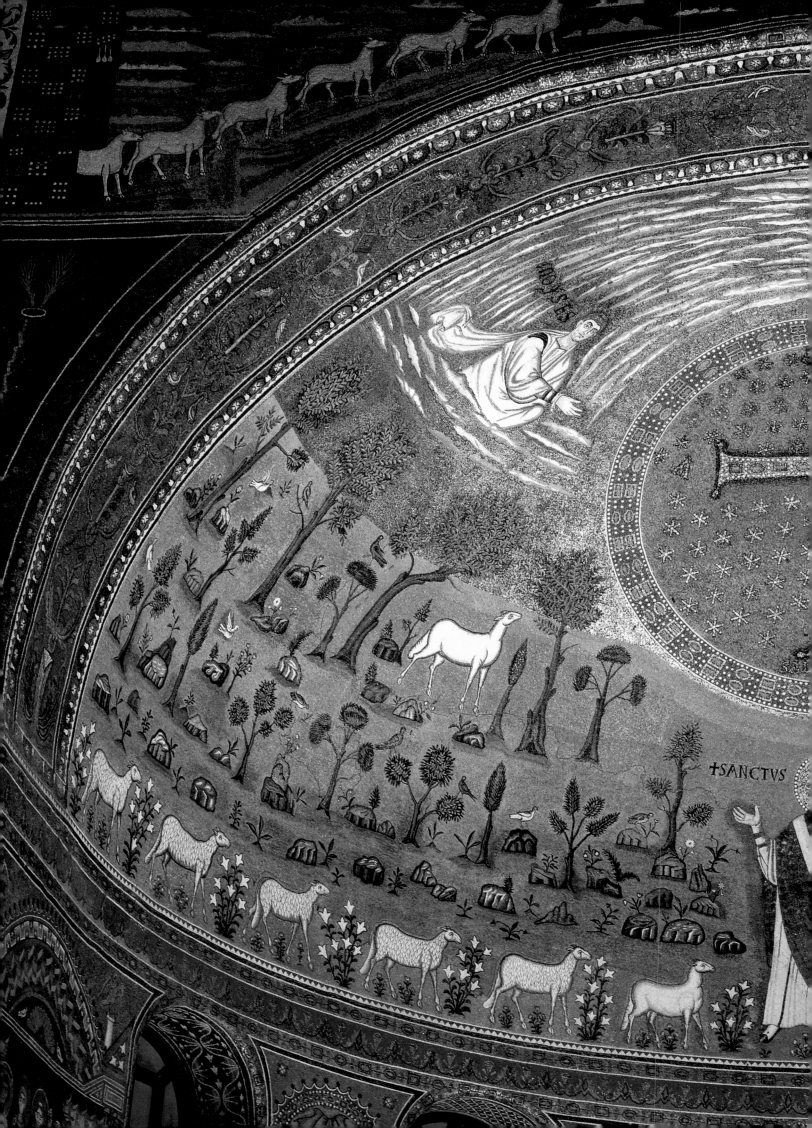

+SANCTVS

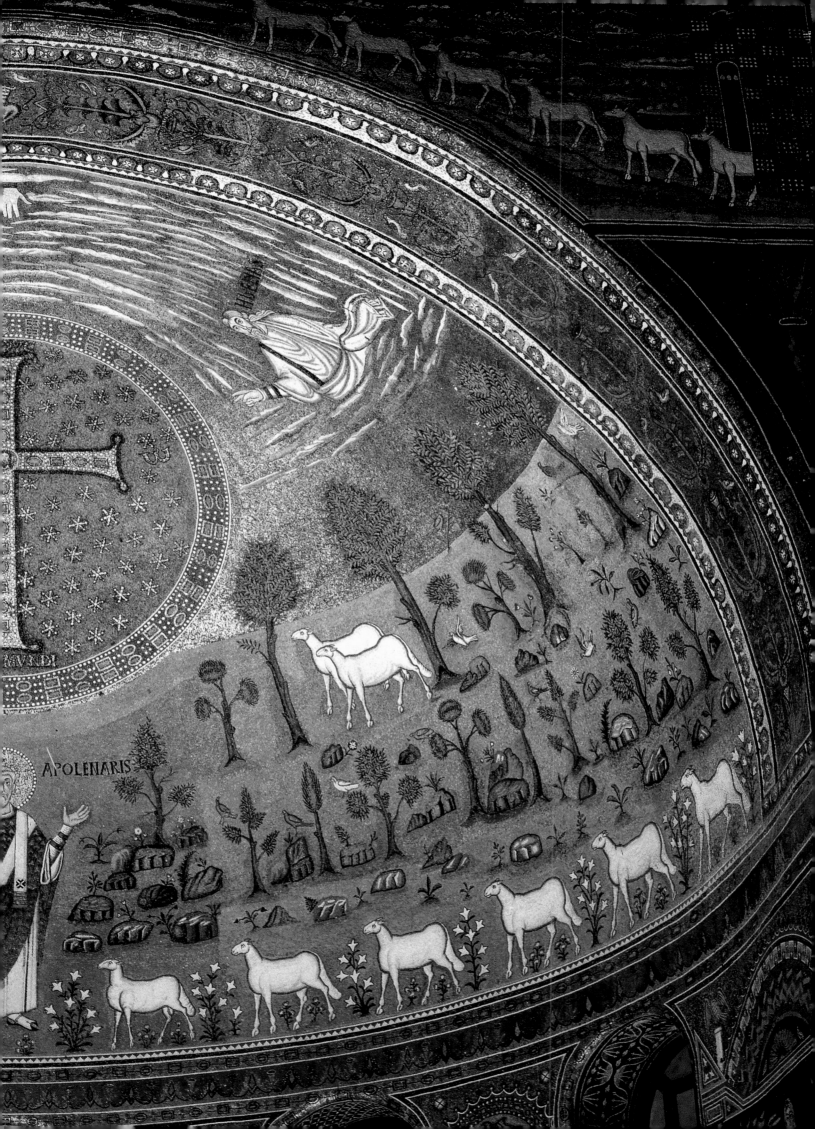

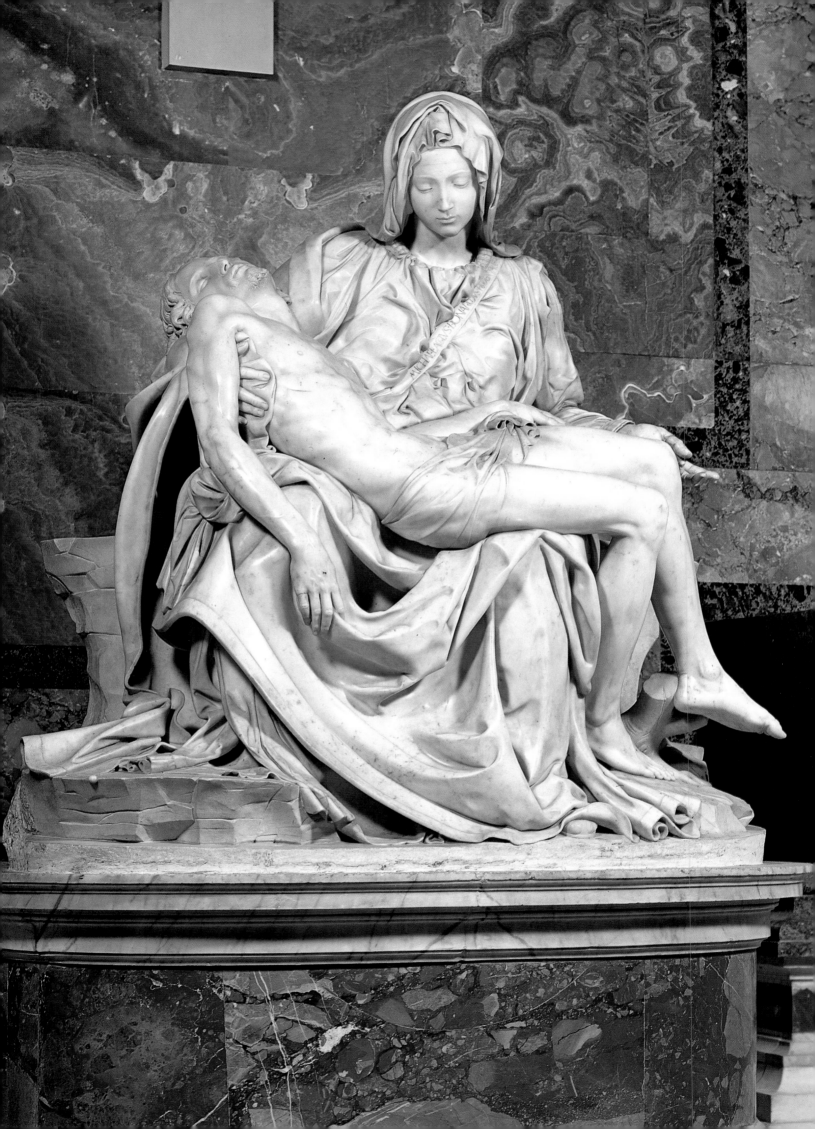

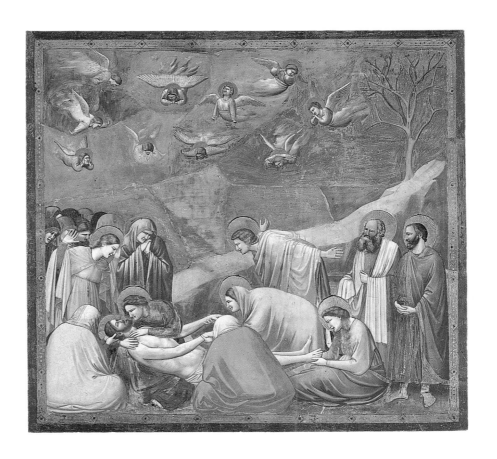

The Lamentation

Giotto, 1305–1306; fresco.
Cappella Scrovegni, Padua.
Giotto (Italian, c. 1266–1337) was the
Gothic-era artist who brought human
realism to painting, evoking the drama
of the moment by abandoning the
stylistic formulas of Byzantine art.
This painting shows a new regard
for volume and form, creating until
then unheard-of spatial effects in art.

Pieta

Michelangelo, 1498–1499; marble; height
68 1/2 in. (174 cm). St. Peter's, Vatican, Rome.
Michelangelo (1475–1564) created three
statues of the Pieta among the last works
of his life, all of which explore the depths
of pathos, as if questioning the meaning
of existence. This composition attains
harmony only with the enlargement of the
Virgin, who holds her dead Son in her lap.

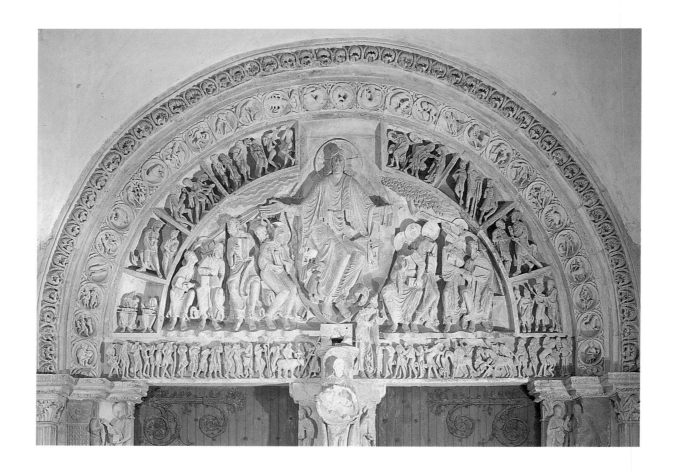

The Pentecost

Unknown artist, 1120–1130; stone scupture. St. Madeleine,
from the tympanum of the narthex, Vezelay.

The creation of Romanesque sculpture was accomplished with
astonishing variety, despite the stringent consistency of iconographic
detail and stylized figures. Master sculptors such as Gislebertus, Benedetto
Antelami, and Nicola Pisano often created visionary reliefs of biblical scenes.

The Meal in Emmaus

Jacopo da Pontormo, c. 1530; oil on canvas;
48 1/2 x 40 in. (123 x 102 cm). Uffizi, Florence.
Jacopo da Pontormo (1494–1556, Italian), was one of the creators of mannerism. In his youth he worked as an assistant to Andrea del Sarto, who influenced him greatly early on. In later years his work became increasingly nervous and contorted—a deliberate confusion of scale and spatial relationships called mannerism, which was a reaction against the equilibrium of form and proportions characteristic of the High Renaissance.

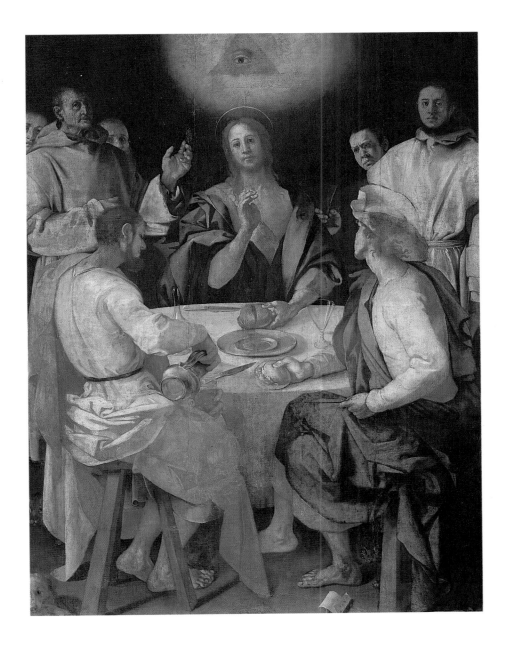

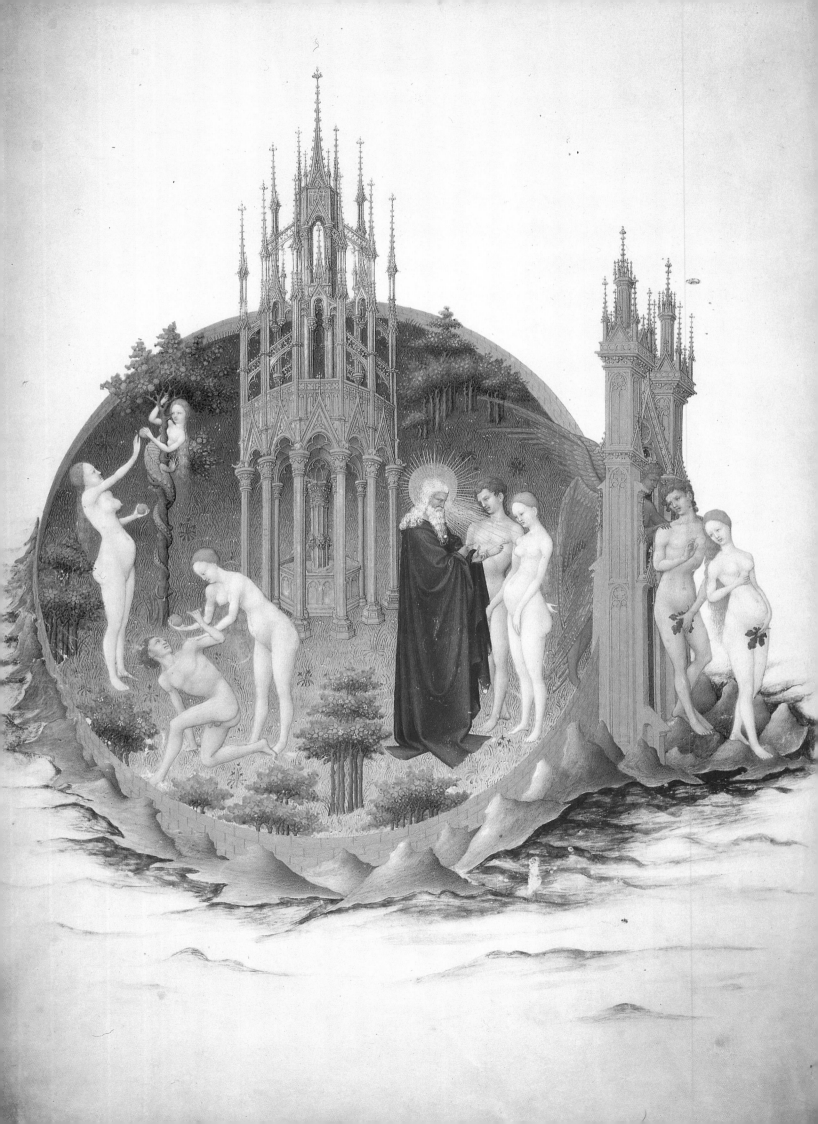

**The Garden of
Earthly Delights; Hell**

*Hieronymus Bosch, 1510; panel;
wing 86 1/2 x 38 in.
(220 x 97 cm). Prado, Madrid.*
Hieronymus Bosch (Dutch,
c. 1450–1516) painted this
triptych late in his life. The left
panel shows the Garden of Eden
as a vast landscape, while the
right panel depicts a nightmarish
scene of burning ruins and instru-
ments of torture. A work for the
ages, the triptych is an epic illus-
tration of man's singular nature
held captive by carnal desires.

Earthly Paradise

*Limbourg Brothers, 1413;
from **Les Tres Riches Heures
du Duc de Berry**; illumination.
Musée Conde, Chantilly.*
The Limbourg Brothers—Pol, Jan,
and Herman (Franco-Flemish, fl.
1380–1416)—of Nijmegen were
the masters of the style known
as International Gothic. Scenes
of humble peasants at their tasks
alternate with noble courtly illus-
trations, all painted in enameled
colors against renderings of the
most famous castles in France.

INDEX